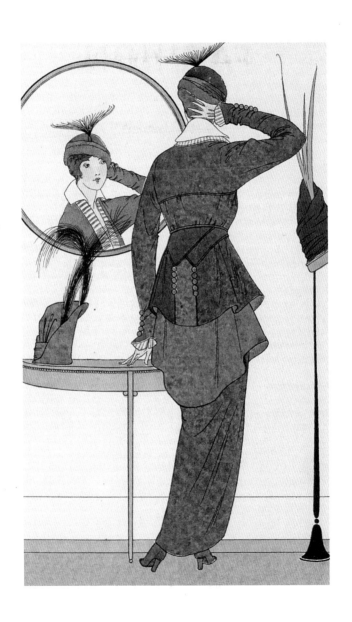

FASHION

Gertrud Lehnert

BARRON'S

For Elisabeth Knoll

American text version by: Agents–Producers–Editors, Overath, Germany
Translated by: Chris Kohler, Richmond, Va.
Edited by: Bessie Blum, Cambridge, Ma.

First edition for the United States and Canada
published by Barron's Educational Series, Inc., 1998.

First published in Germany in 1998 by
DuMont Buchverlag GmbH und Co. Kommanditgesellschaft, Köln, Federal Republic of Germany

All inquiries should be addressed to:
Barron's Educational Series, Inc.
250 Wireless Boulevard
Hauppauge, New York 11788
http://www.barronseduc.com

International Standard Book No. 0-7641-0437-3

Library of Congress Catalog Card No. 98–70751

Printed in Italy by Editoriale Libraria

Content

Preface 7

What Is Fashion? 8

Fashion today / Fashion and traditional costume / Prescribed clothing
and modern democracy / Women's fashion and men's fashion / Fashion
and body / Fashion between art and commerce / Fashion as a paradigm
in our culture

The History 20

Humans—naked-born animals? / Sewing and weaving / Early advanced
civilizations / Cretan elegance / Greece / The Romans / Byzantium / Clothing
in the Middle Ages / The medieval community / Eastern influences / The
rise of the tailor / The age of chivalry ... / ... and women's clothing

Late Middle Ages and Renaissance 32

Human portrayal / Portraits / Ambivalent praise of beauty and fashion / Fashion scoldings / The
body / Women's fashions / Head coverings / The proportions of the female body / The
metamorphosis of men's clothing / The Burgundy court as a center of fashion /
Florentine fashion / A man's matter / The turn of the century and the
16th century / *Lansquenet* fashion / Men's fashion in the 16th century /
Women's fashion / Bodices / Spanish fashion

Baroque Period 56

The 17th century / Fashion / The Spanish influence / Van Dyck's *Marquise Brignole Sale* / Hands / Cleanli-
ness and hygiene / Development of men's fashion / Women's fashion / Children's clothing / The sign
language of fashion and the body / Fashion and body in the Baroque / Louis XIV / Femininity—masculin-
ity / Women's fashion / After the turn of the century / Women's fashion / Farthingales and representation /
Soap and water are out, makeup is in / The decades before the revolution / Fashion magazines / Fashion
and lifestyle / Objectives and audience / Who makes the clothing? / The usefulness of fashion

Empire and the Biedermeier Period 84

Return to nature? / English fashions / Women's fashions / Accessories / Men's fashion /
After 1820: Men's fashion and fops / The Biedermeier period / Mid-century / Hair and hats /
Bourgeois gender imagery

The Invention of Haute Couture 98

New types of work / Clothing manufacture at home and in factories / Women in the bourgeoisie / The genesis of *haute couture* / Crinolines / Silhouettes / Amelia Bloomer / Self-restraint / Change in forms / *Demimondaines* as fashion trendsetters

Charles Frederick Worth 114

Fashion Becomes Fashionable: Turn of the Century to World War I 116

Modern revolutions / The liberation of the female body / Paul Poiret / Avant-garde fashion / The pre-war silhouette /

Coco Chanel 126

The Roaring Twenties 128

Androgyny / Shapes and materials / Accessories, makeup, and hairstyles / Democratization / Sexuality / Fashion and art

Elegant Femininity: The Thirties 138

Evolution of form / Clothing forms / Fashion designers / Fashion as art / Fashion designers of the thirties / War years / *Haute couture* / **The New Look and the Fifties** / Postwar / The fashion creators / The new silhouette / New luxury / New materials / Men's fashion / The triumphal march of blue jeans

CD Christian Dior 152

Modern Youth Revolts: The Sixties and the Seventies 154

The sixties: Cult of youth / New role models / Barbie / The fashion of the street / Carnaby Street / *Haute couture* and *prêt-à-porter* / Hippies and counterculture / **The seventies** / Transitional styles / Nostalgia and exoticism / Hemlines and hotpants / Basic forms of clothing /

Postmodern Fashion: The Eighties and the Nineties 166

Success cults / The cult of the body / Madonna / The media as fashion role models / Modern silhouettes / The internationalization of fashion / Avant-garde fashion in the postmodern period / Gender game / The queen of English fashion: Vivienne Westwood / Gianni Versace / Fashion from Japan / New fabrics, new combinations

Glossary 180
Bibliography 185
Important fashion museums and fashion schools 186
Index of names 188
Picture credits 190

Preface

In recent years, fashion has experienced a degree of public interest unparalleled in its history. It is no longer a topic only for the privileged or a mere pastime for women on shopping expeditions. Today, fashion has become a cultural factor of primary importance. We are constantly informed of its latest whims in the most serious newspapers, on television and, most recently, also in films. Fashion has long since become a serious and profitable industry that not only provides employment for fashion designers and tailors, but also countless journalists and editors, photographers, models, stylists, and hair dressers, not to mention factory and home-workers all around the world or the salespeople in department stores and boutiques.

But where can one turn to learn more about fashion than is regularly reported about the latest trends in the daily newspapers? If you want to know, for example, how long fashion has existed and under what cultural circumstances it has developed into that which it is today? What does fashion have to do with people's ever-changing understanding of themselves and the different roles of women and men? How can we recognize which current fashion trends are culled from the repetoire of ideas from the history of fashion that continually recur, in sometimes fantastically creative and sometimes tasteless or even respectless interplay with the past, culminating in the ultra-modern designs presented for our admiration semi-annually on the catwalks of Paris, Milan and London?

Encyclopedias, individual works (often biographical), and a few larger histories of fashion and costumes are possible sources. But these are often too specialized, too broad, or simply too expensive. There has been a lack of a comprehensive yet precise and understandable introduction to the history of fashion, a book that can simultaneously inform and entertain. This Crash Course on fashion aims to fill that niche. Because fashion is understood as part of cultural and societal history, it avoids a dry recital of bare facts and dates. Instead, this book explains important lines of development as well as the most decisive interactions between fashion, society, and art. Approximately 250 pictures supplement the text and make clear the crucial role fashion has played, and continues to play, in people's self-portrayal throughout the centuries.

This book can also be used as a reference work. It includes a glossary, a bibliography, and a list of several important fashion museums and schools.

<div align="right">Gertrud Lehnert</div>

Fashion today

Fashion, at least in relation to clothing, has become a ubiquitous theme of the media. It was not long ago, though, that so-called respectable newspapers considered themselves above such "banalities," which they condescendingly relegated to the pages of fashion magazines—and these were hardly taken seriously anyway. While it may have been snubbed by the "serious" media, fashion has become a very important aspect of culture, comparable even with the fine arts or theater. We are regularly informed about "haute couture" and "prêt-à-porter" fashion shows. And even in the lulls between these big fashion events, the media constantly offer reports and reflections about fashion; self-respecting newspapers now regularly publish special inserts on the topic. Fashion designers and models are covered by the media—on television and in newspapers— much the way writers and politicians used to be. In short: Fashion has become socially acceptable.

Le Pouf. Evening gown by Paul Poiret, 1924.

We cannot separate fashion from our daily lives. Even people who think they refuse to obey fashion commit themselves to it through their refusal. Anti-fashionable trends always refer to the corresponding current fashion in order to separate themselves from it; they are therefore nothing but the negative to the positive. Even attempts simply to ignore fashion have become difficult: If the "in" color is green, no store will carry a purple dress. If stripes are in, consumers will be hard put to find floral patterns. Fashion, however, is not dictated from a single source and there are no longer any uniform trends; all fashion consumers may draw upon a plethora of trends in putting together their wardrobes. In reality, *the* trend, which until a few decades ago was the style presented every fashion season, has simply been replaced by several coexisting trends. Whatever is not represented in at least one of these trends is just as unfashionable as whatever twenty

years ago did not correspond with the one reigning trend. And, since good taste and elegance are no longer standards for what is considered fashionable, it is much harder to determine what is "in," and possibly witty, and what is already "old-fashioned" and "mega-out." The boundaries between these areas have become grayer than ever.

Thus, fashion simply encompasses a broader spectrum of possibilities than it did in the first six or seven decades of this century—not to mention past centuries. Dress codes are becoming less and less frequent; no one feels obliged to dress up to go to the theater;

Rei Kawakubo (Like the Boys): From the spring/summer 1997 collection.

there are fewer and fewer occasions when one is obliged to wear any particular kind of dress. Casual clothing appears to be appropriate everywhere and always. People around the world are wearing jeans, leggings, T-shirts, and sneakers. The truth is that fashion is conforming more and more to a norm and not, as many people suppose, becoming more imaginative. The idea that one can wear whatever one wants is really only true in a limited sense. Anyone bold enough to wear a dress by Japanese designer Rei Kawakubo, which has humps and bumps in the most unexpected places, to her workplace, or the kind of transparent dress promoted by designers in 1997, would create quite a stir, and

Punks in London during the birthday celebrations for the Queen in 1986.

not necessarily of a good kind. Despite all claims toward enlightenment, a cross-dresser on the street will still be the object of stares and whispers. We may think we are accustomed to seeing people in punk style with green spiked hair and leather regalia, but many still notice and reject anyone in punk dress, and this kind of self-presentation is

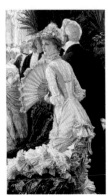

Joseph Tissot: *The Ball*, ca. 1878.

"Milk Sisters." Afternoon dress by Dœuillet. Color lithography from *Gazette du Bon Ton* in 1914. The elegantly dressed town lady pays a visit to her "milk sister" in the country, who is simply dressed. The contrast with the country woman's functional clothing and wooden clogs further emphasizes the fashionable elegance of her contemporary.

hardly likely to help anyone during a job interview if they are seriously trying to find a job.

Fashion and traditional costume

Fashionable developments are, of course, omnipresent in human life, and usually the different fashions—clothing, fine arts, home, industrial, and textile design—are closely related. Ordinarily, however, the term "fashion" per se is used exclusively in connection with clothing and personal appearance, and this is the topic of this book.

Fashion is a modern European phenomenon. Its emergence is inseparable from capitalism in Europe. In the narrower, modern sense, fashion is a development of the bourgeois nineteenth century and the industrial revolution. Fashion can only bloom and become a mass phenomenon in an industrialized society with technological know-how, strong aesthetic demands and pronounced individuality, as well as considerable wealth, because fashion is also a luxury one must be able to afford.

Before fashion, or rather alongside it, there was traditional costume, or simply clothing. Clothing is the more comprehensive term. It emphasizes the functional aspect, such as protection from cold, heat, or other environmental factors. But clothing is not merely designed to protect the human body from cold; as sociologists emphasize, it has served equally since the beginning of time to decorate the human body. Even in cultures in which hardly any clothing is worn, the human body is decorated or altered by means of body paint, tattooing, or jewelry. The roots of fashion lie in this universal drive to adorn oneself. Unlike fashion in the modern sense, however, clothing does have a clearly pronounced purpose. If functionality were all we cared about, we would need far fewer clothes to last us a lifetime than many people have in their wardrobes at any given moment. Fashion sees to it that we are not satisfied with functionality.

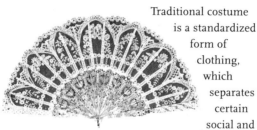

Traditional costume is a standardized form of clothing, which separates certain social and regional groups from each other—city dwellers from country dwellers, farmers from skilled workers, doctors from merchants, California from Minnesota. Traditional costume epitomizes community and constancy; it hardly ever changes, and if it does, it does so only in small details and very slowly. Instead of expressing individual personality, costume indicates membership among a certain group of people. Costume exists in traditional societies; it is timeless, never fashionable.

Fan made of white tulle lace, with mother-of-pearl rods, dating from the early 19th century.

Whoever wants to be stylish follows fashion. This entails constant change. Fashion emphasizes individuality and transience. In fact, it derives its appeal from this very transience. On the one hand, fashion emphasizes belonging to a certain social stratum; on the other hand, it emphasizes the individual, unmistakable personality. Only when aristocrats in the late Middle Ages and, somewhat later, members of the bourgeoisie began to use clothing not only to separate themselves from other social classes and assert their social position, but also to express their individual personality, did the word "fashion" begin to become meaningful. Again, this only became possible very slowly as the bourgeoisie became educated and started to develop the concepts of individuality and privacy as we understand them today.

An essential characteristic of fashion is that the incorporation of individual personality, the aesthetic enjoyment of changing one's outer appearance, and the constant desire for something new outweigh the functionality of clothing and become ends in

Outfit for a winter vacation in St. Moritz, from the *Journal des Dames et des Modes*, 1913.

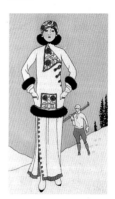

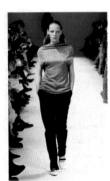

From Jil Sander's autumn/winter collection.

themselves. Since its beginnings, fashion has been a social, psychological, and aesthetic phenomenon. Only in the tension among these demands does its power unfold.

Prescribed clothing and modern democracy

Unlike traditional costume, the fashion of any given social group can be adopted or imitated by others, which forces the dominant fashion strata to once again invent a new fashion to differentiate themselves. Today, fashion functions by constantly imitating, and finds its inspiration on the street and in daily culture. From feudalism through the early 20th century, however, fashion was a phenomenon of the upper class, which in some circumstances may have influenced the lower social classes, but the reverse was never true: the upper class never sought to imitate the lower. In any case, only someone who was very wealthy could afford fashionable clothing. Moreover, prescribed dress laws made sure that from the Middle Ages to the 18th century, people did not overstep the boundaries of their social status. These laws determined who could wear what fabrics, colors, and styles. Purple and ermine were reserved for kings; lace and silks could only be worn by nobility and wealthy citizens, never by servants. Social status, like divine right, was considered God-given; therefore it was believed that no one should try to assume the attributes of a higher social class since this would only cause discontent with one's own station in life.

A wood statue of Balthasar, one of the three wise men, dating from the 15th century—a very elegantly-clothed dandy from the Middle Ages.

Today, in a time of mass production of cheap fashion for all, fashion seems to have become democratic. This, however, is only true on the

surface. Although almost everyone in industrial nations today can dress more or less fashionably, fashion still serves the purpose of social distinction. The criteria have simply become finer and have shifted from the complete silhouette to details in taste of materials and manufacturing. We also find other distinguishing factors such as manners of speaking (including accents and dialects), body language, or carriage that help individualize a person. When clothing was still the clear sign of social belonging, these factors did not weigh equally into the equation.

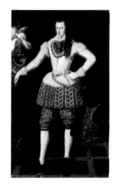

Likeness of Henry Wriothesley, Earl of Southampton.

Women's fashion and men's fashion

In addition to signifying social belonging, fashion signifies gender. This was not always so clear. Until the Middle Ages, or more specifically, until the epoch that art historians designate the era of romanticism, women's and men's clothing could hardly be distinguished. The clothes for both genders were long and draped, covering the entire body. It was not until the fourteenth century that designs began to develop gender specifically. Clothing emphasized the figure more, and through new fabrics imported into Europe from the Orient, also became more diverse and colorful. Women's and men's clothing developed in different directions; although women continued to wear long garments, they now had more complicated designs and were much more form-fitting. Men wore tights that showed the leg and short pants over them. From then on, fashion developed in a constant switching game between female and male elements. There were no fixed principles guiding what might be considered male and what female. Indeed, the conception of "male" and "female" dress is always changing, and fashion contributes to this significantly. During the Renaissance, elegant women did not have cleavage; they wore completely flat corsets. But in the 18th century, deep cleavage, seductively displayed, was an essential characteristic

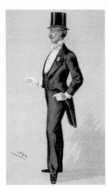

English fashion for gentlemen from *Vanity Fair*, 1885.

of femaleness. Women only started to reveal their legs in the 20th century; before this, it was considered indecent to show more than their ankles. In the 1920s, legs became an erotic signal and breasts became less important. A century earlier hips had played a large role in conceptions of femaleness; crinolines or hoopskirts suggested to all beholders wide, feminine hips, regardless of the actual proportions of the woman underneath. But then hips, too, went out of fashion.

Men's fashion has been at times no less magnificent than women's. In the absolutist 17th and 18th centuries, men and women's clothing actually started to become closer again in style; to the modern eye, the way in which men dressed may seem feminine. Like their female counterparts, they wore striking, colorful garments made of splendid fabrics, rich with lace or embroidery. They did, however, wear trousers, while the women wore skirts.

During this time, fashion was in no way considered a women's matter. It was of equal interest to both sexes, and both were the target for charges from the church that fashion was frivolous vanity. This changed only after the French Revolution, in the definitively middle-class 19th century. Now fashion

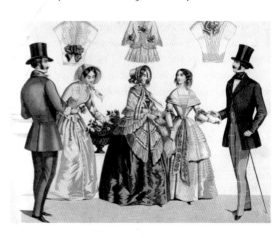

Ladies' and gentlemen's fashion, mid-19th century.

became synonymous with "women's fashion." Men have since worn dark suits that have changed very little in their basic form up to the present. Men no longer dressed fashionably; they dressed seriously. With their dress they conveyed the seriousness of life, which was often synonymous with the seriousness of earning money. To demonstrate the wealth they amassed, they adorned their wives and daughters instead of themselves; their fashions became more expensive and more extravagant and, regardless of their middle-class social standing, more like the aristocratic fashions of past centuries. The divide between women's and men's clothing and therefore the divide between femaleness and maleness became deeper than ever before in Western history. This is only starting to change again today, with a trend toward men's growing interest in fashion, though we still see nothing approaching a symmetrical relationship, in terms of fashion, between the sexes.

Fashion and body

With changes in fashions, the perceptions and therefore the presentation of the naked female body have changed, as art historian Anne Hollander has shown. When laced-up waists and padded hips are in, then even naked women (and men) portrayed in contemporary art have very slender waists and very full hips. If the breasts are laced in, then the naked women also have very tiny breasts.

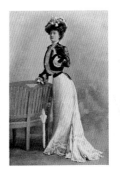

Town dress, 1901.

This allows only one conclusion: Fashion creates a second, fictitious body. It does so first on a material level, clothing a body with fabrics or other materials, and second as an image of a realistic, biological body, which then dictates our perception of the human body. There is no such thing as a biological body as an objective, unchanged fact throughout the centuries. Human bodies are constantly being redefined through biology, medicine, possibly theology, or even through fashion. That is, we always

Woman in pink, 1914.

A "Czarina's dress" from 1787, made of apple-green satin with a double collar of white, filled gauze. The skirt, or white linen and frilled at the border, is worn over a pink petticoat.

perceive bodies according to standards dictated by pre-existing cultural ideals. Therefore, fashion neither can, nor aims to express the "natural" body, since what is considered natural is constantly being redefined. Rather, fashion creates a fictional body that conforms more to aesthetic and erotic ideals than to social or practical requirements. This fictitious body then affects our perception of the "natural" body, and how we think this should be clothed.

The "natural" body is ultimately an ideal, the combination of various beauty ideals. It can be measured and made to be the norm; today, sizing charts define female and male body measurements and thereby assign all people to a fixed clothing size. This is the fundamental principle behind "ready-to-wear" or "off-the-rack" clothing. In fact, however, these charts have to be revised every few years to take into account current ideals and realities.

Fashion, therefore, is continuously creating new aesthetic as well as erotic body images. This is why all attempts of clothing reformers to provide a healthy fashion for the supposed natural body have failed as long as they have only emphasized the aspect of reason. Fashion has little to do with naturalness, although it sometimes plays with ideas of naturalness. The crinolines of the 19th century were no more or less natural than the sack dresses of the twenties, the miniskirts of the sixties, or the current trend of the transparent dress. Does fashion therefore become art?

Fashion between art and commerce

Fashion is applied art. It is never autonomous, but always has a specific purpose: To clothe the human body appropriately. Appropriately means according to custom and social position, and taking the climate into consideration. How useful fashion actually is has already been discussed. Clothing is practical, while fashion is only useful from a social and psychological perspective. Fashion in the form of clothing always relates to the human body as a three-dimensional, living, mobile object with, as a rule, a rump, two arms, and two legs. Using a plethora of materials, this body is covered up and transformed. Fashion is rarely guided by questions of usefulness, but by aesthetic and, no less important, erotic considerations. This often leads to a complete emancipation of fashion from any sort of functionality; it becomes a matter of pure form. This is why fashion is never solely obliged to commerce; its aesthetic aspects are at least as important as its wearability and marketability.

Autumn hats, 1912.

The economic factors, however, ultimately determine what becomes stylish—that is, what is imitated on a grander scale. The best examples of fashion are therefore never exclusively aesthetic or exclusively commerical, but always both in some measure. This is what defines modernism. We live today in a consumer world, where almost everything one can do and be is dependent on material things, and to deny this would be extremely naive. Goods have a tendency to become objects of consumer appetites, often while remaining highly artistic. Fashion was the first field to recognize this trend and has stood its ground. It draws its power from

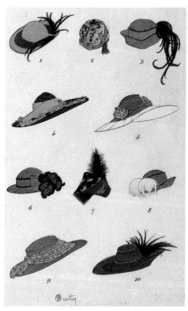

A Sonia Rykiel model, 1997.

the tension between art and commerce, individuality and social restraint, naturalness and artificiality, and aesthetic innovation and practical and social utility.

Fashion as a paradigm in our culture

Typically, today's fashion seeks inspiration everywhere and incorporates a whole range of stimuli. Just about everything has potential to become fashion nowadays. Nothing is taboo, whether influences from art, literature, space travel, computers, youth culture, sexual practices such as fetishism, or even the misery of Third World countries. If everything can be made to be fashionable, fashion invades every aspect of life, whether we like it or not. Fashion is an integral component of our culture. It cannot be removed without destroying the character of the entire culture, which, just like fashion, is characterized by its transience and variability. We live in a world of increasingly manifold images which alternate at a dizzying tempo. Accordingly, fashions wear off faster in order to make way for new ones, even if these new styles are often only an old fashion in a different form. Like literature, painting, or film, fashion is an essential part of the imaginative tradition of the creation of images in our culture. It is impressive evidence of human beings' conviction that we are able to control our existence by determining our external appearance.

In this sense, fashion is not only what the major designers of *haute couture* create in their studios; nor is it the outfits that only the wives of Arab millionaires can afford. *Haute couture* is always developing new ideas and makes it possible for designers to realize their artistic ambitions. These designs, however, are very often neither wearable nor marketable. They are converted into something readily wearable, into mass production clothing, and are sold in department stores as well as designer stores. *Haute couture* is more a kind of advertising

than a huge moneymaker. The French department stores make about 6 percent of their total sales from *haute couture*. The other 94 percent comes from the *prêt-à-porter* collections, and especially from licenses.

Fashion is, of course, also the manufacture of ready-to-wear clothing—that is, the industrial mass production of clothing in all price ranges. These are the department store "labels" that are produced in countries with cheap labor costs and then sold inexpensively and quickly in industrial nations in order to make room for the newest t-shirts, dresses, and leggings. Fashion is omnipresent—no one can escape it. But how did it all start?

Children's apparel.

The History Sewing and Weaving

Timeline:

ca. 5000–2000 BCE Early Stone Age in Europe
ca. 3500–1600 Mesopotamian high culture
ca. 2500 Gizeh pyramids
2300–1400 Advanced Minoic culture in Crete
1500–500 Germanic Bronze Age
ca. 1000 Jewish kingdom reaches its peak (David, Solomon)
800 Etruscans emigrate to Italy
750–300 Classic Greece
ca. 500 Rome becomes a republic
334 Alexander the Great conquers Asia Minor
58–51 Caesar conquers Gaul
30 BCE Octavio (Augustus) becomes a despot
ca. 7 BCE Birth of Christ
98–117 AD Roman empire is most widespread
330 Founding of the Eastern Roman Empire
379–395 Theodosius I; Christianity becomes state religion
476 End of the Western Roman Empire
527–565 Ceasar Justinian "Corpus juris"
768–814 Charlemagne

Humans—naked-born animals?

The history of clothing starts with animal furs. Prehistoric people draped furs over and around their bodies to protect themselves from the environment. Anthropologists tell us, however, that their first priority was to decorate themselves and to impress others, as well as to protect themselves against evil forces. Thus, the impulse to decorate, and not usefulness, is at the root of clothing, and this impulse has led to fashion as we know it in the late-capitalist culture.

Humans can adapt to their environments; clothing is only one means among several to protect one from the cold. The body could be toughened to need hardly any clothing, and, of course, early humans were extremely hairy. Scientists today believe that the skin of humans has become less hairy because, during the course of time, people began to wear more clothing, thus allowing less hairy individuals to survive and reproduce. At the root of the impulse to clothe oneself is not a naked, cold-sensitive person trying to protect him- or herself—the "naked-born animal," as the English romantic the Earl of Carlisle called humans. Rather, this protection became necessary once humans had become accustomed to wearing clothing. Their bodies adapted so that they actually needed clothes to protect them from the elements.

Sewing and weaving

Images of clothed humans have been handed down from the early Stone Age; they are depicted wearing loin cloths or fur skirts. In the opinion of the fashion historian James Laver, the humble sewing needle is actually one of the most important technological advances in human history. It made the transition from draped to tailored and sewn clothing possible, thus offering a new potential for variety. The first sewing needles were made from animal bones.

20

The spinning and weaving of fabrics require a settled civilization. It is estimated that these techniques originated around 9000 BCE in Mesopotamia. Fabric scraps and tools found in Europe also point to the presence of these techniques in the Middle Stone Age (ca. 4000–2000 BCE). Clothing could now be artistically draped and later even sewn into different shapes; untreated furs and leather had only allowed a very limited variation of design. The artistic draping of clothing, however, is a sign of advanced civilizations: It was present in Europe into classical antiquity. The Greeks despised the sewn pants of the Teutons and stuck with their elegant togas. It was the Romans who finally adopted the Germanic clothing. The male Germanic wore tight skirts with cape-like wraps made of fur. They only adopted pants from the Celts or the Skythes, Thracians, or Illyrians during the Iron Age. Germanic women wore ankle-length skirts, belts, and tops, jackets, and a braided hairnet, all fashioned from sheepskin. Women's clothing later conformed more to the Roman model, with belted robes in tunic style.

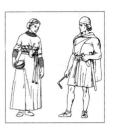

Germanic clothing from the Bronze Age.

Early advanced civilizations

The first known advanced civilization is that of the Sumerians, which existed in Mesopotamia between 3500 and 1600 BCE. The men wore skirts made either of sheepskin or wool with fringed borders. The women wore wrapped coats. The Assyrian women and men both wore short-sleeved shirts over these skirts, and dignitaries wore a fringed scarf wrapped around the

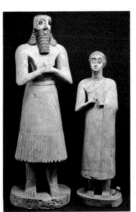

910
Founding of the Cluny monastery
1066
Battle of Hastings
1075–1122
Investiture War
1096–1291
The Crusades
1182–1226
Francis of Assisi
1194–1220
Building of Chartres cathedral
1215
Signing of Magna Charta in England
1273
Thomas Aquinas: *Summa theologiae*
1304–1374
Petrarca
1309–1377
Popes based in Avignon, France
1313–1321
Dante's *Divine Comedy*
1339–1453
Hundred Years' War between France and England
ca. 1350
The plague spreads throughout Europe

Sumerians.

Persian archers, 5th/4th century BCE.

Pharoah Tutanchamun and his wife, 1350-1340 BCE, on the backrest of the throne found in his grave.

body. In the 6th century BCE, the Babylonian civilization was taken over by the Persians. They adopted the Sumerian's love for fringed clothing and introduced pants, which they had previously adopted from Indo-Germanic tribes. They wore smock-like skirts with leather boots. Their official attire was a floor-length tunic copied from the Medeans.

Egyptian clothing (between the third and first millennia BCE) served to distinguish social classes. Men in all social classes wore loin cloths draped in various ways. Members of the upper class wore a transparent tunic over the loin cloth, while servants were practically naked. Women wore floor-length, tight, pleated dresses or pinafore dresses that did not actually cover their breasts. The weave molded to their bodies; this is visible in many Egyptian works of art. A cape or a golden jeweled

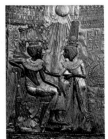

necklace, as large as a collar, covered the upper chest of both men and women.

Cretan elegance

In Crete (second millennium BCE), members of the upper class wore very extravagant clothing. Men wore a variety of draped loin cloths and had very small belted waists and long hair. Women also had

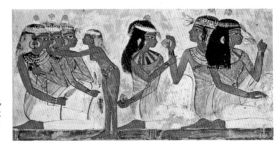

Women at a guest feast, in the Grave of the Night in Thebes, 15th century BCE.

wasp waists, which were achieved through lifelong binding. They wore floor-length A-line skirts and bodice-like tops with short sleeves that left the breasts free and simultaneously pushed them up (somewhat similar to today's push-up bras). Richly decorated belts, apron-like overclothes, and jewels enhanced their colorful outfits. The silhouette is reminiscent of 19th-century France, with its tiny waists, sweeping skirts, and emphasized bosoms. The Cretan garments were sewn and draped.

Greece

The clothing of the Greeks and Romans was only draped, rather than sewn. Originally, around 1200 BCE, garments of the Greeks were similar for both sexes. These consisted of squares of fabric that were neither patterned nor sewn and were draped over the body. They were held by belts, needles, or brooches, and were knee-length for men, floor-length for women. After the 6th century BCE, Greek clothing became more luxurious. The garments became wider and the pleats more opulent. The chiton, worn by both men and women, was sewn together on one side. The fabrics for women's clothing were delicate and loosely woven; men's fabrics were more tightly woven. Sometime during the 4th century BCE, women began to wear the dresses with belts. Over the *chiton* loin cloths, men wore short coats, called *chlamys*; later they wore the longer *himation*. The basic form of the garments remained the same for centuries, even as clothes became more luxurious. Materials and other details also changed, but the shapes stayed the same. Head coverings were unusual in Greece. Women wore their long hair pinned up, and men had short hair. Body hair in

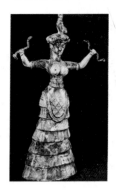

Snake goddess from Knossos Palace, Crete (ca. 1600 BCE). She is wearing a bodice which leaves her breasts open to view and a flounced skirt.

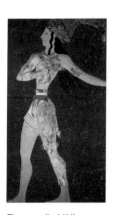

The so-called "Lily Prince" Cretan/Minoan fresco in Knossos, 16th century BCE. Attention is drawn to the wasp waist, achieved by binding.

Achille binds up Patroklos; painting on the inside of a bowl, Greece, ca. 500 BCE.

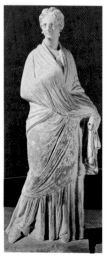

Greece is an interesting topic; it became increasingly unfashionable for men to show body hair, as we can infer from statues of the time. The sculptures, of course, did not show reality, but an ideal; the ideal man was smooth-skinned and youthful. Even beards became extremely unfashionable after the 5th century, except for older, dignified men. Women's hairstyles and hair accessories became more complex and luxurious during the course of the century. Fashion is epitomized in these styles. The Romans later adopted this passion for elaborate hairstyles.

Greek warriors wore metal-enhanced leather loincloths and leg protectors. They also wore helmets that were pushed into the nape when unused. These helmets were often decorated with ponytails.

Female statue, clothed, 3rd-2nd century BCE.

The Romans

Not much is known about early Roman clothing. The Romans adopted the toga from the Etruscans; similar to the Greek *himation*, it may be considered the most important garment of the free Roman citizens. Slaves and women did not wear togas, nor did foreigners. A toga, according to one source, consisted of an oval-weaved piece of wool fabric, eighteen feet long and eleven and a half feet wide. It was cut in the middle and then stitched with both straight and curved seams. It took a certain amount of skill to properly wrap a toga around the body. Worn over a tunic, it was a luxurious and representative piece of clothing with limited practical use, but with great social distinction. Color differences also served this purpose. Pre-adolescent boys wore a toga with a purple edge, which they later exchanged for an adult man's white toga. Dark togas were worn at religious ceremonies or funerals. Senators wore white togas with purple edges. Only landholders or victorious rulers were allowed to wear colored tunics.

Marble statue of Emperor Tiberius in tunic and toga, 1st century AD.

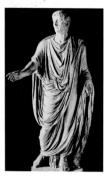

During the Holy Roman Empire, the toga was more or less replaced by the *pallium*, a square overgarment; from that point on, the toga was only used as official government attire. Women began to wear stoles, which were ankle-length shirt-like garments worn over tunics and held on the shoulders by suspenders. Over the tunic and stole, a pall, or drape of linen cloth, could be worn if necessary. The tunic, a shirt made from wool, and later of linen, was the basic element of clothing for both men and women. It was worn directly on the skin. The tunic was sewn together on the sides and shoulders. For women it was floor-length, while for men it was knee-length and held by a belt. In the 3rd century AD, sleeves were sewn onto tunics for the first time, though the tunics retained their cross-shaped cut. The tunic was worn by all social classes; distinctions were made by various stripes woven into the cloth. In public, either a toga, pall, or stole was always worn over the tunic. Only in the privacy of one's home could one wear the tunic by itself.

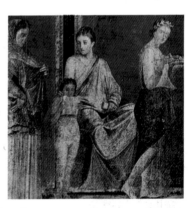

Roman women. From a fresco in Pompeii.

The expansion of the Roman Empire increased the general level of luxury, and this was evident in the clothing worn by the citizens. The basic design of the clothes was upheld, as it had been in Greece, and varied only very slightly. The fabrics, however, became more magnificent. Now, in addition to wool and linen, silk and brocade were used. Greater quantities of fabric and more decorations were used. More jewelry and hair decorations were worn. In his satires, the poet Juvenal criticized the Roman opulence during his lifetime as a sign of decadence.

Roman clothing influenced peoples of many other nations, including the Spaniards, Britons, and Germanic tribes. And the reverse was also true. The

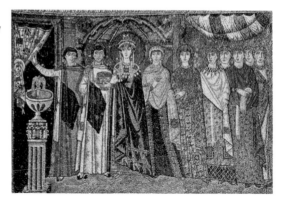

Empress Theodora and her retinue, 6th century BCE, mosaic in San Vitale, Ravenna.

most noted influence on Roman dress during the empire is the adoption of trousers from the Germanic peoples. Although they were originally denounced as barbaric, they quickly infiltrated Roman style and spread throughout Europe as the male piece of clothing.

Byzantium

Oriental influences on Rome and its culture only began to increase in the 1st century AD. They reached their peak as the center of the Roman empire shifted to the east (Constantinople became the Roman capital in 330 AD), and in 376 AD, the western Roman empire crumbled. Byzantium developed its own style, passed down to us mainly through the mosaics from the northern Italian city of Ravenna. In contrast to antique clothing, Byzantine clothing was specifically meant to hide the body. Pleats were more serious and static, and, as Loschek said, "negating body shape and making the wearer appear impersonally, like a monument." Life was strictly regulated and hierarchical; clothing was accordingly stiff and splendid. One wore a *dalmatica*, which was a kind of tunic with long sleeves. The fabric was cut out in a cross shape. Over the tunic, a *palidament*, a rectangular overgarment that was fastened at the shoulder with

a brooch, was worn. Women wore stoles with hanging sleeves over their tunics. In addition, men wore a *tablum*, an antique, striped, rectangular piece of cloth. This cloth was highly decorative and was pinned to the front of one's clothing. It covered the hands when presenting something to one's ruler. Everything was very colorful and decorative.

Even the clothing of the rulers themselves was very different from the simplicity of classical antiquity. Richly embroidered, bejeweled fabrics inlaid with gold were typical. They bear a striking resemblance to the robes of Roman Catholic and especially Orthodox priests today. Linen, cotton, and silk were preferred to the more customary wool. Silk had to be imported from China until the reign of Empress Theodora, when missionaries brought back silkworms from China in order to establish silk production in Byzantium itself. Throughout the Middle Ages— indeed, even into the 17th century—the Byzantine influence on European clothing was felt.

Clothing in the Middle Ages

The Middle Ages in Europe did not have a particularly great variety of clothing forms. The Gauls were Romanized, and then in the 5th century AD they were conquered by the Franconians. Culturally, the Franconians had a considerable influence on western and central Europe. Their attire was similar to the Germanic attire until the 10th century: they wore skirts and pants, with fur skirts and leg warmers in the winter. Anglo-Saxons and Lombards wore wider tunics. Women wore ankle-length, belted robes. Under the influence of the church, women—especially married ones— began to cover their hair and bodies, using veils or coats over their heads. Hats were not yet common. Up until the 6th century, both men and women still

Romans, Gauls and Germanics pay tribute to Emperor Otto III. Minature dating from the 10th century.

had long hair; after that, only women did. The clothing style was the same for all social classes; the difference lay in the fabrics used. The wealthy wore clothing made of fine wools and silks while coarser wool and linens were used by the poorer people. It was in the 9th century that Charlemagne issued the first dress code in which he decreed how much could be spent on a piece of clothing, though not what had to be worn.

Slowly, the clothing of the upper classes in Europe began to change from the Franconian style to the medieval style. In terms of style, the sexes did not differentiate themselves much at this point. The male and the female body was covered by floor-length pleated robes. Uniformity, not sexuality or individuality, was the goal. The common people kept to their short smocks, pants, and stockings.

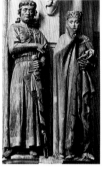

Uta und Ekkehard. Patrons on the portal of the Naumburger Cathedral, 13th century.

The medieval community

People in the early and high Middle Ages had no private lives as we know them today. This period was characterized by what scholar Georges Duby called a "collective privacy." People lived together very closely; houses were small and had no private bedrooms or studies. It was perfectly ordinary for several people to sleep in a single bed. Even a traveler taking lodging overnight in an inn did not usually have a private room and often had to share his bed with strangers. The only way to be alone was to manage to be so in the midst of many people, or else to look for a temporarily empty space—usually out in the open, in nature—for a romantic tryst. Loneliness was considered dangerous; the lonely person was more readily tempted by evil. Although solitude slowly, over time, became more acceptable, it was still regarded with great skepticism. People defined themselves as part of a community or a class, not as individuals, and their clothing emphasized this. It was not until after the 12th century that this slowly began to change.

Eastern influences

The influence of the Moors of Spain and the Crusades on European culture and clothing was for the most part limited, as all fashion is, to the upper classes. The new fabrics, jewels, and luxuries brought back by the Crusaders from the Orient were available only to the wealthy. The Crusaders also brought back fresh ideas for clothing styles, thus influencing the development of fashion in Europe. James Laver believes that veils for women, as well as form-fitting women's clothing, were both imported from the East. In the 12th century, elegant women began to wear dresses, the corsets of which were tied tightly in at the back or sides, and which then flared out from the hip down. These dresses sometimes had trains attached to them. The sleeves were tight on top and became wider toward the wrists. In time, they became bigger and more conspicuous. Throughout the course of the Middle Ages, people became very creative with sleeves, making them more and more bizarre. Over those sleeves, men and women of the upper classes wore a cape-like floor-length coat held together at the chest. The common people wore hooded coats.

Manessian Collection of Ballads, 1320: an aristocratic couple.

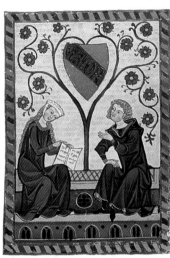

The rise of the tailor

The refinement of patterns in the 12th century is part and parcel of the development of the craft of tailoring. Regardless of their social status, women produced the clothes for their families in their homes until the 12th century. Then came tailoring and the formation of guilds. By the 13th century, there was a distinction between coat, robe, and mending tailors; soon afterwards came the

division into men's and women's tailors. Like the French word *tailleur* (to cut), the word "tailor" comes from cutting patterns, not from stitching or sewing. This suggests that cutting the cloth was considered the most important step in manufacturing clothes. In later years, "tailor" came to denote only men's tailors, whose work was considered more complicated and challenging. Women's clothes were still produced by lowly seamstresses, who garnered none of the esteem accorded the men's tailors. In the Middle Ages, men's tailors made women's clothing as well.

The age of chivalry ...

In the 13th century, the knighthood in Europe were culture trendsetters. The clothing of both genders again became more similar. Clothing again became plainer, pleated and floor-length. The materials used for both sexes were the same: linen, imported cotton, fine lace, and even silk, which since the importation of silkworms in the early Middle Ages could be produced in Europe. The fabrics were colorful and embroidery was very popular. Men wore a type of trouser underneath their knee or ankle-length tunics. The knight's armor was initially very similar to these basic outfits; it consisted of a wide chain-mail shirt that reached to the thighs or knees and was worn over a white shirt and under a tunic.

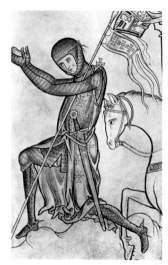

Crusader, from an English psalter dating from the 13th century. The knight is wearing a coat of mail, covered by a robe made of fabric.

... and women's clothing

Women wore several layers of clothes on top of each other: a one-piece dress with no belt was worn over a shirt, often with tied sleeves. Over this, the woman wore a sleeveless overdress. Trains were often attached by buttons. Pleats were sewn exactly

as they were intended to fall. Opulent jewelry, which often bore symbolic importance, and belts made of expensive materials were highly rated. Young, unmarried women and youths wore a flower or metal wreath on their heads. Married and older women wore veils, which were often draped over their heads very creatively. This custom probably stems from the command of Paul in 1 Corinthians 11, on the proper behavior of married women or widows during mass: "Any man who prays or prophesies with his head covered dishonors his head, but any woman who prays or prophesies with her head unveiled dishonors her head—it is the same as if her head were shaven. For if a woman will not veil herself, then she should cut off her hair; but if it is disgraceful for a woman to be shorn or shaven, let her wear a veil. For a man ought not to cover his head, since he is the image and glory of God; but woman is the glory of man."

In the late Middle Ages—during the 14th century—something we can call fashion started to emerge. New clothing styles for both sexes developed, and the distinction between them was now unmistakable. Fashionable developments came faster and change was sought after and often carried to extremes. This has to do with the social and economic changes of a society that, despite its religiosity, was becoming more worldly. The bourgeoisie emerged and grew into an important economic force. Cities grew in importance. Although social belonging and religion still defined the lives of most people, the first signs of individuality and personal achievement developed, as well as a precursor of the modern sense of privacy.

Woman in a field with a falconer. From the Manessian Collection of Ballads, 1320.

15th century
Rise of the Fugger trading dynasty in Augsburg

1431
Joan of Arc is burned at the stake

1438
Beginning of the Habsburg Dynasty

1445–1510
Alessandro Botticelli

ca. 1440
Invention of the printing press

1452–1519
Leonardo da Vinci

1453
Constantinople is conquered by the Turks

1455–1485
War of the Roses in England

1466–1536
Erasmus von Rotterdam

1471–1528
Albrecht Dürer

1475–1564
Michelangelo

1483–1546
Martin Luther

1492
Discovery of America by Europeans

1509–1547
Henry VIII reigns in England

1513
Niccolò Macchiavelli: *The Prince*

1525–1569
Pieter Brueghel

1525
Boer War in Germany

1558–1603
Elizabeth I reigns in England

1573
Bartholomew Night in France

1577–1640
Peter Paul Rubens

The transition from the late Middle Ages to the Renaissance was slow and took place at different times in the different European countries. In general, between the 13th and 16th centuries, decisive social and economic overhauls occurred. The explosion of economic trade, which had been introduced through the crusades, persisted, especially across the Mediterranean. The resulting money-based economy established the basis for our modern

The month of April in *Très Riches Heures du Duc de Berry*, 1416. A richly dressed wedding couple exchanges rings in the presence of their parents; two bridesmaids gather flowers.

economy. A municipal citizenship was formed, which expanded in a self-conscious manner and demonstrated its wealth and political importance. The Protestant Reformation, as well as the spread of humanism, helped to strengthen the concept of individuality. The invention of the printing press enabled the dissemination of written texts far beyond the walls of the monasteries and the private libraries of monarchs. They laid the foundation for a reading culture that would ultimately blossom in the 18th century.

Human portrayal

From works of art we can trace the changes in the human ideal. The portrayals of people develop from the hitherto customary abstract generalizations and stereotypes to depictions bearing more individual characteristics. This transition advanced rapidly, though at a much slower pace in northern Europe than in Italy, where as early as the 14th century the

portrayal of humans was a far cry from the medieval simplifications. In northern Europe, this new view did not gain secure ground until the 16th century. Often, biblical or mythical themes of paintings served only as pretexts for portraying contemporary, elegant life-styles that could not simply be portrayed as such. In an engraving by the 15th-century Master E. S., for example, King Solomon is sprawling on his throne in a dandy-like manner while making a judgment. His skirt is short and belted in the middle. His sleeves are long and cuffed at the wrists. His long legs, which are covered in stockings, are very accented, with one leg stretched out and further optically lengthened by his highly fashionable shoes. His hair is long and flowing underneath his crown. The two quarreling women in front of him are no less elegantly dressed than he; they wear high-waisted dresses with fashionable hoods, or rather veils.

Their posture cannot be explained as being merely functional—one woman is kneeling as a petitioner—but actually corresponds to the contemporary ideal of elegance. This posture brings the women's clothing to the fore. The kneeling woman shows off her opulent skirt, from which her torso rises like a flower. The standing woman is slightly bent, with her stomach protruding, in an S-shape that can be observed in almost all medieval portrayals of women. The people gathered in the scene sport a variety of head coverings and clothing styles. It is tempting to interpret this engraving as an early fashion portrayal, especially since the expressions on the faces of the three main protagonists are very calm, almost smiling, without any glimpse of tension, pleading, hate, or fear. Not unlike today's fashion photography, the artist depicts the contemporary ideals of beauty and elegance by integrating them into a tangible situation.

Portraits

At this time, artists began to depict contemporary people in their own rite, without the pretext of an

1580
Michel de Montaigne: *Essays*
1581
Netherlands declaration of independence
1582
Introduction of the Gregorian calendar
1588
Sinking of the Spanish Armada; Thomas Marlowe: *Dr. Faust*
1556–1598
Philipp II reigns in Spain
1598
Giordano Brunos burnt at the stake
1600
William Shakespeare: *Hamlet*

Master E. S., *Solomon's Judgement*, 15th century.

ancient or Christian theme. Those who commissioned portraits were richly clothed since clothing, of course, expressed one's social status. Facial and bodily beauty, both male and female, was praised in contemporary literature and heightened—or manufactured—by fashionable clothing. Of course, in a time when many people were poor, unkempt, misshapen, and sloppily dressed, rich people wanted to appear beautiful by wearing fine clothes. The magnificence of the clothing was dazzling, distracting attention from any possible physical shortcomings and giving the impression of beauty. Personal hygiene, incidentally, was very important to the elegant people in the Middle Ages. This only changed in the 15th and 16th centuries when it came to be feared that too much bathing could transmit plague. The use of cosmetics seems to have been common already in the Middle Ages. Hair was considered seductive. It had to cared for, but it also had to be hidden, which was why married women wore veils

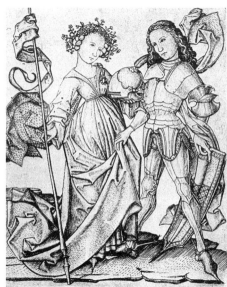

Master E.S., *A Knight with his Lady*, 15th century.

or hoods, and these became an important fashion accessory. Despite the desire for beauty and the capriciousness of fashion, moderation and decency were still preached; no one should try to rise above his or her station in life. No one should be vain; vanity was one of the Seven Deadly Sins.

Ambivalent praise of beauty and fashion
In *The Canterbury Tales*, written in 1387, the English narrative poet Geoffrey Chaucer describes the young wife of an old miller who is dressed richly and

fashionably beyond her position. This woman's vanity is inseparably connected to the fact that she is morally lacking and will inevitably betray her husband. "Fair was this young wife, and therewithal / Like a weasel her body graceful and small. / A sash she wore, made of strips of silk / And a full-gored apron wore she white as milk / Upon her loins. / White was her blouse, embroidered front and back / Around the collar, in silk of coal black, / Inside and out. Her ribbons of her cap were like her collar; / her headband also silk, and worn up high / For certainly she had a lustful eye. / Her brows were plucked into two tiny lines / And those were bent and black as sloe. / She was a fairer sight than a young pear tree / Softer than the wool of a wether / And wore upon her sash a purse of leather, / With silken tassels and studded with brass pearls. / Brighter than a coin fresh from the Tower was her skin / ... She could skip and play just like a kid or calf / After its mother, with a mouth that dripped of apples in the heath, / Skittish she was, as a jolly colt / Long as a mast, and straight as an arrow in a bow. / She wore a brooch upon her bottom collar / As broad as the center of a shield. / She wore her shoes laced high up on her legs."

On holidays, the miller's wife Alison cleans and cultivates herself. The wife of a working man really should not be wearing silk or plucking her eyebrows, but should instead be working hard, and so much finery makes her susceptible; the young woman succumbs to the seduction of an attractive young man who, like herself, is characterized by the particularities of his appearance: "Curly was his hair, and like gold it shone, / Spreading out like a fan, large and broad / Full straight and even lay his pretty part. / His face was red, his eyes grey as a goose. / He sauntered prettily with hose of red, / And shoes tooled like the window of St. Paul's. / Slim and properly clad, / In a long coat of a lovely light blue / Laced thick and fair, above which he wore a gay surplice / As white as is the blossom on the branch." Here, the miller's (and

Chaucer's) description has far more to do with fashion than with mere clothing—that is, it has to do with dress as an expression of individual character. Both characters show a desire to make themselves as beautiful as possible, to affect their outer appearance, and to imitate the reigning trendsetters (that is to climb up the social ladder). This is all described very ambivalently; the text recognizes the joy of beauty but both narrator and author recognize certain dangers in overreaching beauty. Whoever, through fashion, forgets their true social status will likely also forget their morals. The other thing these two passages clearly suggest is that fashion has definitely become gender specific—fashion for men and fashion for women have diverged, and each respectively emphasizes what are considered charming erotic signals.

Fashion scoldings

In 1405, Christine de Pizan, the first woman who ever made a living by writing, criticized the foolish fashions of her contemporaries, who were prepared even to go bankrupt in order to imitate the newest and

The Three Virtues—elegantly dressed—appear in Christine de Pizan's study.

most eccentric clothing of the highest classes. According to de Pizan, this is why there is chaos in the world. As an example of this improper fashion foolishness, de Pizan describes a simple woman who has a dress made for herself from "five Parisian Ellen cloths and many Brussel cloths ..., three-quarters of which dragged on the floor, the sleeves hanging down over the feet. This dress includes a huge headpiece with high horns, a very ugly and not very flattering piece of clothing." De Pizan pleads for a more moderate middle ground; she recognizes that the excesses replace each other quickly, and that one constantly needs new clothing in order to stay up-to-date. In many respects this scolding of fashion is astonishingly modern, if one looks past the concrete description of the dress. We might well conclude that as soon as fashion appeared, fashion critics also appeared on the scene—for fashion consists largely of exaggerations and excesses, which philosophers of good taste and reason never did like.

The body

In the Middle Ages, the body was considered the home of the soul. It was often compared to a house whose openings were the doors through which evil could enter. This was especially true for women, whose bodies were supposedly not as well sealed as were men's, even though, physically speaking, they were basically very similar. It was believed that men had more developed sexual organs, found on the outside of the body, while women's sexual organs were still on the inside. Thus, the reasoning went, women were inferior variations of humanity, which was synonymous with maleness. Because women were so susceptible to evil, they had to be watched constantly. According to historian Georges Duby, "It is their anatomical fate, to be trapped in a body where they may never leave the house without an escort, and if they do, they have to be wrapped in many layers of fabric which is less penetrable than the fabrics worn

"When a man or a woman sees that someone else is wearing something unusual, then everyone imitates this, just like one sheep follows another. And they insist that they must equal the others. But they are right—in truth, a fool must follow another. If, however, the majority of humans were more restrained and intelligent, then these excesses would not be imitated. Rather, the man or the woman who started the fashion would not be valued, and they would be alone in their foolishness. I truly do not know where the pleasure in this lies, since it is missing reason which leads people thusly astray."
From Christine de Pizan's critique of fashion, 1405

by males. A wall must be erected in front of the body of the woman—a wall of privacy." This explains why, in women's fashion, the lower half of the body was completely covered, in stark contrast to men's fashion of the times. While men, starting in the 14th century, could show their legs with tight pants, clothed women had no legs, in a manner of speaking. Of course, they did—anatomically—and no one denied this fact, but the legs played no role in fashion.

One of the pictures in "Les Très Riches Heures du Duc de Berry," a wonderful calendar painted each year by the brothers Limburg for the Duke of Berry with a picture for every month (this calendar has, incidentally, proven a priceless source for our knowledge of the life-styles and fashions of the early 15th century) portrays a winter landscape and a house. Outside, there is a bitter frost; inside a housewife and her maids warm themselves in front of the fire. The servants have, not very elegantly, flipped up their clothes so that their bare legs, right up to their private parts, are visible. We learn,

The month of February in "Les Très Riches Heures du Duc de Berry," 1416. The lady of the house and her maids warm their legs at the fire.

incidentally, from this picture that people did not yet wear underwear at this time. The housewife, more like a lady than a farmer's wife in a simple but fashionably cut royal-blue dress, lifts the hems of her dress delicately so that only her feet and calves are exposed. The message was clear: Fashionable clothing comes hand in hand with fine, polite, decent behavior. The shameless nudity of the body is a problem of farmers and common people, whose civilization process was not yet advanced quite so far. Conversely, this confers upon the privileged a responsibility to behave properly—that is, as befits a wealthy role model. Increasingly, this meant being fashionable and

dressing and behaving accordingly, in order to express social class and dignity. Since God has given each man an individual rank in life, this status must be externally documented. At the same time, it was increasingly believed that what one wore offered a glimpse into the individual's soul.

Women's fashions

During the late 13th century, women's clothing was doubled. That is, the overgarment was cut shorter, revealing the undergarment, which flowed to the floor. The overgarment was also cut so that the sleeves of the undergarment could be seen. Both dresses were different in color; the underdress was lighter, usually white. It is hypothesized that this was a development of the shirt, which was again, as in antiquity, worn directly on the body. By tying it on the side, the desired body shape could be achieved. Even at this time, women bound themselves in order to have the figure that was fashionable. In the 14th century, women's skirts began to flare out greatly from the wearer. They were pleated, with heavy fabrics such as brocade, velvet, or fine lace, and often ended in a train. They were always longer than floor-length. Because the skirt lay on the floor, it gave no hint of the woman's lower anatomy. This was dangerous ground for both women themselves as for easily seduced men, and, as potentially impure, was well-hidden. The width of the skirts was in contrast to the increasing daintiness of the female tops. The waist in the 15th century slid up to right beneath the breasts, and was generally emphasized with a richly decorated belt. The bosom was small, the top slightly pleated and tight; this was achieved by tying ribbons on the side or in the back, or sometimes even in front. The top was usually high-collared; only during the course of the 15th century did the neckline plunge. Often the hem of the underdress could be recognized in the *décolletage* of the over-dress. The sleeves were sewn closely to the narrow shoulders; those of the underdress were very tight and

reached all the way to the wrists. Over them, another sleeve, which widened at the wrist and fell over the hand like a small trumpet, was worn. Even more fashionable were sleeves which were extremely wide from the elbow on and reached all the way down to the floor, optically increasing the width of the skirt even more. The sleeves were often lined with furs or other expensive materials. This is easily recognizable in the contemporary picture of Christine de Pizan, who is

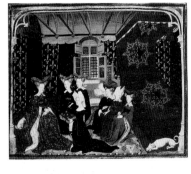

handing the Queen of Bavaria her book. Christine herself is not wearing these trumpet-like sleeves, but the other women in the picture are. She is wearing a different version in which the sleeve runs into a fabric square which falls down the side of her body. In reality, there were fake sleeves at this time which hung emptily onto one's dress, and this is reminiscent of Christine's sleeves.

Christine de Pizan hands a book to Isabella, Queen of Bavaria, 15th century. Note the trumpet sleeves, which drape down to the ground.

On the fresco "Worship of the Cross" by Piero della Francesca, which is pictured on the next page, one can see the false sleeves on the garments of the left woman in pink. In some collections of the 1990s, one could see something similar; no one realized that this idea was actually ancient. During the end of the 14th century and in the 15th century, serrated edges on sleeves and hems became especially popular. They were, according to Ingrid Loschek, the forerunners of lace and were extremely fashionable in the courts of Burgundy. All these details made it unmistakably clear that fashion had nothing to do with being functional. Such sleeves, for example, are on the contrary, completely impractical. At best they demonstrated that the person wearing them could afford to idly drape them over their chair and look pretty. Fashion favors especially those elements of clothing which are new and unexpected and which signify aesthetic shape change. This is the primary reason why fashion was reserved

for the privileged, who could afford to do without functionality in their daily lives.

Head coverings

The women on della Francesca's painting are, we might note, all blond. Blond was imminently fashionable in those days, and whoever was not naturally blond dyed their hair. In the literature of the time, all good and beautiful women were fair-skinned and blond. Dark-haired women were invariably portrayed as having an ambivalent or even evil character. This perception survives even today, most notably in our fantasy literature. Noteworthy on this picture are the head coverings, which become more imaginative and more striking in all paintings of the 15th century. The hennin, for example, was a cone-shaped hat with a delicate veil attached at the tip. This veil was either short or so long that it brushed the ground. Equally fashionable were the horned bonnets. Fabric was artistically draped over two horns, which could be small or could develop into full-fledged horns. They are easily recognizable on the likeness of Arnolfine by Jan Van Eyck. An even more extreme version can be seen in the miniature of Christine de Pizan. Another style was the white veil fastened to a metal frame, which framed the entire face, sometimes even covering the bottom; this was similar to the headpieces worn by nuns today. Throughout the Middle Ages, married women, widows, and older women had to wear bonnets or veils. Later, turban-like head coverings became fashionable for women—a stuffed bulge of fabric with more fabric draped over it. In

Piero della Francesca, detail from *Worship of the Cross*, 1466. Arezzo, S. Francesco.

Jan van Eyck, *Wedding of Arnolfini*, 1434.

Italy, this was called a banzo. Germany had a similar hat, different in that it was always made of white linen, and called a *kugelhaube*, or ball-hat. Hair was pinned up. The hairline was shaved to give an individual a higher forehead; this fashion was extremely popular in Elizabethan England, where portraits of Queen Elizabeth I show the style in practice.

The proportions of the female body

The proportions of the female body were full of curious contrasts in the late Middle Ages. To the modern eye, the tiny, short torsos with narrow shoulders and only a hint of breasts seem almost too delicate against the very large and, through fashionable head coverings, emphasized head. The abdomen gains the quality of a pedestal supporting the seemingly fragile torso, from which the head emerges. Jan van Eyck's *Wedding of Arnolfini* (1434) hints at another reason behind the exaggerated covering of the women's abdomen and the high waists: the woman looks pregnant, and the wide skirt on the one hand hides this, but on the other hand unmistakably emphasizes it. Even if the woman is not really pregnant (and there is no reason to suppose she is), the clothing nonetheless suggests the contours of pregnancy. At the same time, the female belly is hidden from all gazes, well protected, and impermeable. In this paradox of revealing and concealing, fashion henceforth evolves. Vagueness defines fashion.

The bride in Jan van Eyck's picture wears particularly expensively sewn sleeves, trimmed with costly fur (which lines the entire overgarment), opening out into the wider overgarment. The sleeves hang over the dress like a cape, weighed down by a frilly ornamentation of the fabric under the hem. The

woman is also wearing a very fashionable hooded bonnet. In striking contrast, the husband is dressed in solid, dark colors. Over tightly fitting pants (presumably with leather soles attached to his pants instead of shoes), he wears a brown velvet top lined with fur. The dark clothing was peculiar to the wealthy citizens of northern Europe, especially Holland and Flanders, and became increasingly popular in the next centuries.

The metamorphosis of men's clothing

In general, men's clothing, especially that of the aristocrats, was just as colorful as women's clothing in the late Middle Ages and during the Renaissance. Until the 13th century, when they were not wearing armor, men wore long tunic-like skirts that resembled those of the women, but they were shorter and had fewer pleats. In the 14th century, men's fashion underwent a fundamental change. The tunic disappeared, paving the way for the clear definition between top and breeches. Fashion historian Max von Boehn attributes this transformation, which would determine men's fashion for the next century, to the

Two cultivated young men from Masolino's *Awakening of Tabitha and the Healing of the Lame Man*, 1425. Fresco in the Cappella Brancacci in S. Maria del Carmine, Florence.

technical developments in knights' armor. Instead of the formless, chained shirt of the 13th century, knights now wore a tight armor that provided better protection and defined the body clearly. The upper part of the body was armored; waists were again emphasized. The armor reached to the hips, where it connected with the leg armor. This tight armor required underclothes other than the erstwhile white shirt, and so men's clothing became closer fitting and began to emphasize the body more. This means basically that a new body shape was created. For example, similar to the armor, the jerkins of the "civilian's clothes" were so padded that the man's

chest swelled proudly outward, regardless of his actual physique. At the same time, the jerkins were held so tightly against the body that they had to be buttoned or tied. The men's skirts were richly pleated and, during the course of the 15th century, became shorter. This prompted moral protests that men's clothing was indecent because it exposed their private parts and their buttocks. Further, young fashion fops wore tight stockings, usually in two colors, to which leather soles were fastened. Alternately, they wore increasingly longer and pointier shoes in which they could barely walk. The government tried to regulate the length of these shoes through dress codes, but this was not very effective.

The more sedate older men did not participate in these foolish fashions; over their pants they wore knee-length or sometimes floor-length coats lined with fur. These served as skirt and coat simultaneously. They were sewn shut on all sides and had to be pulled over the head. They either had arm holes or were open at the sides. The sleeves of men's undergarments were imaginatively designed; for example, some ballooned out at the shoulder and tightened toward the wrists.

The Burgundy court as a center of fashion

In the 15th century, the court of Burgundy became the leader of fashion. This was an oasis of relative peace in the midst of wars all over Europe, and here it was possible to devote oneself to the aesthetic aspects of culture. A strong etiquette developed and it included appropriate clothing. For the first time, the top and bottom components of the male breeches merged into one, instead of being tied together with ribbons. Trousers, however, were now joined to the jerkin with more bands, which required quite some effort. The more expensive the clothes, the more bands. The crotch became more noticeable and proudly pointed to the genitalia. The genitals were not actually visible, but were, in a sense, newly presented as a symbolic

phallus. Fashion, thus, created a second, fictitious body that corresponded to, but did not show, the biological body.

The Burgundy court was the first in Europe to introduce black as a color for male court attire. This was in sharp contrast with the magnificent colors that were common throughout Europe, and only later did black begin to be used for formal and festive wear. The head coverings of men became more sweeping. The gugel, a hood with a collar, disappeared completely, making room for more imaginative creations. Felt hats were worn either by themselves or as a frame for a "foolhardy combination of heaped fabrics," according to historian von Boehn. The connected strips of fabric hung down at the sides or were tied turban-style on top of the hat. Hats were also decorated with precious jewels. The men of Burgundy usually went beardless, while beards were still very fashionable elsewhere during the 14th century and became so again in the 16th century, at least for dignitaries.

The Burgundian fashion spread throughout Europe with some variations. Through these variations, fashion began to become nationally differentiated. In the year 1405, Christine de Pizan commented that French fashion was the most extravagant and most fickle; "the clothing of other nations, especially of Italy, is more useful despite its cost. Because even though these clothes are much more conspicuously decorated with pearls, gold, and jewels, they are not that expensive, considering that they last much longer and can later be worn with different garments."

Florentine fashion

Italian paintings from the 15th century show many of the emerging distinctions between Italian fashion and the French and German. Northern European paintings are elegant and stylized. They follow an arabesque ideal of beauty that can be described as late medieval and is totally absent from the paintings of the early Italian Renaissance. While the latter retain this

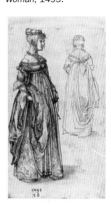

Albrecht Dürer, *Venetian Woman*, 1495.

element of elegance, they show people who are still connected to the ground on which they stand. The women wore comparably simply cut dresses—an overdress over an underdress, which was visible from the side. Either the side seam was not sewn together, or the overdress was sleeveless and revealed the sleeves of the underdress, as in the *Worship of the Cross* (mid-15th century). The sleeves were either tight or had an opening at the elbow, revealing an underlying fabric of another color, usually white. This opening was decorative, and at the same time it allowed women greater freedom of movement. The magnificence of the clothes was seen in the very rich pleats, which often dragged on the ground. Gold-patterned brocade was popular with all Italian women; most of the women in paintings are portrayed in single-colored dresses, which only gives us limited information about the actual nature of the fabrics used. The dresses did not show much cleavage, but the nape and the base of the neck were free.

The women's (invariably blond!) hair is austerely pinned up, with a band encircling their entire head into which their hair is braided. Somewhat later, the hair at the temples of young and unmarried woman was curled and hung loosely around the face; this style can be seen in Domenico Ghirlandio's fresco of the birth of St. John. Married women always wore bonnets or veils, as did many younger women at times. These were considerably smaller and less conspicuous than

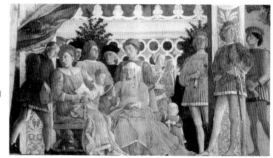

Andrea Mantegna, detail from the north wall of Camera degli Sposi: *Il Corte*, 1474. Mantua, Castello di San Giorgio.

the fashionable sweeping head coverings then prevailing in northern Europe. Men's hats, on the other hand, were noticeable and large. Hats with brims and turbans in a plethora of variations were worn. Some men wore towering structures and artfully wrapped turban hats, supposedly derived from twisted hoods.

A man's matter

History suggests that the more exciting clothes were worn by men. The women in portraits are stylishly elegant, but they always give off an air of modesty and decency. In Italy, as in every other part of Renaissance Europe, the actual fashion experiments and excesses were a man's matter. Men wore tight trousers with short, pleated skirts over them to emphasize their waists. The more fashionable men even wore two-colored trousers; this style is seen in Andrea Mantegna's *Camera degli Sposi* in Mantua. One leg was red, the other blue. This so-called *mi-parti* was popular in the Middle Ages and was found in a number of variations. In addition, of course, men wore a hat or the turban-like mass, the *balzo*. The fabrics, which were used for the clothing of wealthy men, were as rich and manifold as those of the northern Europeans—velvet and brocade lined with fur or silk. Over their skirts, they wore a toga-like cape or a full- or half-length straight coat which did not emphasize the waist, which had openings into which they could put their hands. The two young men on Masolino's fresco of 1425, looking blasé and disinterested in their audience, display these wonderful coats and grand hats.

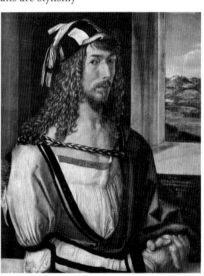

Albrecht Dürer's *Self-Portrait*, 1498.

One of the most fashionable portraits of the late 15th century is Albrecht Dürer's self-portrait, drawn in 1498. Dürer documented his entire life with self-portraits; in the process, he expressed a sensibility that was slowly becoming fashionable—a sensibility of the self and the ability to reflect upon oneself. This introspection, which had essentially not been possible in earlier years, marked a shift from the Middle Ages to the Renaissance in northern Europe. Dürer's youthful self-portraits show a man who pays great attention to his outer appearance. The portrait of 1498 is a pinnacle of his fashionable self-exhibition. Immediately apparent is the neckline, which the men temporarily usurped from the women.

The turn of the century and the 16th century

In the late 15th century fashion became more delicate in northern Europe. Necklines plunged lower and were now emphasized with collar-like trimmings. People also wore fine white scarves made of batiste or linen in their *décolletages*—that is, across their bosom—which was again very much *en vogue* in the 18th century. The large *décolletages* allowed the people to wear conspicuous necklaces. The figure as a whole became more fluid. Sleeves remained very important in the 16th century. The trumpet sleeve, however, disappeared, as did the pointy hat and the horned hat. These were replaced by turban-like head coverings or bonnets, which fit tightly and swept outward in the back. In the 16th century, the female waistline slid back down to what we would nowadays call its "natural" position. The upper body was shaped by a bodice, easily seen on Lucas Cranach's *Mary Magdalene* of 1525.

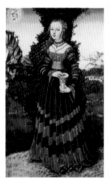

Lucas Cranach the elder, *Mary Magdalene*, 1525.

The posture of the fashionably dressed people on contemporary paintings remained extremely elegant and markedly arabesque; one did not simply stand up straight with two legs on the floor. The whole body was arched into a flowing snake-like shape, which made it appear fluid. This posture greatly contributed

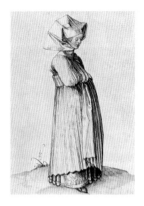
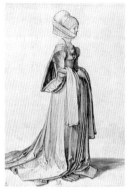

Right: Albrecht Dürer, *Woman from Nuremberg in Ball Gown*, 1500.

Left: Albrecht Dürer, *Woman from Nuremberg in Sunday dress*, 1500.

to the impression of a fashionable person. The fashion was put blatantly on display, whether the model was standing as one of the three wise men, as St. Barbara, or as a private individual. This modeling was as "natural" as any that takes place on today's fashion-show runways, where the fashionable body is exhibited as a moving ornament, and elegance of form is more important than the body of flesh and blood. The presentation of the body began to change during the 16th century. Bodies gained more substance; this had much to do with the changing portrayal of fashion in art, as well as with changing fashions and a consolidated image of individual personality.

People now began expressly to document fashion. Heinrich Aldegrever created his copper engraving series *Wedding Dancers*. Clothing books such as those by Hans Weigel or Jean Jacque Boissard demonstrated an interest in fashions of foreign cultures, while the unique documentary by Matthäus and Veit Schwarz showed all the fashions men had ever worn. These books are a priceless source of knowledge about the cultures and fashions of the 16th century.

Lansquenet fashion

The most popular fashion during the 16th century was the slitted sleeve and, for men, slitted clothes in general. This style derived from hired hands, whose

clothing was colorful, imaginative, and very swanky. The *lansquenets* were mercenaries, soldiers for hire who fought with various armies for wages, rather than out of any convictions. Not surprisingly, they were considered "undisciplined riffraff" by people with more settled lifestyles. The spread of their style of dressing represents the first time that a fashion "off the streets" climbed upward. Usually—and this was the case even into the 20th century—fashions trickled down from the upper to the lower classes, rather than the other way around. The upper class was constantly striving, usually in vain, to curb the fashion development of their inferiors by imposing dress codes on them. The *lansquenets*, however, were generally spared. They already had such a hard life, it was felt, that it seemed only reasonable to allow them the pleasure of dressing colorfully and extravagantly.

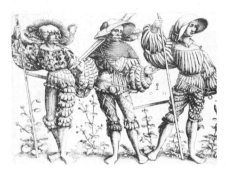

Daniel Hopfer, *Three German Lansquenets*.

Their "ripped-up clothing" soon became general fashion. Clothing was cut apart in the tight spots, and a different colored patch of fabric, usually silk, was sewn in underneath the tear. This silk puffed out prettily and rustled when the wearer moved around. The more fashionable the wearer, the wider and fuller the sewn-in patch, and the more it puffed out from underneath the overgarment. Later, these "cuts" were actually woven into the fabrics. In the middle of the century in Germany, a type of knee-length pants with vertical stripes became popular. These pants had a contrasting fabric sewn underneath. The slits in the clothes were usually not hemmed, but instead were allowed to fray.

Men's fashion in the 16th century

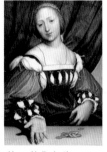

Hans Holbein the Younger, *Lais of Corinth*, 1526.

The decisive fashion changes of the century came in men's clothing. The narrow trousers of former times

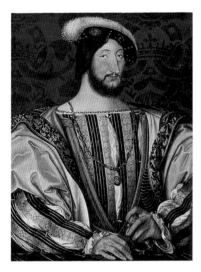
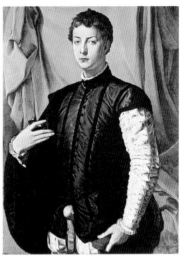

evolved into two different fashions, stockings and knee-length pants, which were attached to the shirt with straps. These straps, which were similar to modern shoelaces, were reinforced with metal tips. Until the 17th century, these straps were used to hold together pieces of clothing. On some portraits, one can discern the straps hanging down, especially on men's clothing. These straps themselves eventually became a decorative element, as buttons did in the 18th century. The crotch became more prominent, with many different styles of ornamentation— sometimes long, sometimes round, sometimes decorated with ribbons. The sleeves maintained their fashionable importance; they were often manufactured separately so that one set of sleeves could be attached to different garments by means of additional straps, providing more opportunity for variety.

Around this time, the neckline disappeared from men's clothing. A shirt was visible below the neckline, which was richly pleated and gathered to form a stand-up collar. This so-called ruff became larger and larger and, around 1600, developed into a "millstone" collar.

Right: Angelo Bronzino, *Portrait of Lodovico Capponi*, 1550–1555

Left: François Clouet, François I of France.

As the collars increased in size, the chest of men's shirts became less important, since they were almost completely covered by the increasingly higher-cut jerkin. The most important piece of clothing for men was a coat with long, wide sleeves and a collar in the back, to which richly folded fabric was attached. The front was open, like some coats today. Together with the beret caps, these became the classic clothing of the German humanist, the forerunner of robes later worn by professors, priests, and lawyers. The berets were flat and sweeping and were worn at an angle. Hair was worn shorter, and, after the neckline disappeared, beards were again often sported. The changes in shoe fashion during this century are quite notable: the pointy shoe disappeared to make way for its exact opposite—"ox mouth" shoes, which were very wide and rounded in the front. (The modern Birkenstocks are narrow in comparison!)

Women's fashion

The women, like the men, loved rich, magnificent fabrics such as brocade and gold embroidery, which were exported from Italy. Their clothing was thoroughly transformed in the course of the 16th century. Trains disappeared. Skirts became shorter so that they no longer dragged on the floor, but they still remained wide and pleated, and were often lined with

Chopine. Venice, ca. 1600

silk or fur. The waist stayed more or less in the middle of the body and was emphasized with a round belt, often with a little purse dangling from it. The *décolletage* was big and square; later, it was often covered. Women wore a shirt under their dresses which was similar to those worn by the men, with pleats and an upright collar. Women also—at least in Germany—wore the "ox mouth" shoes and berets or bonnets. This footwear fashion failed to catch on elsewhere in Europe. In Spain, for example, shoes were pointed, and this came to be the preferred style in the rest of Europe as well. A very special shoe fashion evolved in Venice: the *chopines*, which

allowed women to wade through mud without soiling their feet and legs. In the rest of Europe, simple farmer's wives wore wooden shoes with high heels that also served this purpose. The high-heeled shoe developed in Venice quickly disentangled itself from such profane uses, as demonstrated by the expensive materials from which the *chopines* were manufactured. Covered with brocade, velvet, and silk, and richly embroidered, they were strictly articles of fashion.

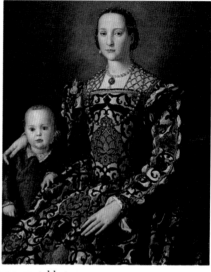

Angelo Bronzino, *Portrait of Eleonora of Toledo with her son Giovanni*, 1545.

The head coverings worn by women became smaller; it was now acceptable to show hair. Most women wore berets or bonnets instead of veils. The sweeping collars had the effect of making women's heads appear smaller, and also made it necessary to pin long hair on the top of the head so that it did not interfere with the collar. Von Boehn tell us it was Italian women who first decided to dispense with head coverings. They also began to use fans, but these were not the same folding fans that later became popular; rather, they were small streamers. So-called flea-furs also became fashionable; these were animal-shaped stuffed skunk, marten, or weasel furs worn around the shoulders, supposedly to attract fleas away from humans. Such misguided efforts make it clear that the cleanliness culture that had characterized the Middle Ages had completely disappeared. People no longer washed themselves; instead they used powders, cosmetics, and "flea furs."

Bodices

The style of women's bodices varied throughout Europe in the 16th century. Paintings by Holbein and Cranach show women with tightly bound waists, but

very prominent breasts. Holbein's paintings give us some indication of how women's fashion adopted the slitted style: the slit shapes the bosom and adorns the oversized sleeves. In Italy and Elizabethan England, bodices changed shape; they were designed to suggest a completely flat, long, conical, upper body. Later, they stretched down far below the waist; this style can be traced back to the so-called "goose belly," which Henry III is supposed to have invented for men, and which women quickly adopted. The goose belly was a jerkin with a long, thickly padded lace panel, patterned after armor, and it made the crotch superfluous.

Spanish fashion

Except for the brief reign of the Burgundy court, no single nation was a leader in fashion. During the 16th century, however, Spanish fashion began to wield more and more influence. The Spaniards introduced severe black as the most important color; single-colors, tight fit, and severity were hallmarks of Spanish style. Sleeves became tighter, although they might still be slitted; they were attached to the

Left: Unknown artist, *Sir Philip Sydney*, 1576.

Right: British school, *Joan, First Wife of Edward Alleyn*, late 16th century.

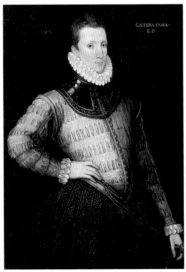
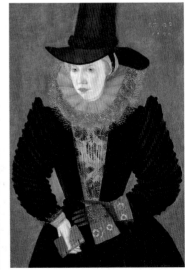

shoulder in a bulge. The jerkin was topstitched and very stiff. Breeches were shorter and balloon-shaped—this effect was achieved with padding. Long and opulent coats were replaced by short, barely hip-length coats.

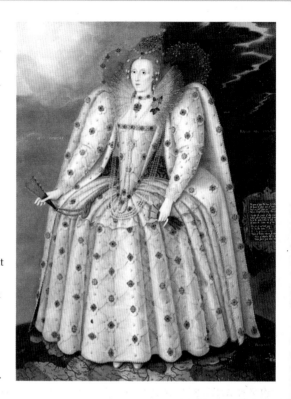

Spanish fashion caught on throughout Europe but was modified in different regions. For example, the French did not adopt the Spanish black, but opted for the same stern, high-necked style in many colors. Margarete of Valois modified the strict ruffs, transforming them into a flattering, open collar that stood up fan-like behind the head and was worn with a plunging neckline.

Marcus Gheeraerts the Younger, Queen Elizabeth I, ca. 1592.

In Germany and the Netherlands, black had been a popular color for clothing ever since the Reformation. These countries did adopt the Spanish tendency toward stiffness and covering the human body. England, under Elizabeth I, exaggerated the Spanish forms to the point where court dress hardly seemed to allow any movement at all. This sober severity soon faded, however, and the queen presented herself in colorfully and richly jeweled costumes. She instituted dress codes for her female subjects so that her own appearance would stand out all the more. According to von Boehn, when she died, her estate included 6,000 dresses and 80 wigs.

1564–1642
Galileo Galilei

1618–1648
Thirty Years' War

1622–1673
Molière

1626–1696
Marquise de Sévigné:
Letters

1635
Founding of the French
Academy

1637
René Descartes:
Discourse on Method

1639–1699
Jean Racine

1643–1715
Louis XIV reigns in
France

1656
Holland and China
negotiate trade pact

1661–1683
Colbert is Minister of
the Economy in France
(Mercantilism)

1670
Blaise Pascal: *Pensées*

1687
François de Fénelon: *On
the Education of Girls*

1687
Isaac Newton:
*Philosophiae naturalis
principia mathematica*

1689–1761
Samuel Richardson
(*Clarissa, Pamela*)

1698
The Bill of Rights signed
in America

1701–1714
Spanish Throne War

1738
Invention of the spinning
wheel

1749–1832
Johann Wolfgang von
Goethe

Brooch with a forty carat green diamond from a diamond garnitur, 1768.

The 17th century

The 17th century is marked by both the Thirty Years War (1618–1648) and absolute monarchy. Louis XIV of France ruled from 1643 to 1715. As the so-called Sun King, he set the tone for culture, economy, and politics in all of Europe. The 17th century was also the century of colonialism. It was a time of deep religious fervor and at the same time the beginning of libertarianism. During this period, as Norbert Elias noted, society became more refined than ever before. Many of our ideas of civilized behavior (how to speak, how to eat with a knife and fork) originated during this time. Much of this came from France, where, for example, the *Académie Française* was established to regulate the French language itself (vocabulary, grammar, style) to such as extent that even today a 17th-century French text can be understood easily. An English text from the same period, on the other hand, would be problematic for today's reader.

While Germany was divided into a vast number of principalities, French power was more centralized. France became the most important economic and cultural center in Europe. French became the language of the upper classes, while Latin remained the language of the scholars. But, during the second half of the century, as a sort of counterweight to the centralization of power at the French court, drawing rooms, or salons, were formed. It was here that art, philosophy and the latest works of authors were read and discussed, and a unique way of thinking and speaking developed. This was strongly influenced by women, who presided over the drawing rooms. Women were increasingly important in the drawing room culture and were considered intellectual equals.

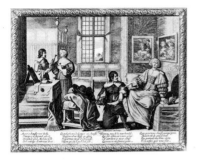

Abraham Bosse, *The Shoemaker*.

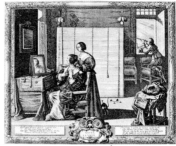

Abraham Bosse, *The Five Senses: Sight*.

Philosopher René Descartes asserted that soul and body are separate, paving the way for a perception of people that was no longer dependent on biological (and especially not on religious) considerations. The philosopher Poullain de la Barre went even farther by proclaiming that the soul has no gender; if women were given the same educational opportunities as men, many of their female vices—held up by some contemporaries as proof of their inherent inferiority—would disappear. De la Barre recognized that certain apparently gender-specific characteristics are produced by social environment. His ideas were not initially popular with the general public, but in the elite world of the drawing room, with its feminine culture, and among the tiny fraction of intellectuals who participated in such gatherings, de la Barre's theories seemed to gain credulity.

Of even greater moment and more enduring impact for the female image in general, however, even into the 18th and 19th centuries, was the thinking of Bishop Fénelon. Fénelon's writings about the upbringing of girls describes females as naturally fickle, dumb, gossipy, and vain; therefore, the bishop advises, they need to be raised very strictly. Their upbringing should in no way address their intellectual capabilities or the acquisition of knowledge; rather, their education should aim to subjugate their "natural" qualities (fickleness, vanity, etc.) and mold women to become

1751–1780
Diderot and d'Alembert publish their encyclopedia
1756–1763
Seven Year War
1759–1805
Friedrich Schiller
1762–1796
Czarina Catherine II
1762
Jean-Jacques Rousseau: *Social Contract* and *Emile or Education*
1768
The steam engine is invented
1775–1783
North American War of Independence
1775
Last witch-burning in Germany
1778
Voltaire's death
1781
Emmanuel Kant: *Critique of Pure Reason*
1785
Invention of the mechanical loom
1789
French Revolution

good wives and mothers. This was a bourgeois ideal, which was not yet particularly important to the aristocracy, who still seemed to focus on the figure they cut in the world.

Fashion

Fashion—or more specifically, what was considered an exaggeration of fashion—was a thorn in the side of such reforms. Dress was still supposed to be appropriate to one's social position; it was a foregone conclusion that the king and the nobility would display their rank through opulent clothing. Anything less would be unseemly and even impertinent. But fashion slowly began to become independent. People began to dress fashionably out of a taste for variety and an appetite for the new and bizarre. And as soon as common people began to imitate the wealthy, the wealthy had to invent new fashions in order to distinguish themselves from their social inferiors again. Fashion also began to attract interest as an independent cultural phenomenon with its own history. For critics, however, fashion continued to be a means for people to perpetuate social hierarchy: It allowed the poor to appear rich and the rich to appear even richer, thus leading to disproportionate standards of living. The daughters of the lower classes were raised and prepared to lead a simple life and only taught things that would assist them in their foreseeable lifestyle, and their mode of dress was expected to be correspondingly simple and modest, conveying a sense of appropriateness to one's station.

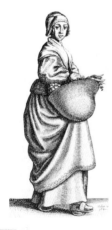

Wenzel Hollar, *Country Woman*, 1640.

The encyclopedias, the first European compendiums of knowledge which appeared in the second half of the 18th century, pragmatically state that fashion existed to make people appear more beautiful and to boost the economy of the state. The roots of this conclusion can be traced to mercantilism, an economic system emerging in France that paved the way for the modern age. France's cultural and fashionable leadership in the 17th century stemmed from its centralized economy,

which was based on exports and avoided imports. This lack of imports was enforced by dress codes; money was to stay in the country. The French minister of finance, Jean Baptiste Colbert, ordered domestic manufacture of lace so that it would not have to be imported from Italy; lace then became a very important element of 17th-century French fashion. In general, the French luxury industry experienced a boom in the 17th century. Silk and brocade were manufactured in Lyon. French fashion was exported to foreign countries; to this end, fully dressed mannequins were sent to foreign courts so that the newest styles could be reproduced.

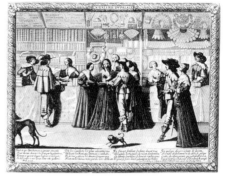

Abraham Bosse,
The Gallery in the Royal
Palace.

An engraving by Abraham Bosse (ca. 1640) shows a sales gallery where the high society bought lace, fans, ready-made collars, cuff-links, ribbons, and many other components of fashionable attire. This individual mixing and matching gave the fashion consumer more say in their own dress, even though clothing could not yet be bought ready-to-wear, but was ordered from tailors, seamstresses, and milliners.

In general, fashion became extensive and opulent, and this tendency grew noticeably over the course of the century. Consistent with the different fashions in courtly society, a new "ideal body" again emerged.

The Spanish influence

Ultimately, France became the leading nation in matters of fashion in the 17th century. The century had started, however, with the Spanish influence in full sway, a holdover from the century before. Spanish fashion retained its influence in some courts, such as Vienna and Madrid, for certain ceremonial occasions throughout the 17th century. Details such as starched collars were worn even longer, but, because they were

so uncomfortable, they were softened somewhat. Eventually, they were completely replaced by broad lace collars.

Van Dyck's *Marquise Brignole Sale*

Anton van Dyck's painting of the Marquise Brignole Sale from the 1620s is typical of Spanish-influenced fashion of the early 17th century. The marquise's dress has a high, relatively straight-cut collar; the effect is very stern. But the dress is not painted in gloomy black as Spanish style had once dictated—a style still often seen in the early 17th century, especially in Holland. Rather, as if in contrast, it is white and gold. These light, magnificent colors and rich decoration transform the majestic clothing; the severity is modified but not quite dispelled. The overall posture, though, is still very stern. The woman's body and head seem to be separate; the head appears small in relation to the body and lies as though detached from the body on a fine, starched, high artistic collar. There are no head coverings at all; women at the time wore only a net of pearls around a chignon. This hairstyle was simple and sat close to the head.

Anton van Dyck, *Paolina Adorno, Marquise Bignole Sale*, ca. 1621–1625.

The skirt reached to the floor all around, and was a little too long to be straight. It did not drape softly, but gathered into harsh pleats. The taffeta probably rustled loudly as the woman moved. The skirt was also stiffened through trimming with stiff gold borders. Skirt and top were separate, and the front point of the top was pulled down. This was a variant of the goose-belly, supposedly invented by Henry III of France in the second half of the 16th century. Patterned after the armor of the knights, it came to a sharp point in the front. It originally replaced the crotch and eventually served a similar function—to point toward the male

genitalia, which were paradoxically concealed in a rather conspicuous manner. For women, this was an almost phallic appropriation of male clothing elements, but it was also clear evidence of the female gender. The top was altogether very narrow and completely flat, with no bosom. Despite the white-gold fabric, the Marquise's bodice seems like a conical metal case shaping the female torso into a magnificent, hard, immobile shield. The female body, the flesh and blood, disappeared completely. The top was slightly inclined toward the back, which suggests that it was short and pulled the torso back, while the front was so narrow that it must have pulled the breasts inward.

The sleeves were attached very close to the front, so that they protruded more than the (nonexistent) bosom, and were noticeably different from the original Spanish sleeves. Although they were a variation of the ballooning sleeves with relatively narrow (double) frills, they were wider and more magnificent than the narrow fitted sleeves of the Spanish. They were further accented by a train, which was sewn on the dress like a third sleeve. The train was turned up at the top to reveal the magnificently patterned lining as well as a second layer of the same fabric underneath. As we have seen, double sleeves were already very fashionable in the Middle Ages as a sign of wealth as well as being thought tasteful. The sleeves of the marquise end in a ruffle, which is the same shape as the collar and does not completely cover the wrist, thus drawing attention to her white, soft, rounded hands.

Hands

Apart from the face, hands were the only bit of bare skin visible in 17th century dress. For this reason, hands were carefully attended. Rings and sometimes bracelets accented the beauty of the hands, which are often exhibited very conspicuously in paintings. They combine idle relaxation and graceful movement, vividly illustrating the contemporary ideal of female loveliness. Thus, a painting by Gerard Terborch from

Gerard Terborch, *Woman Washing her Hands*, ca. 1655. The contrast between the simply dressed maid, who is holding the bowl for her mistress, and the fashionably styled lady in her rich satin dress, highlights the opulence of the contemporary clothing.

Abraham Bosse, *The Barber*.

the year 1655 which shows a woman washing her hands in a basin held by her maid has more significance than the simple act of washing hands which we perform countless times daily. For this woman, it is an important act, one that is carried out with thought. Since hands were seldom washed, clean hands would greatly influence on the impression she would make on others.

Cleanliness and hygiene

Clean hands and snow-white collars and cuffs were outward signs of people's cleanliness. In the 16th century, people believed that water was harmful to the human body. They thought it could penetrate the body or open its pores so much that harmful vapors could seep in. People did not wash themselves, and largely avoided contact with water. They rubbed themselves with dry towels and wore clean clothes; it was believed that wearing white shirts directly on the skin would absorb all sweat and dirt from the body. The more often the shirt was changed, the cleaner one was. People actually believed that they were culturally more advanced than antiquity because they no longer needed bathrooms. Shirts were often visible underneath necklines or sleeves and were an outer sign of cleaniliness. By the 17th century the shirt became less visible; its function was taken over by lace collars and cuffs.

Underwear thus gained in importance in the 16th century. Not only did it warm and form the body, but it was also part of the "strategy" of self-control, which at the time ensured that social constraints were internalized and good social conduct

developed. The few visible edges of underwear suggested the remaining, unseen underwear, thus conveying the wearer's degree of cultivation; if the underwear was clean in the areas that were visible, one could assume that the entire person was clean. These assessments were also, of course, attended by moral judgment about the person's character. Equal cleanliness in the concealed areas of the body and the visible areas suggested a high degree of "self-control," and therefore civility.

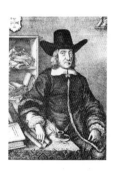

Wenzel Hollar, *Portrait of Sir William Dugdale*, 1656.

Underwear consisted for the most part of the shirt already described, which was often worn as a nightdress as well. The wealthy, however, owned separate nightshirts. Men also wore underpants that were tied in the back. Women only wore the shirt and a hoopskirt, or the farthingale, with several underskirts made of linen, wool, or cotton.

Development of men's fashion

Men's fashion was the first to diverge from the Spanish style; women's followed somewhat later. This change was already evident by the 1630s. The men's exaggerated padded vest disappeared. Instead, sleeved jerkins and a kind of cape adopted from Sweden took over, which was worn over the basic doublet. These styles were inspired by soldiers' clothing, and were originally made of leather, serving as a durable form of protective armor. The style was then adjusted slightly, for example, the smaller tails than were then fashionable in France and elsewhere in Europe were added. In their civilian incarnation, the modified jerkin and cape were made of cloth. The jerkin was sleeveless or fitted with decorative but functionless sleeves. Its tail was initially fastened to the top, which can be easily seen on an engraving from 1735. The tails themselves consisted of single wings which became wider towards the bottom. Only after 1630 was the cape made as a single piece with sleeves, and this is the origin of the gentleman's top coat. The once serviceable fastenings became decorative.

Couvray, from Grégoire Huret, *Cavalier in Front of the Mirror*, ca. 1635.

63

Men's collars were high, and over them they wore lace collars. These became larger and larger in men's as well as women's dress, resting on the shoulders and sometimes even covering parts of the arms. These draped collars made room for the hair, which men now wore longer, sometimes cut unevenly, with one side longer than the other and twisted into a braid or curled. Now wigs became fashionable for the first time and, because new hairstyles demanded new hats, wide, soft felt hats with a variety of brims became popular. These were sometimes adorned with a large plume on the top.

Sleeves became wider and were gathered in broad cuffs The legs of breeches became wider as well; pants which hung loosely around the legs and were tied with ribbons just below the knee were in. In the second half of the 17th century, "petticoat breeches" became the fashion for gentlemen and shortly thereafter for the bourgeoisie. These pants were so baggy they looked like skirts; they were cut like skirts as well. They were worn with a short (waist-length at most) open vest worn over a voluminous white shirt. At the knees, the breeches could have huge flounces (*canions*). They were worn with silk stockings and heeled shoes.

Shoes were worn with colored silk stockings and often trimmed with rosettes or buckles, which were particularly fashionable early in, and then again in the second half of the century. They were generally replaced by top boots in the middle of the century. The boots were very wide and sometimes lined with lace and batiste.

Romeyn de Hooghe, *Gentleman in Petticoat Breeches.*

64

Women's fashion

In women's clothing, two-piece fashion became popular for a time. Skirts were now moderately wide, floor-length, and once again full, folded into strong pleats. Hoop skirts, or farthingales, went out of fashion around 1600. The hips were padded with tow bulges so that the fabric fell evenly to the floor, or the skirt was shaped by several stiff underskirts. Another

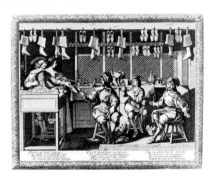

Abraham Bosse, *The Shoemaker.*

manner of accenting the hips was to gather the underskirts, which in turn widened the pleats of the outer skirt. On the top, ladies wore a high-buttoned jacket with wide sleeves and a sweeping lace collar. Bodices became somewhat less stiff than in the former Spanish style, and were either pointy or rounded at the borders. Like the men's outfits, the jackets were lengthened over the waists with tiny tassels. Wenzel Hollar's engraving of an Englishwoman seen from behind clarifies this silhouette, as does Abraham Bosse's engraving of a haberdashery.

After ruffs were abandoned, necklines plunged deeper and were cut square, but they were often covered by lace collars or fine batiste. The new, angular necklines are recognizable in van Dyck's portrait of the youthful William of Orange and his bride Mary of Anton (1641). The children are dressed in the same manner as the adults: The young girl wears a dress with a conical skirt, a moderately laced pointy bodice, and a lace collar that drapes over the shoulders. Her hair is "naturally" styled into small curls framing her face. Her sleeves are relatively wide,

Wenzel Hollar, *English Lady with Fan and Mirror,* 1640.

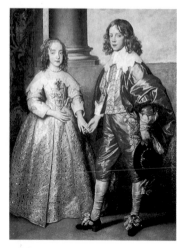

Anton van Dyck, *Prince William of Orange and his Bride, Mary*, 1641.

and despite ornate cuffs, are not tight around the wrists. She wears pearls around her neck and woven into her hair.

Van Dyck's 1634 painting of the Duchess of Croy with her son shows a different *décolletage*, an adaptation of the Medici collar. Noteable here is the rich pearl jewelry and the separation of the over- and underdress into two parts, creating a magnificent sleeve effect.

Children's clothing

In van Dyck's painting, the boy seems to be dressed like a girl. This was customary in those days, because sons belonged initially in the female sphere; they were cared for and raised by wet nurses and nannies. Only later, when their upbringing was taken over by male tutors, did they develop into little men, and were dressed accordingly. Often, as the picture of Prince William shows, they were dressed like miniature adults. Childhood in the 17th century was not yet considered a stage of life with its own value. Such a view would not become acceptable until the early Romantic period—that is, until the late 18th century, when it was propogated by the French writer Jean-Jacques Rousseau (1712–1778). Clothing is an effective barometer of the perception of childhood in an epoch. In the history of fashion, boys developed their own clothing style—that is, a manner of dress distinct from their elders—

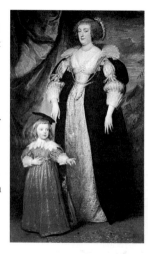

Anton van Dyck, *The Duchess of Croy with her Son*, 1634.

earlier than girls did. This male childhood style was worn between infancy and adolescence, while girls continued to be dressed like little ladies. Only in the late 18th and 19th century, as perceptions of childhood changed, did a bona fide children's fashion emerge.

The sign language of fashion and the body

Baroque theater developed a clear sign language for specific postures and movements on stage. This visual vocabulary was prescribed so that the audience could understand what was being portrayed. In the same manner, people's lives, behavior and their self-portrayal off-stage were also increasingly regulated. Life followed a system of signs, of which clothing was a component; how it was worn and how one moved in it were part of the body language. Courtesy became a hallmark of proper social behavior. One was expected to suppress one's own feelings out of consideration for others. Politeness, or "civilité," might be considered a controlled art form of self-portrayal. The language of the body, Ariès says, was an outward projection of individuality for people during the Baroque, and was clear to others. As a result, everything that was withdrawn from the eyes of the public was presumed to be indecent. Outward propriety became moral constraint, which was expressed through clothing.

Young girls were dressed like women; boys had their own fashion styles once they had grown out of baby clothes.

The 17th century brought new attitudes toward the human body. People now held themselves at a distance from one another, as Ariès writes. It was during this time that people began to eat with a knife and fork from individual plates (instead of everyone at the table eating out of a single bowl, as was the practice in the Middle Ages); this is indicative of the trend to individuality, which also found expression in fashion. Fashion now created a space around individuals by increasing their girth and giving them new form.

Fashion and body in the Baroque

The construction of Baroque fashion was quite complex. It created "unnatural" forms, although it

Detail of a woman's dress, 1775.

seemed more natural than the Spanish fashion of the previous century. Fashion in the 17th century was like architecture: It created three-dimensional shapes that magnified the surface area of the body and differentiated people from each other. These new styles were in perfect harmony with the period architecture, which was opulent and splendid and especially loved to fool the senses. It is no coincidence that *trompe-l'oeil* was a favorite painting style at the time. The naked human body was simply not splendid enough; it afforded too few opportunities for surprise or tricking the senses. Also, nakedness was in opposition to the trend toward refining conventions and taming natural urges and bodily functions. These topics were no longer discussed openly. In the French salons and their offshoots, this new coyness, which cloaked itself in the euphemistic term "refinement," was driven to absurd extremes. Words like "breeches" were no longer spoken aloud lest the mention of the word suggest the part of the body that the article touched. Instead, breeches were described with newly invented terms, which only made sense to a chosen few (and themselves soon passed out of fashion).

We have already seen how little fashion has to do with the "true" body—no less in the past than today. Instead, its purpose is to constantly create new bodies. This was very clear in the Baroque era, when fashion was completely liberated from the actual body; this was replaced by an artificial shape that was simply called a body. In short, fashion speaks constantly of bodies, but these are always products of the latest trends.

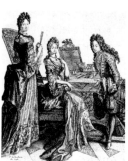

Nicolas Arnoult, *The Duke of Bourgogne visits the Princess of Savoyen*, 1690.

Louis XIV
While Spanish fashion had dominated the 16th and early 17th centuries, the somewhat simpler style

Dutch style of clothing influenced dress in Europe until the middle of the 17th century. The Puritans retained the austere style of the Netherlands even longer, but by and large, the French influence became more important among the already fashion-conscious in the second half of the century. Under the reign of Louis XIV, the words fashion and French finally became synonymous. Around 1680, silhouettes and shapes changed completely once again; the fashionable 18th century was on its way. Men's clothing was simpler than women's, and even their finery, once replete with ribbons, bows, flounces and ruffles, became much more subtle. The fashion was in fact just as complicated and rich as ever, but in a different form.

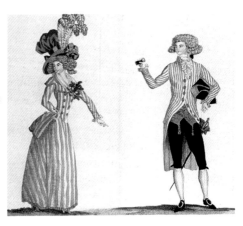

Broad stripes were highly fashionable for both men and women in the 1780s.

Probably because he himself spent so much time on the battlefield, Louis XIV introduced a variant of the soldier's jacket as the ultimate piece of apparel. Some fashion historians support the view that it was King Charles II of England who introduced the simpler clothing, which was described as "Persian," as a countermovement to French opulence, and that Louis XIV merely followed suit, so to speak. Whatever the origin of the style, it marked the introduction of the *justacorps*, a kind of jacket that reached to the knees, worn under the topcoat. It covered the vest worn underneath, as well as the knee breeches. Only the silk stockings and buckled shoes with relatively high heels were visible. The *justacorps* (also known as the "just-au-corps"), as the name suggests, was close-fitting and tapered, and usually simpler than the richly embroidered vest. In fact, only the king and his favorites were even permitted to wear embroidered clothing; embroidery

was otherwise proscribed in France. In the 18th century, however, embroidery became more widely used, even on the *justacorps*. Its sleeves were narrow at the top and wider at the wrists. At the neck, one wore a *jabot*, a forerunner of the necktie, which was made of fine batiste or lace. Lace remained stylish, but bows, ribbons, and excessive jewelry (bracelets and earrings had been worn by men) fell out of fashion.

Instead of his own hair, the fashionable gentleman wore a periwig. Teased up to great height and with thick curls, the artificial hair fell down the chest and back. Atop the wig the gentleman wore a hat with an upturned brim, which soon evolved into the three-cornered hat. This style survived, with some variation, until the French Revolution almost a century later.

Femininity—masculinity

As men's clothing became outwardly simpler, women's clothing became more lavish. This was the beginning of a trend toward complementarity, which peaked in the 19th century. Complementarity is inherently linked with changing perceptions of femininity and masculinity. Until the 17th century, people had been of the opinion that men and women basically had the same body, but that women's genitals had not "evolved" as far as men's had, which is why they were inside the body. Women were thus considered flawed, incomplete versions of the perfect, masculine person. Accordingly, they were considered socially inferior beings. Late in the 17th century and in the course of the 18th century, however, people came to believe that women and men were two completely different beings. Not only their genitals but their entire bodies, souls and intellects were considered as fundamentally incomparable as apples and oranges. The gap between the genders became wider than ever, and it is no coincidence that contemporary fashions reflect this separation between the masculine and the feminine. Indeed, fashion actually contributed to the establishment of these differences.

Women's fashion

In the mid-17th century, ladies' hair was allowed to frame the face in "natural" curls. Around 1670, the "cabbage" hairstyle became popular for a while: curls were combed out and loosely piled atop the head. Flowers or pearls were braided into the hair. Women's headdresses now became bigger and more opulent. Women wore hairpieces because their own hair rarely offered sufficient fullness to achieve the desired look. One or two thick curls fell down the back, and the rest were pinned up. For a while, small curls combed down the forehead were in fashion, but high shaved foreheads soon became popular again. At the end of the century, the indoor cap known as the *fontange* developed; named after the Duchesse de la Fontanges, it was a high, tower-like cap adorned with beads, wires, and metal rods set over the forehead and interwoven with the lady's own hair. Women did not wear hats during the entire 17th century. At most, they tied a lace cloth over their heads when they went out, though married middle-class women wore little bonnets.

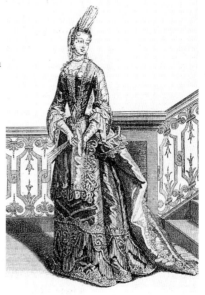

The Marquise de Rochefort with a fontange.

Dress consisted of an overdress, the *manteau*, worn open at the front and thereby showing the underdress (not to be confused with underwear) or skirt, which was made of similar, expensive fabrics. The overdress was pulled into a bustle in the back or at the top and ended in a train. It was made of velvet or heavy silk, while the underdress (made of lighter fabric) and the top part of the dress were richly embroidered or trimmed. The top was a triangular bodice of laces and bones, sometimes even iron plates, which met at a point at the bottom. A piece of brocade or other expensive material was

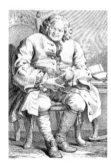

William Hogarth, *Simon Lord Lovat*, 1746. The gentleman is wearing breeches, stockings and buckled shoes, a wig, and an overcoat decorated with plentiful large buttons.

attached in front. Sleeves were tight and ended at the elbow with lavish lace trimmings. Bosom and cleavage were deep and no longer covered with lace collars or handkerchiefs. A constituent part of the outfit was the fan, usually a folding fan and not the flag-like fan of the Renaissance. It was also considered very elegant for a woman to hold an expensive lace handkerchief in her hand. This was exclusively a fashionable accessory, and was never actually used to blow one's nose or for other similar unseemly purposes.

After the turn of the century

All in all, this style was popular for several decades. Only after the death of Louis XIV, who in his old age had become very religious and despised all frivolity, was the rigidity relaxed somewhat. The severity became attenuated and the overall tendency became softer and more comfortable. Or so it appeared. In men's fashion, not much changed initially, except that the wigs worn by men were slowly replaced by different kinds of wigs. The newer style had three big curls, one of which could even be tied back. These wigs were much more practical than the unshapely and heavy wigs they superseded. Later, a more practical version, the "hour boy," and the "soldier's braid" were added; the latter can be easily recognized in portraits of Prussian soldiers. In any case, a wig in some form was always a necessity. One's own hair was only allowed to be seen in the privacy of the home, in informal situations. The best wigs were made from human hair, but since this was very expensive, goat hair, horse hair, or plant fibers were also used. The wigs were powdered white or gray. This custom began in the 1690s and remained up until the French Revolution. A man usually carried his hat underneath his arm rather than on his head, and his outfit generally included a rapier. This was more than simply decorative: it was also kept to hand for use in defense or for a duel.

The sleeve cuffs became smaller over the years, and the laps of the waistcoat and *justacorps* were stiffened

so that they fell away from the body, like women's skirts. The buttons of the *justacorps* were not fastened, or, if they were, only at the top of the jacket. The bottom ones remained open, revealing the richly embroidered vest, or waistcoat, underneath. Both the waistcoat and the *justacorps* had long rows of illustrious buttons from top to bottom. Knee breeches were still worn at this time; their bottoms were tucked into the stockings. It was only in the 1730s that men stopped wearing stockings under their breeches.

Of course, not all men wore embroidered vests. For middle-class citizens, vests were cut in the same style but made of simpler fabrics with little decoration, except for the buttons, which played a very important role. William Hogarth's engraving of the Scottish rebel Lord Lovat, who was executed in 1747, shows us the simpler, everyday variation of men's clothing, including the wig. A forerunner of the necktie can also be seen, as well as a shirt with white flounces protruding from the skirt, which was still very big and ornamented with buttons.

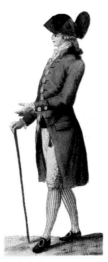

Gentleman in a bottleneck colored overcoat, with mother-of-pearl buttons; underneath he is wearing a black silk waistcoat with a green floral pattern. The breeches are coal-grey and have white metal buttons.

Women's fashion

Women's fashion abandoned its tight, stern, vertical form. Ladies still wore tight corsets, as well as tiny shoes in which they could virtually only sit—standing was painful, and to walk in them almost impossible. Wide and comfortable-looking dresses now entered fashion, influenced by maternity clothing; these styles were called "Adrienne," "robe volante" or the "French sack." They were usually open in the front and only slightly cinched at the waist. They were worn over a hoop skirt and a bodice. They were called *negligées*, that is, everyday wear, as opposed to the more sophisticated formal clothing. (Only much later did the word "negligée" come to denote underwear, or rather, night or morning clothing.) These dresses appeared shapeless; they were very wide at the back because the folds were inlaid and sewn on at the shoulder, falling to the floor with no waist. This style became known as a

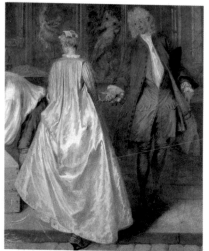

Antoine Watteau, *Shop Emblem of Gersaints*. This detail shows a lady's dress with the typical Watteau folds, here in pink satin. The lady's hair is powdered grey and styled respectably; her headdress consists of a simple bow. Only a few decades later, women's hairstyles and hats were to take on gigantic proportions. The gentleman is wearing an appropriate day suit.

"Watteau fold," because it was worn by almost all the women painted by the French artist Antoine Watteau. The fold stayed modern throughout the rest of the 18th century, and was revived in the 20th century by Vivienne Westwood, who was an ardent admirer of Watteau.

Only very little clothing was "closed;" that is, consisted of a top and a skirt without an opening. Much more common was the "open" shape, where the overdress, or "manteau," opened up like an upside-down V from the waist down allowing the richly decorated skirt to show through. This is easily recognizable in François Boucher's 1759 painting of the Madame de Pompadour. The bodice is pointed at the bottom, and the overall effect is that of two Vs standing top to tail, like an hourglass. The rear of the dress may well have Watteau folds. In the middle of the century, the manteau became gathered so that the typical Rococo impression was of an overdress made up of several layers of rustled material.

Laced-up bodices and corsets of wood, metal, or whalebone were used to shape the female upper body. While in the 16th and 17th centuries these garments and their stays served to hide all suggestion of a rounded bosom, they were now increasingly used to push up and accent the breasts. Furthermore, cloth handkerchiefs of expensive fabric were still worn in the front of the bodice.

The *décolletage* plunged

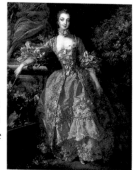

François Boucher, *The Marquise of Pompadour*, 1759.

deeper, so that toward the end of this period, almost the whole female bosom was exposed.

The fontange headdresses went out of fashion around 1715. Instead of these artificial, tower-like hairpieces, women wore curls framing their face, or even more often, pinned up, as seen in the portraits by Watteau. The women's heads therefore appear smaller, while the skirts grew bigger, and the hooped skirt came back into fashion.

Farthingales and representation

The farthingale, a hoop skirt which had been put in mothballs for several decades, now celebrated its revival. Farthingales were constructed with reed hoops and reached only to the knees. For less formal occasions, the hoop skirt might be replaced with pads attached to the hips; these were much more comfortable. Initially the skirts were conical, but after the 1720s, dome-shaped skirts with a circular outline took over. The skirts became shorter, and very fashionable ladies exhibited their feet, or rather, their graceful, elegant slippers made of precious fabrics (rarely leather), that were expensively trimmed or embroidered. These shoes served a more representative than functional purpose. The majority of women continued to wear wooden shoes or similar footwear in which it was possible to walk and work.

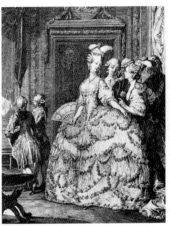

Jean Michel Moreau the Younger, *The Queen's Maids of Honor.*

For the courtly gala clothing ("*grande parure*") in the middle of the century, oval hoop skirts became fashionable. These were called "*panier à coudes*" because the skirts were supposedly so wide that women could rest their arms on them. The skirt was flat in the front and back, but so wide at the sides that a woman could not walk forwards through a door. This example again reinforces our propostion that fashion creates its own silhouettes and body images, which have very little to do with actual bodies. Fashion in the

The artist Adelaide Labille-Guiard portrays herself in expensive dress to emphasize her rank, while her two pupils are more modestly dressed. 1785.

A woman in a violet *redingote*. Originally worn only by men, women adopted this cropped coat form around 1785. The woman is carrying a handkerchief in her hand—not to use it, but as a decorative accessory.

17th and 18th centuries transformed bodies into living works of art, consistent with its representative social function. One must keep in mind that these fashions were designed for the ladies and gentlemen at court, the aristocracy. After losing their political clout during the reign of Louis XIV, they compensated by physically distinguishing themselves through more opulent dress. The rising bourgeoisie, which competed with the aristocracy in part by imitating it, strove (successfully) to become their cultural and fashion equals. As had beem customary already in the 17th century, rich citizens liked to marry their children off to impoverished aristocrats in order to gain a title. For their part, the penurious aristocrats gained money from these marriages, which allowed them to preserve their prestige and idle lifestyles; the aristocracy did not work for money. Their job was ever to *represent* (which should not be undervalued as an unusual and indisputably exhausting form of work); their lifestyle was very public and meant to be seen by others. This required a lot of money to buy every imaginable luxury, and it enhanced the social role of fashion. Only fashion could so easily convey what someone was, or at least wanted to be. And only fashion could clearly distinguish the upper from the underprivileged classes, who were not aristocratic. However, because these classes constantly imitated the fashions of the aristocracy, the aristocracy had to continually alter its fashions in order to keep ahead of its socially inferior pursuers.

Soap and water are out, makeup is in

In his series of engravings called "A Harlot's Progress," Hogarth portrays a young country woman, simply clothed in a dress and apron with a laced bodice. She is received by a richly dressed old harlot, whose occupation can be discerned by her exaggerated youthful and rich style. This dress is consistent with neither her environment, a dirty carriage station, nor her old face. Her profession is also indicated by the

William Hogarth, *A Harlot's Progress*, 1732. Madam rigged out far too extravagantly for her age, and recognisable by the beauty marks on her face (indicating sexually transmitted disease) welcomes a young, naive girl who has just arrived from the country.

many artificial beauty marks dotting her face. Although it was common in the 18th century for sophisticated people to wear beauty marks in various sizes and shapes on their faces and even their bosom, the unusual distribution on this woman's old face suggests a woman marked by syphilis who is trying to camouflage the sickly spots on her face with beauty marks. The young country girl, when she becomes a prostitute, will also in time be marked by such beauty spots. Thus a fashionable detail, which originally served as a mark of distinction, became a means to cover up the trails of an "indecent way of life," and paradoxically, made this lifestyle even more apparent.

People still did not wash themselves in the 18th century; instead, they concealed dirt with makeup and covered up odor with perfume. The makeup was invariably white and contained what we now know were toxic amounts of lead. Cheeks were reddened with a very unnatural-looking rouge. Hair was powdered. In the middle of the century illustrious hairstyles came back into fashion, using masses of real and fake hair, wire and other support materials: they were so complicated that one could

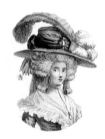

Headdress in the 1780s became ever more sweeping, every hairstyle and hat was given its own, imaginative name.

English riding costume for women (ca. 1786), consisting of bottle green fabric with gold-plated brass buttons, lemon-yellow waistcoat, hat, gloves, and jabot. Her costume was obviously inspired by the men's fashion. The gentleman is wearing a soot-coloured suit, also combined with yellow. The breeches are buttoned at the knee, and the trouser bands hang down.

not possibly style one's hair every day (not to mention washing it). Hair was simply "reworked" each morning by the hairdresser or maid. Of course, vermin made themselves at home in the hair and had to be removed, or shifted about, with small ivory "scratchers."

The decades before the revolution

In the 1780s, hairstyles crossed into altogether new territories of fashion. Hair and hats became more adventurous and bigger every year. Skirts, by contrast, became relatively modest and somewhat smaller in circumference. The *calico*, a type of jacket, became very popular among women during these years; men wore *redingotes*. The jackets were always tightly fitted and had long or short laps, depending on the fashion of the day. As a whole, fashion appeared slightly sterner and more "masculine" than in the middle of the century. However, the bright colors, extravagant fabrics, and imaginative hats compensated for this. All colors had fantasy names: flea colors, bottle green, bishop's violet, canary yellow, and they were combined in a way that looks daringly bold to our eyes. However, the colors always harmonized.

The basic principle for men's fashion stayed the same: Men wore knee breeches, vests, and the *justacorps*. For a while, however, the knee breeches became so tight that men could no longer sit in them. The vest and the *justacorps* changed shape; the vest became shorter, and the

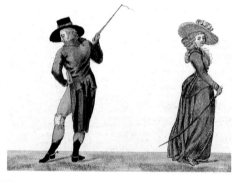

justacorps were cut higher in the front so that the tails seemed longer at the back, and the pants, which were previously completely covered, were now visible at the front. This new form was more comfortable and had aesthetic charm. Pants had a bib with two slits, and watches could be hung on the belt. These watches were only for decoration and demonstrating wealth, not for telling time. The women also quickly adopted this fashion accessory.

Colors and fabrics were as expensive and luxurious as ever. The very noble fabrics, however, were now occasionally replaced by fine cotton and light, very color-intensive *calico* (which had once been illegal to import).

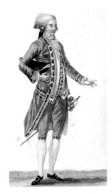

Gentleman in festive attire. His suit is made of purple satin, with pink and green silk embroidery. His waistcoat, of white satin, is embroidered to match. The buttons are mother-of-pearl. The rapier is an integral part of the costume.

Fashion magazines

From the latter part of the 18th century on, the development of fashion is documented without any gaps. This is thanks to the first fashion magazines, which were created in the 1770s. Before these emerged, fashion was disseminated by the international distribution of fashion mannequins. It was also spread via collections of single-fashion copper-toolings and engravings. Also, fashion satires and caricatures appeared in the weekly papers and there were also sewing patterns. Costume books, which had been around since the 1600s in no small numbers, only portrayed the attire of foreign peoples or of past times. There were already journals that published fashion descriptions, but now, for the first time in history, there were fashion illustrations. In England, the *Lady's Magazine* began publication in 1770; in France the pioneers were the *Gallerie des Modes* (1777) and its successor, the *Cabinet des Modes* (1785–1786). The best-known German fashion magazine was the *Journal des Luxus und der Moden*, which started publication in 1786. After the French Revolution, Niklaus Wilhelm von Heideloof's *Gallery of Fashion*, published in London, and the French *Journal des Modes* became important.

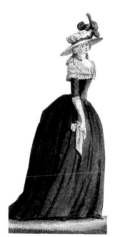

Woman in mourning dress: black taft, decorated with white gauze. The first stage of mourning, when only wool may be worn, is obviously over. Pictured in the 1786 edition of *Cabinet des Modes*.

Fashion and lifestyle

These journals were dedicated to what we would today call "lifestyle." They discussed everyday designs, new books, theater, and the good life. At the heart of all this, however, were the newest fashion reports. Every magazine (the magazines usually came out every one to two weeks and were accordingly thin) contained one or more hand-colored fashion picture, with exact descriptions of the portrayed clothing. From these descriptions, things that could not be recognized on the picture were pointed out: how the vest the man was wearing under his skirt was made, what fabric was used (or recommended), which buttons were most stylish, where the fabrics could be purchased if desired, where the clothing could be sewn, who wore the clothes, the name of the hairstyle, the measurements of the hats, and so on.

One can glean from these magazines exactly how quickly fashions were changing even in those days: One magazine mentioned that no one was wearing a certain type of hat that had been the latest fashion only a few weeks before. They are also a good source of information about appropriate social customs, such as the clothes to wear during mourning. Here, fashion definitely maintained its prescriptive role: For example, the *Cabinet* reported, that for parents and spouses, mourning was to last for six months, in a succession of three stages during which

Right: Woman in half-mourning.

only certain fabrics, materials, and colors could be worn. For a few weeks, only wool was worn, then silk. For a certain amount of time, clothing was to be unadorned with any kind of draping, although jewelry was acceptable. In this way, outsiders could tell by the fabrics and accessories the exact stage of mourning a person was in. Under some circumstances it was even possible to recognize the relation of the mourner to the deceased.

Objectives and audience

The *Cabinet des Modes* had a long subtitle describing the goals and purposes of the magazine. This was: "Gallery of the fashions, or the new fashions. Clearly and precisely described and illustrated with colored pictures. The work imparts exact and prompt knowledge of clothing, the presentation of people of both genders, new styles of furniture, new interior decorations, as well as the beautification of homes, the new forms for coaches, for jewelry, gold work, and in general of everything special, pleasant, or interesting, which fashion has to offer." The luxury which the magazine presented to its wealthy readers was justified in an ostensibly enlightened way: Luxury was necessary as a means of redistributing wealth. The lower classes who were being paid to produce the luxury goods for their social superiors. The subtitle does not mention, of course, that only the wealthy could ever afford to buy the *Cabinet*, let alone the fashions described in its pages. The exclusive audience of the magazine, however, is easily enough inferred from its lavish production.

This lady has combined her flea colored jacket with a pink skirt, white bodice, and yellow leather gloves. Instead of a bonnet, she is wearing a creation of fine gauze in butterfly style on her powdered grey wig.

Who makes the clothing?

Even so, the clothing magazines were read by the poorer people. Servants in better homes got ahold of

the discarded issues and thereby informed themselves of the latest trends. However, the serving class hardly had the means to have the fashions depicted tailored for them—and in any case they had to dress appropriately to their position. But occasionally a lady's maid might be lucky enough to receive a cast-off dress from her mistress, and would be permitted to wear it if she altered its appearance. Nonetheless, exposure to the fashion magazines influenced the manufacture of their own dress, for, of course, servants and simple people made their own clothes. In this manner, fashion, a thoroughly elite phenomenon, spread to the general population with the help of fashion magazines far more readily than had even been possible before.

Wealthy ladies and gentlemen continued to have their clothes made by others—sometimes by members of their staff, but usually by tailors or seamstresses. The wearers themselves, however, were still able to bring their own imagination to the design of their clothing. Thus, Madame de Pompadour was considered an incredibly fashionably creative woman, who brought many new ideas to fashion. Queen Marie Antoinette employed a milliner named Rose Bertin who became, in a sense, the first fashion designer known today by name who rose above the anonymity of being just a seamstress. She laid the groundwork for a development that bore fruit in the next century. Only then did fashion designers become artists whose works were proudly monogrammed with their names.

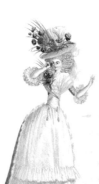

This lady is decked out in white and yellow. Note the watch on her belt, worn as an accessory.

The usefulness of fashion

The *Cabinet des Modes* enthusiastically declared its

own usefulness, asserting that it made the expensive production of mannequins as unnecessary as the sending out of commissioners, who could convey only a very vague idea of the French fashions anyway. Through the *Cabinet*, the unusual qualities of Parisian fashion were announced to the whole world, not simply the French provinces. Two things hereby become clear: first, that Paris was the self-proclaimed fashion capital of the world (an attitude that still prevails today), and second, the belief that it was one's duty as a citizen to support one's national economy and luxury production. The dual purpose of fashion, in short, is viewed objectively: It has an economic side and an aesthetic side. It is both consumption and cultural asset.

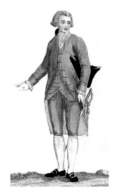

Gentleman in satin suit: It was unusual for everything—even the buttons to be uni-color like this.

This is reflected in a description of striped clothing for both genders from January 1788: Stripes had already been fashionable for a while, but would probably remain so for some time— much to the joy of merchants, but also much to the joy of good taste. For good taste can always find something good in the plentiful variety of fashions. Beauty confers pleasure by constantly re-appearing and appeals to good taste by always appearing to be new. The phenomenon of fashion is clear in this statement: Its essence is constant change. It loves newness for newness' sake, and find beauty only in surprise. Fashion not only distinguishes individuals, but also distinguishes nations (that is, it has political uses in a broad sense). In short, for the European peoples of the 18th century, fashion was not a superficial frivolity but a sign of refined taste and a constantly developing culture, fully the equal of any other cultural endeavor. The increasingly clear, visible drawbacks of this culture, however, led to the revolutionary events of the ensuing years.

1789
Constitution introduced in the United States
1791
France gains constitutional monarchy
1792
France declares war on Austria and Poland
1793
Louis XVI executed in Paris
1793–1805
Coalition Wars
1798
Napoleon campaigns against Egypt
1804–1815
Napoleon is emperor of France
1804
Napoleon's *Code Civil*
1806–1807
France wages war against Prussia and Russia; Prussia crumbles, continental barrier erected
1812
Napoleon campaigns against Russia
1813
Prussian-Russian treaty
1814
Napoleon abdicates; Louis XVIII becomes king of France
1815
Vienna Congress
1818
English conquer India
1819
First steamship sails from Europe to America
1825
Uprisings in Russia
1830
July Revolution in France
1830–1848
King Louis Philippe, known as "the People's King," reigns in France

Return to nature?

The French Revolution fundamentally changed the social order in Europe—even if only temporarily—and with it, fashion. In the last decade of the 18th century, on the one hand democracy was being championed while on the other hand a romantic "back-to-nature" movement was being propagated, marked by a preference for plainness. Of course, the simplicity of cut and color that characterized men's clothing had been around for some time, but now it consolidated its position and became the norm.

For a time, the lines of women's fashion were also "reduced," in a manner of speaking. In the course of the 19th century, however, the luxurious and opulent silhouettes were again revived, and it was not until the 1920s that simplicity finally reemerged.

English fashions

In the early years of the 19th century the popularity of French aristocratic fashion diminished and, simpler, countrified styles were favored. Elaborate embroidery and expensive, heavy fabrics, ruffles, and lace disappeared, as did huge hats and gigantic powdered periwigs. These gave way to simpler fabrics, lines, and colors, natural, unpowdered hair, and smaller bonnets and hats. This is not to say, however, that English country fashion took its cue from the farmers and peasants. It was, rather, the fashion of the landed gentry, and of wealthy landowners who adopted the simpler styles for

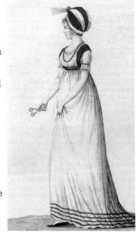

Turbans were highly fashionable at the turn of the century. They replaced the sweeping hats of the pre-revolutionary era.

practical reasons. Snug pantaloons with boots replaced knee breeches worn with shoes; jackets were made from well-fitting woolens. Vests were short, and round hats replaced the tricorner. In the years after the revolution, long pants returned as standard men's attire, though this came about relatively slowly; for quite some time, men still wore knee breeches on formal occasions. Otherwise, they wore ankle-length pantaloons with stirrups under the feet for a better fit.

In France, long pants became a political symbol: Knee breeches had been the clothing of the aristocracy. Only sailors and workers had worn long pants; now they slowly spread, symbolizing the rejection of the trappings of the hated privileged classes and the new democracy. Finally, long pants or trousers became what we view today as being the epitome of men's wear. As an ironic *coup de grâce* of the revolution in fashion, knee breeches ultimately were relegated to lackeys.

Thus, changes in fashion during the era of the French Revolution actually originated in England, not in France. The new trends, however, soon crossed the Channel, where they were quickly adopted by the French and again, some felt, heightened to excess.

1830
First railway between Liverpool and Manchester
1835–1848
Rule of Emperor Ferdinand of Austria
1837–1901
Queen Victoria reigns in England
1840–1861
Friedrich Wilhelm IV rules Prussia
1838
Daguerre invents photography
1842
England acquires Hong Kong
1847
Karl Marx and Friedrich Engels: *The Communist Manifesto*
1848
February revolution in France; German revolution; uprisings in Italy, Hungary, and Bohemia

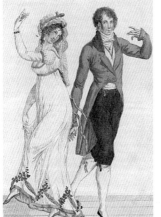

Women's fashions

In fashion portraits of the time, white predominates in women's fashion. White was considered the color of purity and therefore an embodiment of the desire to return

Ball gown from *Journal des Dames et des Modes*, 1800. The lady is wearing a particularly extravagant headpiece consisting of a long lace shawl—an adaptation of the *négligée*; the interaction of various fashion elements influencing each other can be observed here.

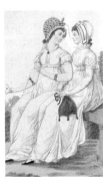

Morning toilette, 1800.

to nature. It was also reminiscent of antiquity, since people were under the false impression that ancient garments had been predominantly white. Women's fashion consciously took on a supposedly antiquated look in the years after the revolution. Lightly printed cottons or white muslin were made into *robes en chemise*, or shirtdresses. These were worn without corsets or crinolines; they flowed over the body and were gathered into a waist just under the bosom. Such styles actually bore little resemblance to garments of antiquity, but they were considered antique by the people of the time. The new styles were a stark contrast to the opulent, exaggerated, and stiff fashions from before the revolution, which had completely distorted the female form.

The new fashion, on the other hand, seemed to display the body more. For the delicate, transparent dresses to have their full effect, one could no longer wear underwear; at most, a woman might wear a type of pink or flesh-colored bodysuit under her outer garments.

Around the turn of the century, clothes became more colorful again: sky blue, rose red, and even black were picked. Styles also changed. For example, tunics, worn over long dresses, became popular again; these were usually white. Another style variant was the skirt, slit at the front or back to give the impression of a sort of apron being worn over the dress. These were also called "tabliers" or "aprons." Trains became rare and eventually slipped into total obsolescence.

1805: this elegant lady is wearing a straw-colored silk dress with silver embroidery. A white band, tied at the back, serves as a belt. Pink shoes, pearl earrings and collier complete the outfit. Pearl bows adorn her hair, which has been combed out straight.

Accessories

Necklines plunged again. Sleeves became tight and

either reached all the way to the wrist or were short and combined with gloves. Lightweight fabrics and form-fitting cuts no longer allowed for pockets in women's clothing. Instead, women carried little purses, called "réticules" or "ridicules." These were fashioned from wire or cloth, in a great multitude of fanciful forms—in basket form or heart-shaped, among others. Shoes were small, delicate, and pointy, with either flat or no heels. Around the turn of the century, shoelaces were introduced and popularized; these could be tied all the way to the knees (similar to the toe shoes worn by ballerinas). White was the preferred color, but many shoes also came in canary yellow or some other "pretty" color.

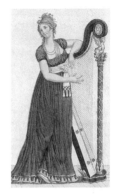

The woman with a harp is wearing the highly fashionable color black, and a "headdress of hair:" i. e., neither hat, bonnet, or scarf.

Among the novel fashions of the late 18th century were so-called "spencers," named after the English Lord Spencer. These were short, tight, bolero-like jackets with or without sleeves. The *fichu*, a triangular scarf worn over the bosom, was no longer used to cover a lady's cleavage; instead, it was used to "accentuate the female allure," as the *Journal des Dames* claimed. It might also be wrapped around the body into an arrangement that looked something like a cross between a belt and braces, as illustrated in the picture of the lady with a small turban and her lorgnette in her right hand. The belt, an essential component of the lady's ensemble, was usually made of colorful ribbons. How these were tied and how the ends were left to dangle was constantly changing. How well a woman tied her belt was indicative of her fashion competence.

Cashmere riding costume. The French dubbed it the "Amazon," since the style closely resembled the male version.

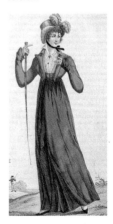

Instead of a coat, women wore a large cashmere scarf, as in the portrait of Madame Récamier; later, paisley scarves came into vogue. Draping the scarf became a form of art, so to speak, and was described in great detail in fashion magazines. In fact, how a woman wrapped her scarf even came to indicate her status: Decent women knew how to wear their scarves correctly. In February 1805, the *Journal des Dames et des Modes* announced that while all women

Turban with loose ends and spencer in Algerian style; in addition, the lady is carrying a basket-shaped handbag. Handbags were highly fashionable.

wore scarves (or shawls), not every woman knew how to wear one correctly. The *Journal* also explained that "when an elegant woman appears to sit down casually, it is actually mere affectation. Watch her carefully and you will see that the way in which each fold of her shawl and skirt falls is premeditated. This is known as the art of presentation and is one of the most skillful accomplishments in contemporary dress. Our women drape their dresses everywhere—at balls, paying visits, in the theater."

Women—that is, married women—wore a lot of jewelry, especially necklaces. Young girls, however, were not supposed to wear jewelry; at most they might wear a flower in their hair and a ribbon around their waist. The general view was that a young girl's natural appearance was her most valuable asset. Women carried fans (at least with evening dress) in her hand, small corsages, or even lorgnettes; the latter were a fashion accessory and had little to do with the bearer's eyesight.

François Gérard, *Madame Récamier*, 1802.

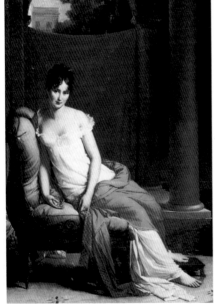

Turbans were the most popular form of head covering. Wrapped in different manners, and decked with different decorations, the compact turbans were the antithesis of the sweeping hats of the pre-revolutionary period. Early styles covered the entire head; later versions sat on top of the hair, which was therefore

visible. Turbans remained fashionable for several years and were appropriate for all occasions, even for evening dress (which at that time differed from daywear only in the materials used and not in actual form). Around the turn of the century women wore jockey hats, which might be described today as rather "sporty." These caps were like helmets with a brim; they vaguely resembled the modern baseball cap, but were usually overdraped with a veil. In 1798, the *Journal des Dames* announced that poppy-red was the ultimate hat color, much more popular than green or sky blue.

The *Journal des Dames* noted with a degree of regret that hair, instead of being combed, was now casually tousled with the hands. Earlier generations had spent hours of time and vast pools of creative energy styling their hair and donning complex hat formation, but "today's woman takes her hat, puts it on her head, ties the ribbon under her chin, glances at herself in the mirror, and is off in her carriage in a flash."

Hairstyles also became smaller. The happy

Tunique de bal—ball gown, 1802, worn with a tiara of roses.

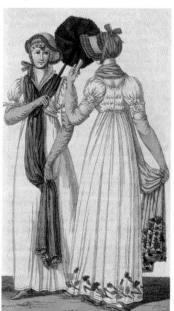

Scarves—or large shawls—came into fashion at the beginning of the 19th century. A great deal of skill was required to drape them correctly for different occasions. These two women are wearing them around their necks. Note the color contrast between the scarves and the embroidery on the dresses. To our eyes they no longer harmonize. Ladies always carried parasols when out walking. The woman on the left is also wearing Medici trimming and walking shoes; the other is wearing "normal" shoes.

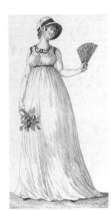

Lady in jockey hat with a modern—"tousled"—hairstyle, 1798.

medium was considered "natural"—not too much, not too little. A shaved head was just as unnatural as a head of excessive, stacked curls according to the fashion magazines of 1798. The English women were repeatedly held up as paragons. Even so, natural hair was still not considered stylish; wigs or hairpieces were preferred. A lot of oil was applied to hair in order to separate it into pretty strands. The hair color was changed over the course of the day; in the morning, elegant women chose blond. For gala evening events, black or mahogany was preferred. Even the highly fashionable "Titus" style, where the hair was cut evenly and strands were combed onto the face, a wig was worn over one's own hair, which was usually considerably longer. According to the *Journal des Dames et des Modes*, wigs in 1802 were so light and well made that they could hide even the

Fan, around 1800.

"biggest and thickest head of hair" without making a "big bulge."

The July 19, 1802 issue of the *Journal* described in detail the fashionable head decorations for women: "Three types of head coverings are almost equally popular: the 'Titus' style with its whole mass; the pointy veils, which completely cover the hair, and the half-'fichu,' which sits on the head and tightly pushes in the cheeks. It is tied under the chin. Next come coverings with braided hair, fastened with a comb or hairpin, and 'paysannes' of lace worn very far

The woman is wearing a white dress and scarf, which was then highly fashionable. Known as "half-*fichu*," it pushed the cheeks in tightly and was tied under the chin. On the hat stand in front of the lady is another fashionable headpiece from 1802.

forward, black straw hats, and bonnets *de fantaisie* of white satin."

Men's fashion

Regarding the male clothing, the *Journal* averred on July 26, 1802: "Many young men wear leather breeches and boots with yellow cuffs. some, being particularly elegant, have gold buckles on their shoes. Clothing is still blue, brown, or black. Black breeches, breeches, and long pants of nankin, are all equally common. *Jabots* with rounded folds are still in use. Round hats are somewhat coarse-haired and have one, two, or one-half-inch wide brims, together with a five-inch head, which is wider on the top than on the bottom; the hat string is very narrow."

Men's fashion was similar to women's fashion in several respects. Simple, single-colored fabrics were preferred. The waistline had moved upward, and the impression of nudity—which also characterized women's fashion—was reinforced by the skin-tight pantaloons, visible up to the waist; these were worn with very short vests and jackets, open in the front. Men who did not have ideal figures stuffed their calves or thighs with padding. Occasionally, two or three vests—successors to the doublet and forerunners of the modern sleeveless waistcoat—were worn over each other, some with long sleeves.

The new styles were believed to hark back to antiquity; this illusion was supported by the "Roman" Titus hairstyle. As with the women's dresses, however, there was really nothing very antique about the fashions. Men wore very novelly styled neckties, some of them so thick that they had to be supported by small

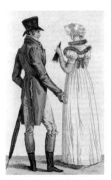

The lady is wearing a satin scarf with marten-fur edging. The gentleman's hair is cut short at the back, but is long in front. Under his coat, we are told in the description, he is wearing a pink waistcoat with a black diamond pattern and a white vest. His boots have fashionably upturned gauntlets.

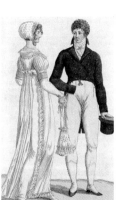

Women's and men's fashion taken from the *Journal des Dames et des Modes*, Autumn 1802.

cushions. Jackets and vests had upright collars, sometimes so high and stiff that a man could not move his head. Collars were frequently embroidered. Men no longer wore rapiers for decoration; these were replaced with elegant walking sticks. The French poet and novelist Honoré de Balzac (1799–1850) was a walking stick enthusiast and is reputed to have spent a fortune on them.

After 1820: Men's fashion and fops

One style swiftly superceded the next in the "natural" and "democratic" fashions of the decade after the French Revolution. Contemporary paintings reflected this trend. Fashion soon regained its decorative and opulent quality; forms became so exaggerated that, even with the best intentions, they could hardly be considered natural. These changes became especially apparent around 1820; this was the beginning of the period known as "Biedermeier," drawn from the stilistic influences prevalent in Germany. Men's fashion by this time had arrived at the classic form that has persisted, with some small variations, through our own time. One variation that came and went along the way was laced corsets, which both men and women wore to reduce their girth and give them the appearance of a smaller waist. The predominantly respectable but nondescript character of men's clothing meant that each new fashion could only distinguish itself from the last by simplifying it even further: Fine distinctions of fabric quality, workmanship, and cut now became more significant. About this time, a new variation on an old theme among fashion types appeared:

The gentleman is wearing a blue jacket and grey-green trousers, and carries a walking stick.

the "dandy." Dandies had been around since the English Restoration drama back in the late 17th and early 18th centuries—then they were more commonly known as fops. Dressed to the nines, they exhausted their intellect on witty *repartée* and shallow philosophy, much along the lines of the Englishman Beau Brummell (1778–1840). The 19th-century dandy still lived for elegance, but unlike his predecessors, was never conspicuous; or if he was, then only by dint of his exaggeration of current style. He hired the best tailors and wore the most perfect cuts and the finest fabrics. His necktie was always immaculate and his behavior impeccable. The dandy believed himself to be imminently superior to the trivial bourgeois world and its mundane routines. Around the turn of the century, French poet Charles Baudelaire (1821–1867) declared the dandy to be a phenomenon of political and social change.

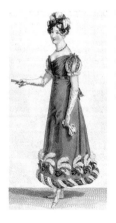

On account of its heart-shaped form, the bodice of this dress was known as *à cœur*. The lady is obviously about to go out. Dresses have become shorter, and the skirts less tight.

The Biedermeier period

Women's dresses again became shorter and somewhat stiffer. Trains disappeared completely, and the hem of the skirt formed a perfect circle. Hems were reinforced with ruffles, piping, or other ornamentation that held the skirt away from the body rather than letting it fall softly to the wearer's foot as in earlier decades. The waist was still relatively high, but was beginning to migrate downwards. The fitted top took on a characteristic heart shape, known as *à cœur*, very narrow at the waist and opening out wider toward the shoulders. This was emphasized by the corset, which was once again popular, as well as by the fuller skirts and sleeves. The corset was often pleated horizontally,

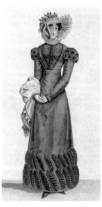

Fashion has already begun to repeat itself: This dress boasts a Spanish collar, reminiscent of the 16th and 17th centuries.

93

1820: The costume consists of a red cropped jacket and blue skirt.

which altered the shape of the *décolletage*: Now it was lightly curved and higher than before. Visible cleavage was increasingly reserved for the evening; during the day, women wore dresses with high necklines. Sleeves were puffed at the top and trimmed with ruffles.

Large collars were again popular; the underlying intention here, as with sleeves, was to suggest the fashion of the Renaissance. The Medici collar became fashionable again; even the Spanish neckruff could be seen. This was both fashionable and practical: It brought back a modicum of modesty, which, after the forwardness of the turn of the century had now come back into vogue. Times became steadily more prudish through the middle of the century.

Right: Around 1830 the change in basic style is unmistakeable. Opulent hair styles make the head appear larger, shoulders have sunk lower and are emphasized with puffed sleeves. The skirts are wide with crinoline to help them stay in shape.

Left: In 1831 cape-like pelerines have been added to the coats to pad out the slanting shoulders. Capote hats have come into fashion.

Women's collars often had cape-like pelerines, which fell over the shoulders. Scarves went out of fashion for a time, though they would make their comeback in the following years.

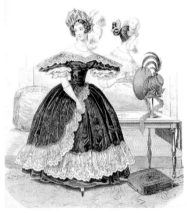

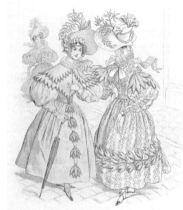

Caricature of the laced bodice, 1828.

Mid-century

During the following years, sleeves became larger and larger, and skirts wider and longer. Sleeves were at their fullest in the 1830s, and then shrunk again. But while they were at their fullest, they reached literally monumental proportions, often doubling or even tripling in fullness. A popular style was the "muttonchop" sleeve: The tops of the sleeves slid down over the shoulder, rather than being inset, and the shoulders slanted downwards, giving the impression that the woman's neck opened swan-like into her arms. Broad shoulders were considered coarse, as was tan skin. Paleness was considered attractive, and women were supposed to look delicate, even sickly. Under no circumstances was a woman to appear vigorous or robust. Women were also often the victims of fainting spells—a natural consequence of their tight corsets, constricting their ability to breathe properly. However, since the women who wore these unnatural bindings were hardly expected to move at all, the corsets were in general bearable, much the way spike heels are bearable for women who don't spend much time on their feet. So far as period footwear went, ladies wore delicate silk shoes tied with ribbons like ballet slippers; these were ill-suited to walking on the

Festive dress and town attire, 1843.

footpaths of the day, just as modern women's dress footwear may be to walking along city streets.

Corsets, together with many underskirts and horsehair padding, forced the body into the hourglass figure that was characteristic of the time. The waist was again cinched to a wasp waist; the silhouette then widened out dramatically toward the top and the bottom. Day wear still called for high necklines; evening wear was cut straight across the chest, leaving the shoulders bare, though the bosom was still not visible at all.

Hair and hats

Hairstyles in the Biedermeier period were highly imaginative, though the fashion for fanciful coiffure only lasted briefly. Most popular in the 1820s and 1830s were curls above the ears or on the forehead, adorned with feathers or flowers. Somewhat later the hair was smoothed back and pinned up, allowing at most a few stray curls to fall to the side of the cheeks. Braids were sometimes rolled into buns over each ear. And people wore their own hair, not wigs, and decorated it with flowers or lace.

On their heads, women wore the *capote*, or poke bonnet. This had an almost vertical brim which resembled blinders and did in fact severely restrict the woman's peripheral vision. The poke bonnet had a soft crown that framed the woman's head. Made of fine straw or sometimes taffeta, these caps lent themselves to rich decoration with flowers, ribbons, and all kinds of trinkets. They were tied under the chin with a wide ribbon. Around mid-century the *capotes* became

Right: Town overcoat; left: Imaginative formal dress suitable for receiving guests, with a velvet Renaissance cape edged with lace and matching fingerless gloves (*mitaines*).

smaller again, but still remained the most important type of hat next to the standard bonnets. These became tremendously popular, being relatively simple and modest in design. Coats, capes, and especially shawls were also worn again. The latter could easily be draped around the woman's full attire, even over enormous sleeves and skirts.

Gentleman in a coat, 1820.

Bourgeois gender imagery

Colors as a whole tended to be dark and monotonous. The overall impression was one of completely covered, decent, gentle, delicate, and modest women of leisure. A new image of femininity arose, and even fashion assumed a different social function: No longer an aristocratic phenomenon, it moved into the ranks of the middle class.

19th century paintings help to trace the increasing simplicity and functionality of men's clothing after the end of the 18th century. After the French Revolution, however, women's fashion constantly abandoned simplicity in favor of ever-changing extravagance and ornamentation. Ever since, fashion has been predominantly the province of women, and men's general dress has changed little. Men seemed to pay little attention to such frippery; they occupied themselves instead with life's "serious" matters, while women apparently had little else to do but transform themselves into objects of beauty, frittering away their lives on such superficialities as fashion. This conviction had its roots in the socioeconomic changes of the 19th century and the industrial revolution. The function of the aristocracy as social icon was dying out; the new values of the working bourgeoisie now dominated: diligence, acquired wealth, social climbing, and education.

Ball gown of pink silk, topped with ruffed green tulle. According to the picture description, this dress could also be produced in two tones of the same color, or in pastel coloured tulle over white silk; but two colors or tones were always required. The evening dress on the right, from 1843, appeals through the rhombus-shaped cuts on both sides, through which the white satin petticoat can be glimpsed. The cuts are buttoned together with engraved gold buttons.

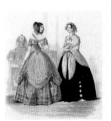

1851
First World Exhibition in London (Crystal Palace)
1852–1870
Emperor Napoleon III and Empress Eugénie
1858
India becomes a British crown colony
1859
Charles Darwin: *On the Origin of Species by Means of Natural Selection*
1860
Italy unified
1860–1865
Abraham Lincoln is president of the United States of America
1865
Mendel elaborates the laws of hereditary
1870/71
Franco-German war
1890
Bismarck dismissed
1899
First Peace Convention in Hague
1899–1902
Boer War in South Africa
1900
Sigmund Freud: *Interpretation of Dreams*

New types of work

Along with industrialization and the spreading middle class, working conditions in the cities (which were growing larger and more important in both Europe and America) were being fundamentally transformed. Where craftspeople had once worked from home or from small shops, production now assumed mass proportions and shifted to factories and offices. Only farmers remained relatively close to their workplace. Now, men went out to work to provide for themselves and their families. Women— responsible for housework and raising children— stayed at home. The consequences for working women were different to those for the better-off women of the middle class. In light of their husbands' low wages, working-class women were also required to earn money in order to feed their families. However, since they were more or less shut out from public life, they had few options, except for becoming maids or other to work from home for terrible pay. Consequently, they became increasingly impoverished.

Clothing manufacture at home and in factories

Typical women's work, which could be done from home included tasks such as needlework; jobs were assigned by so-called middlemen, who in turn received their orders from clothing manufacturers. Most women worked as servants, but the second most common occupation for women was in clothing manufacture, followed by the textile industry. Off-the-rack clothing had been available for a while, but was not yet wholly produced in factories, and there was still demand for handiwork done by women in their homes for low wages. Almost all women could sew anyway, so no special training was necessary; this, of course, did little to enhance the prestige of the work.

In 1851 Isaac Singer patented the first Singer sewing machine, which was the first model to be

widely produced and sold. Many women bought them to keep pace with the competition. The sewing machine was not directly responsible for the growth of ready-to-wear (*prêt-à-porter*) clothing—which had been available since the 1830s—but it did contribute to its meteoric take-off. The socioeconomic impact of the sewing maching was in many ways just as significant as its impact on the course of fashion. Machines were often bought on installment plans, driving the women into debt. They served to isolate women even more, virtually tying them to their workplace.

The alternative to cottage industry was to work in a tailor's studio or in a textile factory. Textile production became strongly industrialized in the 19th century. By around 1860, for example, knitting machines had replaced the old knitting stools. The new machines could produce very fine and elastic textiles, such as silk for stockings or fine gloves (although these still had to be cut out and sewn together; the circular knitting machine, which also allowed the production of seamless stockings, was not invented until the 20th century).

Most of the women who worked in factories were young and unmarried. Married women were more likely to work at home, which allowed them to continue caring for their families. Around mid-century, women began to be hired as salesladies for the women's clothing sections of the new sales phenomenon—the department store. In the department store, female employees were valued for their ability to serve rich customers in a modest and helpful manner. Of course, corporate and managerial positions, even on departmental level, were still held by men.

In short, the clothing and fashion sector employed a significant number of women, exceeded only by the service sector. A typical working day lasted at least twelve hours, sometimes fourteen or even more, and the working week was six, sometimes seven days (the

latter was especially likely in cottage industry). Children were often enlisted to help the women, especially those working from home—though they were also employed in factories. Their labor was carried out in unsafe environments, in ill-lit rooms with little or no heat or ventilation, in short, the classic "sweat shop," and they were so poorly paid that they could barely keep their heads above water. To wear the fashionable clothing they produced was definitively impossible.

Women in the bourgeoisie

For the wealthier families, the separation of the workplace and the home had different consequences. Wives were relegated into status symbols for their husbands: they were to be his most beautiful possession. Men no longer necessarily tried to demonstrate their wealth or status through their own attire. Instead, they exhibited their wealth by dressing their wives splendidly. The wife's clothing needed to show that she herself did *not* work; accordingly, dresses from this period allowed little movement and were too restrictive for any activity beyond small walks. The more beautifully a woman dressed, the more her husband was envied, since his wife was a showpiece for his wealth. Thus, women were reduced to mere luxury objects; the world of power and influence belonged uniquely to men. In 1899, sociologist Thorstein Veblen coined the term "demonstrative consumption" to describe this phenomenon.

As a result, high fashion became even more extravagant in the 19th century. And it

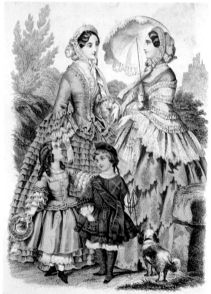

Ladies in walking dresses, with children. The little girl is wearing a short dress, and her pantaloons are visible beneath. The boy, being too young for trousers, is also wearing a dress.

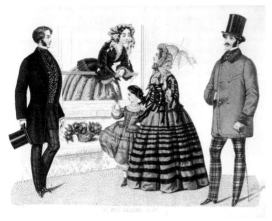

Outdoor clothing, 1853. The clothing style stresses the upper half of the man's body, from the waist up, whereas the sweeping skirts clearly lead the eye to the lower half of the women's bodies.

changed with lightning speed, since one constantly had to outdo others—and this could only be done via the use of surprise and novelty. Meanwhile, men's clothing became increasingly simple, more serious, and very dark; men had nothing to prove. Women were believed to be superficial, fickle, dumb by nature, and incapable of earnest cultural achievement. Thus, fashion seemed to be an appropriate pastime for them. To dress well and to be the bearer of fashion became in a sense a woman's most important function in middle-class society. Thus, what was in fact an artificial social custom was reinterpreted as a direct expression of some natural law. Of course, a critical look into fashion history would have readily revealed that no such natural law existed; but prejudiced study of the past seemed to confirm that there were fundamental biological, psychological, intellectual, and anatomical differences between the sexes, and men and women were now viewed as being two distinct species.

The genesis of *haute couture*

The industrial revolution brought with it increasing specialization. People were no longer competent in everything as some had been during the

Bathing costumes in 1860 were still made with a great deal of fabric.

Renaissance. Each person carried out specific assignments. An obvious example is factory work, which divided each operation up into a series of smaller tasks. Each small task was carried out by one worker, who performed only that task. The worker did not even need to know what the final product would be. This specialization, of course, was not confined to factories—it characterized all of modern industrial life.

The bourgeoisie, new to wealth and social influence, was not considered as having infallible taste, as the aristocracy had been accredited with. On the other hand, the middle class was looking for its own style, while on the other hand it was competing with the nobility. The upshot was a kind of specialization. Matters of fashion were now delegated to a new corps of specialists: One would be hired to decorate the home tastefully; another was responsible for acquiring proper artwork; a third would advise on fashionable dress.

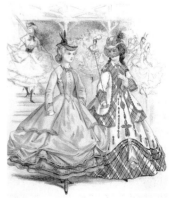

It was under these conditions that the profession of the *couturier*, as an autonomous creator of original ideas, emerged. From this point on, fashion gained

Toilette des Eaux: In 1864, one went out walking at the fashionable seaside resorts in order to see and be seen.

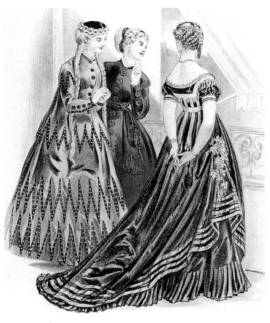

Evening and day wear, 1867.

a different face. This was, in fact, the beginning of fashion as we know it today. Namely, what this means is the coupling of style with a certain designer's name, as well as a clear separation of men's and women's clothing. At the same time, the manner in which clothes were produced changed. Women's fashion was now made by male tailors, which meant that men were shaping the ideal female. These tailors were seen as "artists," in contrast to the seamstresses, milliners, and other women who had once been responsible for making women's clothes. These had never been accorded the same respect paid to the tailors of men's fashion, and had certainly never been credited as having any artistic ability.

Now that *couture* had arrived, women continued to do the actual handiwork of clothing production but were reduced to acting as the conduit and tools of the designers. Also, fashion for women was now for the first time produced in a single house by a single

Three women in ball gowns, 1854.

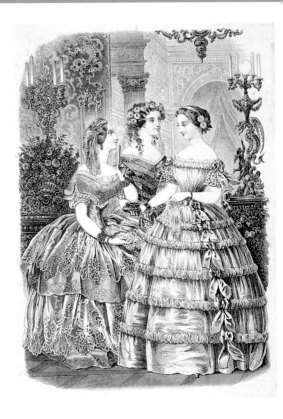

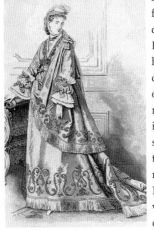

Visiting dress of embroidered sky-blue silk, seen in *Harper's Bazaar*, 1870. The decorations became increasingly more extravagant and ornate.

hand, just as men's fashion had been for quite some time. Previously, women had to buy the various components of their outfits—fabrics, lace, ribbons and flowers— in several different shops, and then have the dress made (or to make it themselves). Now, however, women were presented with a complete outfit.

Crinolines

Around the middle of the 19th century, women's fashion—now a redundant phrase; women's fashion was the *only* fashion—became more lavish. Skirts were so wide that two women could barely walk side-by-side. In his novel *Nana*, French author Emile Zola observes that when two women conversed (for example, in the theater), they blocked the way so that no one else could pass. This was not mere hyperbole. A skirt could literally be as much as thirty feet around, supported and reinforced with countless underskirts and horse hair padding. (The word crinoline is derived from the French word for horse hair, *crin*.) Women dragged so much weight along with them that the invention of crinolines and steel hoops, however burdensome they may seem to us

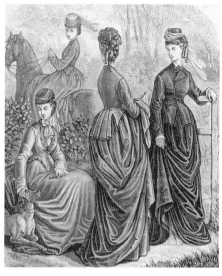

Riding costume for women was adapted from the men's fashions. In contrast to the lavishly decorated gowns for other occasions, it was remarkably simple.

Folgen des Schnürens. Druck auf den Brustkorb.

People were convinced that the corset altered the female anatomy irrevocably. This picture is taken from a schoolbook for anatomy and hygiene, from around 1900. Interestingly, the corsetted woman has an elegant hairstyle and dignified facial expression, while the woman of the left wears her hair loose and smiles amiably.

Two dresses, 1875.

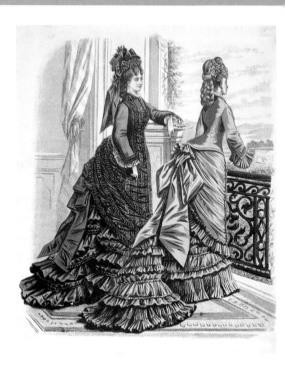

today, was in fact a huge relief. Women finally regained some leg room and were no longer encumbered by heaps of fabric and horse hair. The crinoline was considered very progressive; unlike its predecessors from the 18th century, it was light and flexible. The result was that skirts became even wider, and were embellished with even more ruffles.

Silhouettes

While women's skirts became wider and more voluminous, the waist became narrower. Women laced themselves up mercilessly in order to achieve a wasp waist, which was an essential element of looking good in these sweeping skirts. A popular fashion was the pagoda sleeve, which was tight down to the elbow and then sprang open in a cone shape. It was worn over a visible white undersleeve often held in place and shaped by wire hoops. In these

costumes, women looked more like dolls than living beings. Only their upper bodies were discernable, and even those looked very artificial after being forced into excruciatingly tight corsets. Small hats or bonnets were usually worn, including the poke bonnet, which was still in fashion.

The female silhouette on the whole looked like two bowling pins stacked on top of the other. The lower body was nothing but a huge base with neither legs nor hips visible, and yet somehow unmistakably evident. This was nothing new in the history of women's fashion. Precisely this concealment lent these huge skirts their seductive quality; what was meant to be hidden became the object of men's fantasies, making it that much more enticing. The giant skirts' appeal was further heightened by the unpredictable mobility they allowed. It took enormous skill to be able to move in such a hoop skirt, much less sit down without the frame flipping up and exposing the lower body for the world to see.

According to fashion historian James Laver, the hoopskirt was hardly the decorous piece of clothing it claimed to be, although this image stays with us until today. To us they appear unbearably static and stable, but Laver vividly describes crino-lines' incalculable quality: "A crinoline was constantly moving, thrown from one side to the other. It was like a restless captive balloon and in no way, except in shape, resembled an Eskimo igloo. It swung from side to side, then tilted a little upward, or swayed forward and backward. Every bit of pressure exerted on one side of the steel hoop would be transferred to the opposite side by its elasticity, and the skirt often shot into the air. This was probably the source of Victorian men's hangup about ankles, and certainly one reason for the new boot fashion." Instead of flat-heeled ballerina

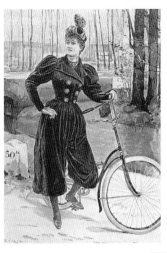

1894: The daring woman wears trousers to go bicycle riding.

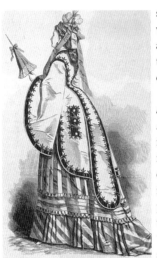

1872: Women wore such dresses for riding out in their carriages.

slippers, women now wore laced, heeled ankle boots with their hoopskirts and crinolines.

Amelia Bloomer

Amelia Bloomer fought the hoopskirt fashion and unsuccessfully tried to introduce the first pants for women in the mid-19th century. "Bloomers" were ankle-length knickerbockers, worn with a straight cut, knee-length dress. Amelia Bloomer and her reform attempts were derided, but largely because people were apprehensive; if women started wearing pants, the patriarchy surely would crumble, feared men. Pants, even the bloomers (which scarcely resembled the traditional male cut of trousers), were synonymous with men's power, and therefore could not be tolerated on women at any price. It was only toward the end of the century that the more courageous women begin wearing knickerbockers for riding bicycles.

Self-restraint

A teenage novel, published in 1863, shows just how much fashion served to domesticate the female body and soul and bind it in such a way that women had no choice but to act in a civilized manner. Clementine Helm's *Teenager's Sorrows and Joys* tells of a sixteen year-old country girl who goes to visit her aunt in the city in order to acquire a good—that is, urban—lifestyle. For the first time in her life, she learns to be orderly and decent and takes this to heart so strongly that she can no longer live any other way. This began

with personal hygiene, trivial as it may seem to us today. The country girl had always washed her hands in the morning and rubbed her face with the corner of a wet towel, but now her aunt/mentor teaches her that she must wash her nape, neck, and entire face with soap and sponge. The washstand and basin was incidentally in the bedroom which the two shared, and not in a separate bathroom. The young girl also brushes her teeth for the first time in her life.

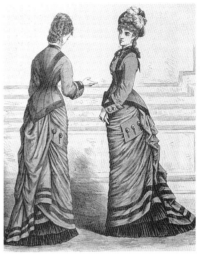

Next, she had to braid her hair neatly instead of just tying on her morning bonnet and stuffing her hair up under it. Instead of throwing on her comfortable morning robe, which according to the aunt was reserved for illness, she ahd to dress herself properly. This entailed lacing and hooking clothes in order to give the body the upright, stiff posture that precluded any slackening. And, finally, she was to wear tight, firmly laced boots instead of her comfortable slip-on morning shoes. Only in this "civilized" outfit was she a pleasant sight to onlookers; only now could she face her day. This proper clothing, so the author implies, resulted in proper behavior; girls should always behave in perfectly modest and proper manner. They should never over-do things and should eat, drink,

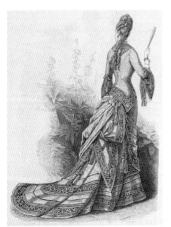

In 1876, the female silhouette had slimmed down, and the sweeping skirts had been gathered into a *cul de Paris* at the back. The upper half of the body was still very slender. The large, decorative buttons on the side of the dresses are supposed to attract attention. The dress is designed as a "strolling dress" and at the time, according to *Harper's Bazaar*, was very popular as daywear.

Visiting toilette, 1876.

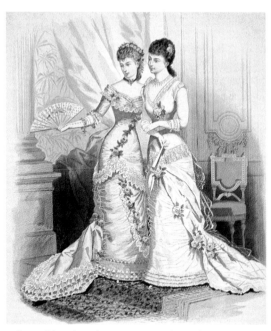

Ball gowns, 1879.

talk, and laugh with restraint. In short, they were to curb spontaneity and control themselves constantly. A picture of graceful and modest charm resulted, but the supposedly "natural" femininity was the product of a strict upbringing and had a lot to do with fashion. These, we must remember, were the ideals to which the middle class aspired. Young women from the aristocracy might be forgiven certain shortcomings in upbringing on account of of her social class (and prospective dowry); they were allowed to indulge in a certain amount of coquettishness and fickleness. Indeed, these characteristics were even considered to have a certain charm, though they would have been utterly inappropriate for young bourgeois women.

Change in forms
In the 1860s skirts became somewhat shorter and were gathered so that one could see the underskirts, providing more opportunity for fine embellishment. Crinolines became smaller. The focal point of the

female figure slowly shifted toward the back; the crinoline became a bustle consisting of horse hair padding on the lady's bottom, over which the skirt was gathered and opulently draped. Skirts were now often made from two contrasting fabrics. The top was also often a different color so that the overall impression of drapes, folds, pleats, and different colors must have been quite confusing.

The hairstyles corresponded to the woman's overall profile: Piled high at the back of the head, they were fashioned imaginatively out of a combination of hairpieces and real hair. On top of the tower of hair sat a relatively small hat; this was originally set toward the back, but slid forward in time until it finally rested almost on the forehead. Clothing was always high-necked during the day, in summer as well as in winter. A low *décolletage* was only allowed in the evening, when it was essential.

Visiting gown made of velvet and silk with fur edging, 1873.

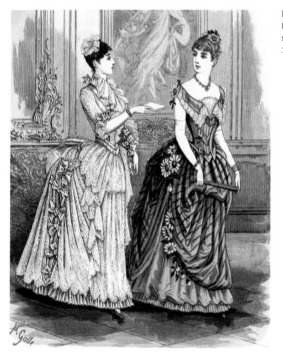

Left: Society gown with lace; right: Ball gown of silk gauze and tulle, 1886.

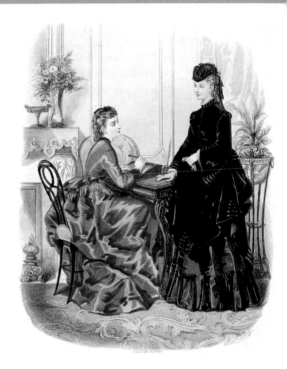

Mourning dress.

Left: summer visiting gown; right: walking dress, 1884

In the 1870s silhouettes became temporarily slimmer, and the bustles receded until they actually disappeared completely. The front became straighter, flatter, and longer; it now reached down to the hips and was tightly tied. The skirt ended in a train.

Bustles returned at the end of the 1870s, but the horse hair was replaced by a flexible wire structure that could even be folded up when the woman sat down. The *cul de Paris* no longer created a soft, flowing line; instead, it formed a very abrupt, almost 90-degree angle at the back. Trains disappeared and the overall impression was less fluid.

Demimondaines as fashion trendsetters

French author Marcel Proust describes one of his heroines, the *demimondaine* Odette de Crécy, who rises to be one of the most prominent ladies in her society thus: "Her body, which was admirably well-formed, could

Folding fan, ca. 1895.

only be imagined in its entirety with great effort. (This was due to the prevailing fashion, for she was one of the best dressed women in Paris.) Her waist bulged over the fictitious looking stomach panel of the dress, which ended in a sudden point; below this, sea of skirts surged forth. The woman looked as if she consisted of several ill-adjusted parts: ruffles, flounces, and vests, each followed their own whims. The line thus created led to bows or lace trimmings or slid down the front of the waist without any guidance from the living body, which, depending on how tight or loose the fabric was, either seemed imprisoned or detached."

Such passages illustrate how the fashion of the time rejected the natural body and how it actually strove to create new forms that would captivate through their own shape. The fact that Odette de Crécy was a kept woman is especially interesting in the context of fashion history. In the second half of the 19th century, a number of *demimondaines* were fashion trend-setters. They were audacious enough to experiment with fashion—which the more respectable women in society avoided doing—but also their appearance was their greatest asset. If they were to be kept as mistresses by wealthy men, they needed to look as spectacular as possible. *Demimonde* and fashion have been inextricably connected since the 19th century—an often secret side of the bourgeois world. Society women imitated the fashions initiated by the *demimondaines*, and thus fashion became a point of indirect contact between the different realms.

James Tissot, *Chic Society*, 1883/1885.

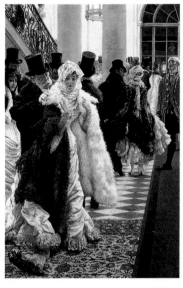

Charles Frederick Worth read the writing on the wall—his foresight showed him the potential of fashion. Not content to remain a nameless, undervalued businessman who visited clients at home, he had his clients come to him and made it clear that he was doing them an honor by selling them his creations. He even turned away several female customers, making himself only the more highly sought-after. He created his own special image, which he used cleverly to market his extraordinary talent; and by the second half of the 19th century he had successfully overhauled all his competitors as dictator of style. Worth thus attained a social standing unheard of by any tailor before him. He was no longer

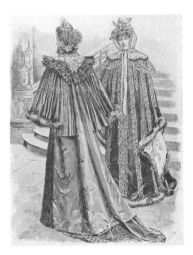

Coats for both driving out in carriages and for evening events (1894). The left one is made of black satin, with marter fur and Guipure edging; the coat on the right is embroidered from top to bottom.

Afternoon gown by Worth, 1897.

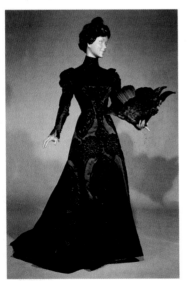

a mere craftsman, but an artist who created original works of art and signed them with sewn-in labels.

Worth was born in England in 1826 and died in 1895 in Paris. His heirs maintained his house until the 1950s. Originally a fabric salesman, he went to Paris in 1845 and worked in the Gagelin fashion house. Here he introduced his own designs, winning a prize in 1855 at the world exhibition. In the late 1850s he opened his own house. Worth was responsible for dressing Empress Eugénie, who was considered the epitome of fashion in her day. He also worked for Queen Victoria, the nobility, the wealthy bourgeoisie, and even the *demimondaines*. It

was considered refined to be dressed by Worth.

In truth, Worth was an ingenious clothing artist. He is credited with a plethora of innovations. When the crinoline craze was at its peak at the end of the 1860s, he created a new line that took off like a rocket—dresses that were flat in the front and gathered in the back. Ten years later, he again altered the silhouette dressing women in big sleeves, flat fronts, and trains. The combination of traditional English tailoring with Paris chic made his fashions distinctive. In this respect, he was well ahead of his time; for even today, the most innovative fashion designers in Paris are English—John Galliano, Alexander McQueen, and Vivienne Westwood—and combine British tradition with avant-garde ideas.

Worth turned visits to his salons into special social events. He

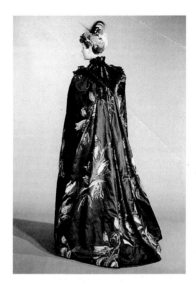

Cape by Worth, 1890.

designed whole collections from which his customers could select their wardrobe. This was a completely new concept at the time. He was among the first fashion designers to use live mannequins to model his designs. One of these "mannequins" was his wife Marie Vernet, who significantly contributed to Worth's success. Worth's creations had their own signature style, and they had glamor. Even today, when one looks at them in fashion museums, they exude an unrivalled, glamorous quality.

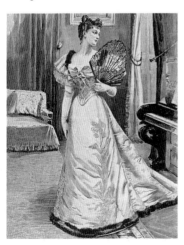

Evening gown by Worth of sky-blue satin, embroidered with pearls and edged with fur along the bottom hem and on the shoulders. The woman's hair is simply styled and she carries a black folding fan.

1900
Nobel prize established; Max Planck expounds radiation laws
1901
Thomas Mann: *Buddenbrooks*; anthroposophy movement started by Rudolf Steiner
1903
Gertrude Stein moves to Paris and commences work on *The Making of Americans*
1905
Einstein begins work on his later theory of relativity; revolution in Russia
1908
Pablo Picasso and Georges Braque start Cubism
1909
Russian Ballet in Paris for the first time
1912/1913
Balkan wars
1914
Panama Canal opens
1914–1918
First World War
1917
Salzburg Festival installed; Bolshevist revolution in Russia
1918
Max Planck receives Nobel prize for physics; Oswald Spengler: *The Decline of the Western World*

Modern revolutions

The 20th century is the undisputed era of fashion. In our time fashion has become a mass phenomenon, from which people in the industrial nations can no longer escape. Modern silhouettes are fundamentally different from those of earlier centuries, and change has come at an unprecedented and once unimaginable speed. The 20th century has produced the most significant fashion revolutions: pants for women, the renunciation of corsets, miniskirt, sport fashions. According to many fashion historians, women's fashion finally became "modern" in the 1920s. It managed this by adopting the hundred-year-old guiding principles of men's fashion: functionality, apparent simplicity of form, and a well-considered structure that dispensed with further decoration.

Of course, the fashion of the 20th century has repeatedly imitated the fashions of the past; today, this is truer than ever. Fashion in the 1990s thrives on the interplay of current and past styles, just as do modern literature and art. Fashion recycles; and by recycling, it creates something new. The most radical changes in fashion, however, took place in the beginning of the century. During this time, revolutionary new fashion silhouettes showed men and women in a completely new light.

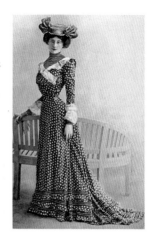

The liberation of the female body

Women's fashion underwent the greatest changes. By the beginning of

Daywear by Redfern, from *Les Modes* magazine, 1901.

the 20th century, women were far more likely to be found in public—participating in sports, traveling, working, and just plain out and about. Their clothing accordingly became (or appeared to become) more functional. And this functionality brought with it a new conceptions of beauty. Increasingly, simple lines were considered beautiful and seductive. Extravagant outfits were considered less and less elegant. Fashion become more form-fitting; dresses were increasingly worn without corsets or padding over the buttocks or hips. At least, this was generally the case, though there were times, such as during the fifties, where this female body "armor" enjoyed a resurgence of popularity. Still, in the early decades of the 20th century, women's fashion broke free of many of its constraints.

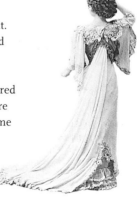

House dress, 1901.

The corset did not, of course, disappear overnight. Certainly, by the turn of the century, clothing reformers were pleading for their abolition; they disfigured the female body terribly, even to the point of posing a health hazard. The initial alternative to the (now) "ugly" fashions requiring corsets was the unshapely sack dress.

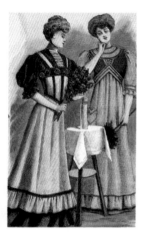

This, however, was seen as being rather ridiculous, and did not catch on properly. In late 19th-century England, designer William Morris also strove to get rid of the corset as part of the anti-industrial Arts and Crafts Movement, of which he was a founder. At the beginning of the 20th century, nouveau

Aprons for home and serving, 1906.

artists like Henry van de Velde and Gustav Klimt pleaded for a sensible, hygienic redesign of the corset in the interest of comfort; this, they believed, would necessarily produce a more aesthetic mode of fashion. They were not in favor of completely abandoning this "torture device." Van de Velde despised the constant drive to change fashions; he believed that there was an objective, unchangeable ideal of beauty, which could be expressed with a timeless fashion.

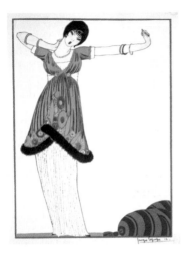

Dinner dress by Paul Poiret, called "lassitude," from the *Gazette du Bon Ton*, 1912.

Paul Poiret

The zeal of the reformers achieved little; fashion simply does not work along lines of reason. What was needed was a brilliant fashion artist whose vision could accomplish what rhetoric and fine art could not. Paul Poiret (1879–1944) was the most important fashion designer in the pre-World War One era. He not only changed fashion by creating the new silhouette; he was also the first to build a virtual fashion empire. In 1911, Poiret founded a perfume factory and marketed his own perfume, "Rosine" (launching what has become common practice among big fashion designers—by selling their own fragrances, they enjoyed the lion's share of their profits come from cosmetics). Poiret designed a workshop for the applied arts in which he produced fabrics, furniture, and other decorative items consonant with his style. He transformed fashion shows into huge social events and was the first to have his models tour through Europe and the United States. It was upon Poiret's initiative that the French union for the protection of the art of tailoring was established; its purpose was to

prevent the copying and imitation of fashion, which was rampant (as it is today). In short, Poiret had a modern business strategy and a modern marketing concept for the production and distribution of fashion. With these, he set the trend for the fashion industry of the 20th century.

Were these his only accomplishments, however, Poiret would hardly be ranked among the most significant fashion designers of the century. The honor is paid him first and foremost for the fashion styles he designed. Though to our eyes they appear extravagant, Poiret's styles were praised by his contemporaries for their innovative simplicity. Particularly the cuts of the dresses were regarded as simple; in contrast to other dresses worn by fashionable women at the turn of the century, Poiret made do without corsets or padding. He leaned toward the flowing forms of empire fashion and the antique styles. At a time when strong emphasis was being placed on the waistline and female curves, he designed clothes that were gathered under the bosom and disguised the waist. He created embroidered or transparent tunics to be worn over long dresses, kimono-style coats, harem pants, and turbans of oriental provenance—or, at least, based on the prevailing European notions of the oriental. These fashions were a conglomeration from the *1,001 Arabian Nights*, full of Byzantine, Indian, Chinese, and Russian elements.

In 1909, Sergei Diaghliev's *Ballets Russes* performed their first season in Paris, stirring up a sensational furor that reverberated in the fashion world. Vassily Nijinski, Anna Pavlova, and Ida Rubinstein were the new stars in Mikhail Fokine's choreography for *Armida, Sheherazade, Cleopatra, The Firebird,* or *Afternoon of a Fawn.* The public was fascinated by the "barbaric" Russian music and by the strange and colorful costumes and

From the *Journal des Dames*, 1913.

Fashion of 1912.

scenery, mostly designed by Leon Bakst and Alexandre Benois. Oriental fashion, perfectly suited to Paul Poiret's tastes, spread like wildfire. He translated these trends into fashion with unprecedented elegance, boldly combining eclectic folkloric elements with historical influences in a way that no other designer dared to do.

Poiret introduced bright colors into a fashion that had, in the preceding decades, sworn by discreet colors—mauve, gray, delicate blues. He used fine and magnificent fabrics—velvet, brocade, and silk muslins, often of deep red or pink, bright green or yellow, or sometimes even a delightful, intense brown. He also imaginatively incorporated gold and silver, sequins, and bright wool embroidery. In light of his colorful creations, it is not surprising that Poiret was dissatisfied with black and white photography. He hired the young artist Paul Iribe and later, Georges Lepape to make an album of wonderful fashion paintings; these later appeared in the fashion magazine *Gazette du Bon Ton*. These drawings continue to fascinate today.

Avant-garde fashion

Paul Poiret was without a doubt one of the most creative fashion designers of his time. His reputation derived not only from his designs themselves but also from his personality and self-promotion. Poiret threw glittering parties to which he invited *tout Paris*. Decades later his parties were still

"Middle Ages" dress of velvet, imprinted with gold, and with silk insets by Mariano Fortuny, ca. 1910.

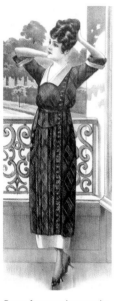

Dress for everyday wear by Arnold & Martial, 1912.

remembered as legendary. Naturally, he was not the only one who shaped fashion. He himself acknowledged that a designer could never create new ideas out of nothing and then force them on the consumer. Rather, one grasps after the spirit of the age, the *zeitgeist*, and attempts to express this in a material form. Only when one knew what women wanted, he claimed, could one become successful, and certainly not by trying to force some external form upon them.

One of the most artistic fashion designers of the early 20th century, whose financial success, however, never equaled that of Poiret, was Mariano Fortuny (1871–1949). Born in Spain, Fortuny worked in Venice and created his own unmistakable style (that has often been imitated and is still being revived today). He was inspired by the heavy brocade garments depicted in paintings from the Italian Renaissance, by Greek *chitons*, and by apparel from the Far East. Feather-light silk pleats, which made a woman appear like a Greek statue, were his trademark.

Winter fashion 1912.

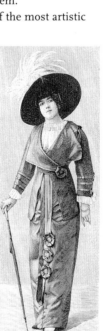

Silk jacket costume with gathered skirt and wide-collared cropped jacket; pictured in the 1912 edition of *Die Dame*. The pattern of the dress could be purchased.

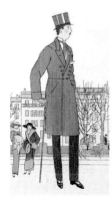

Attire for young gentlemen, 1912.

The pre-war silhouette

Jacques Doucet, Doeuillet, Paquiny, and others, working with the upper classes, helped to set fashion trends just as much as did Poiret and Fortuny. There were, moreover, countless fashion designers at the time whose names may be forgotten but who all contributed to the setting of style. They dominated the pages of the less glamorous fashion magazines of the day. These were family magazines, addressed not to an elegant, wealthy audience, but to readers who were nonetheless increasingly fashion-conscious. They offered helpful tips on sewing one's own fashionable wardrobe.

The general trend of fashion from the turn of the century to the First World War was increasingly simple, even containing a degree of austerity. But simplicity can have many facets. Dresses with ruffles and trains might be worn with stern jackets; tunics and empire dresses were seen in the company of lace-up dresses with wasp waists and emphasized bosoms. The style was, of course, always appropriate to the occasion; well-to-do, fashionable women did not wear the same outfit all day long. They owned different outfits for each time of day and for every occasion—morning wear, dresses for afternoon

social rounds, for outings, for shopping, for large dinner parties, or for intimate dining, for the theater, and so on.

Negligées and dresses for home, so-called *robes d'intérieur*, were as a rule softer and fuller than street or

House dress, 1901.

walking dresses. They were a clothing genre in their own right, and fashion magazines advised ladies not to neglect them—not only that they might please surprise visitors, but also to offer their husbands a pleasing and seductive view. These *robes d'intérieur* or "tea gowns" should under no circumstances be confused with what many people wear at home today—sweatsuits or bathrobes, for example. They were very proper clothing, meant to be seen by visitors to one's own house, though not by the public on the street nor in someone else's

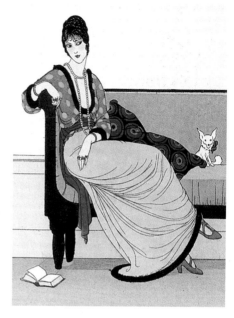

Tea-gown, 1913.

house. When making social calls, one dressed very formally; the *robes d'intérieur* were more lavish and playful. Later, certain aspects of style from these tea-gowns—and even from the more private variation, the *deshabillé*, would be incorporated into general fashion. This pattern of adopting interior styles for exterior use is still practised today. Only a few years ago,

Underwear, 1912.

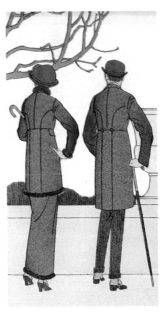

1913: The stern cut of the lady's suit is similar to that of the gentleman.

so-called lingerie dresses became fashionable; these were uncannily similar to actual lingerie. This path from the private to public sphere can be traced throughout the history of fashion.

By contrast, women's streetwear was patterend after the sterner men's wear. One- and two-piece suits became increasingly popular. Often they were distinguished from men's suits by feminine trimmings, such as decorative buttons. Under the severe jacket, the woman wore a lace blouse with an upright collar. The more avant-garde the woman, the more severe her suit, at least during the day. This is still true today. The same went for hats; they were, as a rule, still very sweeping and richly decorated. Especially notable were Poiret's turbans and the smaller caps of some progressive milliners, which set the trend for the twenties.

Evening wear continued to be magnificent. Here, deep *décolletage* was allowed; during the day, one was expected to be completely buttoned up. Dresses were long and flowed narrowly from the bosom downward. They often ended in a small train. Over the dresses, women wore furs and lace. The most fashionable shape was wide at the top and tapered toward the bottom. This, too, was a precursor of styles to come in the twenties.

Summer hat decorated with white feathers around the edge of the towering brim.

In the years just before the war, and during the war, dresses and skirts became narrower and shorter. They now showed not only the foot, but also the ankle and often even part of the calf. Two-piece dresses were common. Hats initially stayed big, but in the war years they slowly grew smaller. During the war, the pattern of women's suits and coats followed the style of men's uniforms. Overall, fashion became even straighter and lost its frills, partly because of the scarcity of fabric and partly because it was con-sidered to be patriotic to show a certain degree of modest restraint.

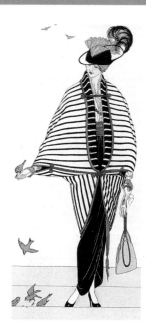

Woman in half-mourning, 1913

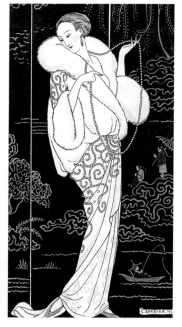

For the evening: A white velvet coat, embroidered with pearls, over a damask dress; pink shoes complete the outfit.

125

Coco Chanel was the embodiment of the twenties—in fact, she embodies the modern woman of the 20th century. Although she was no feminist, she often spoke of a desire to liberate women. To some extent, she accomplished this through her fashion and her lifestyle, which were linked inseparably. She herself was the "new" woman for whom she designed clothing.

Coco (née Gabrielle) Chanel was born in 1883, in Saumur in north-west France, in very poor conditions. As a young girl, Gabrielle

sang in provincial cafés and dreamed of a singing career; for years she lived as a kept woman. One day, one of her lovers helped her open her first store as a hatmaker in Paris; this

Coco Chanel, 1936.

marked the beginning of her fashion career. This was still before the First World War. At a time when hats were still highly adorned, Coco's simple little hats were a sensation. Her dresses were also simple; she designed and made her own clothes and was soon clothing several other society women who also wanted to dress differently from the masses.

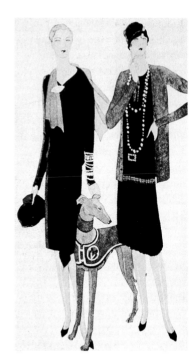

Chanel dresses in the Franch edition of *Vogue*, 1927, sketched by Misia Sert.

Coco's fashions included straight-cut skirts, long-belted jackets, simple colors, and white blouses. These were to influence the next decade. In the twenties, she developed this style further and gained worldwide renown.

Coco Chanel, unlike Paul Poiret, borrowed nothing from the past. She was inspired more by contemporary men's clothing, but instead of imitating it, she modified it into an independent, feminine style. The results were single-colored skirts combined with sweaters, slick suits, simple

shirt-dresses, and the famous "small black dress," which, however, did not become a wardrobe necessity until the fifties. White collars (reminiscent of schoolgirl uniforms), combined with costume jewelry, mitigated the severity of clothes and added a somewhat ironic-frivolous touch. Chanel made costume jewelry socially acceptable and even mixed the fakes with real jewelry—something unheard of at the time.

New styles called for new materials. Chanel bought up scraps of jersey—a cloth previously used only for athletic clothing and men's underwear—from the company Rodier. She manufactured women's clothing out of this material and, much to the dismay of the naysayers who thought her innovations would bomb, was again successful. In jersey, she had finally found a material in which women could move comfortably. Other fashion designers soon copied Chanel's bold idea.

Coco Chanel was an enthusiastic horseback rider and walker. She believed that fashion must meet the needs of modern life, give women freedom of movement, and help them bring their "natural" beauty to the forefront. To Chanel, a pretty woman was active and athletic and stood in the middle of life—not an idle or reserved socialite who sat on the sidelines. In her fashion, Coco Chanel parted

with her past. World War I was beneficial for her growing success, while the Second World War disrupted her career. In the fifties—when Chanel was in her seventies—she then enjoyed a comeback, rejecting the retro-fashion of Christian Dior and instead reintroducing her own contemporary fashion. This was when she designed the Chanel suit, which is today eponymous with her style: straight-cut skirts and box-shaped jackets made of wool tweed, with a wool border and gold buttons. Mademoiselle Chanel worked like

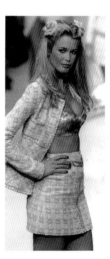

Claudia Schiffer in a Chanel suit, 1995. The style is unmistakeable, though Lagerfeld has adapted it considerably for the 90s.

a fiend until the end of her life and remained loyal to her style, which she modified slightly to fit the times. She died in her apartment in the Ritz Hotel in Paris in 1971—apparently bitter and lonely, despite the many friends and colleagues who remained loyal to her.

1919
Introduction of the 8-hour workday in Germany; foundations of the Bauhaus in Weimar laid; Treaty of Versailles
1919–1930
Weimar Republic
1919–1933
Prohibition laws in the U.S.
1922
Mussolini and the fascists come to power in Italy
1921
Albert Einstein wins the Nobel Prize for physics
1922
Soviet Union founded; James Joyce's *Ulysses* is published
1923
First Berlin radio broadcast
1924
George Gershwin: *Rhapsody in Blue*
1927
Charles Lindbergh crosses the Atlantic
1928
Premiere of Bertolt Brecht's and Kurt Weill's *Three-Penny Opera*
1929
Black Friday: U.S. stock market crashes leading to economic crisis

Androgyny

The First World War radically changed political and social conditions in Europe. Many women, in the absence of their husbands, were forced to become independent and were reluctant to give this autonomy up when the war ended. Women were more frequently seen in public without male companions. Many more women were employed. Previously they had generally worked as nannies, housekeepers, seamstresses, milliners, and the like; during the war, however, they were also needed in offices and factories. The employment of women in the office radically changed the image of the young working woman. Young women participated in sports, drove cars, traveled, and had boyfriends or girlfriends. Even sexual morals were more relaxed, at least in the big cities. Indeed, the twenties may be considered a metropolitan phenomenon.

During this time, a type of fashion developed that accentuated the aesthetic tendencies of the pre-war years. For women, the new objectivity in fashion meant the final breakthrough of modernism. Profuse amounts of fabric and excessive ornamentation became hopelessly outdated. The new silhouette was simple and slender, without frills or other distracting details. Women wanted to be able to move without any hindrance, or at least to appear as if they could. Thus, skirts became shorter and shorter, until they barely covered the

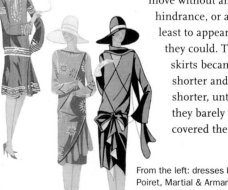

From the left: dresses by Poiret, Martial & Armand, and Dœuillet, 1927.

knees. While skirts did eventually become longer again (short skirts did not reappear until the sixties), the floor-length skirt disappeared completely.

Dresses and skirts were cut straight, oblivious to waists, hips, and breasts. They hung loosely on the body and seemed to be worn without corsets. This, however, was illusory. The women of the twenties may not have worn corsets with whalebone or metal stays anymore, but they did wear bodices made of modern materials. The effect was similar, specifically accenting some shapes and de-emphasizing others. In the twenties, breasts were supposed to appear as flat as possible. Boyïshness was desired, and androgyny was the new buzz word. The new woman cut her hair short, wore short and stern dresses (which, as opposed to a decade before, appeared masculine rather than feminine), smoked in public, and projected a self-confidence that was considered by many to be too masculine. This goes to

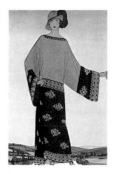

Afternoon dress by Paul Poiret, 1923.

Clothing for mother and daughter by Lanvin, 1923.

Blasé; colored dinner jackets presented in the *Gazette Du Bon Ton*. 1923.

show just how subjective such views on femininity and masculinity were: Masculine in the twenties denoted everything that diverged from the fashions or behaviors of women in previous decades. True, fashion designers of the time used the precepts of male clothing to incorporate functional elegance into women's fashion, yet they did not merely imitate. Rather, they created something entirely new, which

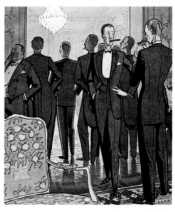

Evening wear by Worth, 1923.

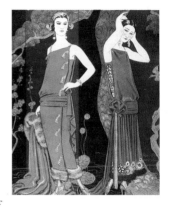

appears perfectly feminine to us today. At first, however, one had to become accustomed to the new silhouette and to the concomitant emancipation of women.

The new fashions also appeared very youthful. The cult of eternal youth, still worshipped by many today, was born. The mature woman was no longer requested. Instead, in the face of changing lifestyles and extremely rapid technological development, taste ran in favor of a young, athletic, and mobile ideal. The new fashion de-emphasized curvaceous shapes through short, baggy dresses and short hair—both styles were supposed to express youthfulness.

Shapes and materials

Although the two-piece suits of clothes were popular in the pre-war years, one-piece designs assumed preeminence in the twenties. These dresses were originally slightly formless and appeared somewhat stiff. Toward the end of the decade, clothes became closer fitting once again: Wavy and supple, they enveloped the slender body. Classic examples of this style are the ingenious flowing garments of Madeleine Vionnet. She introduced the bias cut in fashion, which allowed her

"On part, on part ..."— travelling costume by Madeleine Vionnet, 1924.

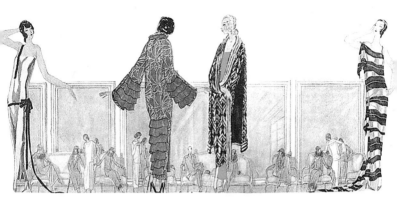

From the *Gazette du Bon Ton*, 1923.

to achieve certain elegant effects especially prominent in the thirties.

The waistline in the twenties dropped down lower and lower. In pre-war fashion, it ran under the bosom; by the twenties it sat on the hips, marking the transition to a swinging, bell-shaped, or uneven skirt that fell no further than to the middle of the calf. The uneven handkerchief skirts were a delightful compromise between long and short; one could wear a soft tailed dress over a uni-color slip. Tunics remained popular as well. To counteract the simple basic form of the clothes, sleeve designs were elaborate.

All these shapes required soft and flattering materials. Coco Chanel had made jersey fashionable, and it was now surprisingly popular. Knit fabrics also gradually became stylish, and the first synthetic fibers appeared. Fur was still very desirable. Alongside the classic furs—ermine, sable, chinchilla—which were beyond the means of many, there were now simpler alternatives: rabbit, mole, fox, and muskrat. Women who could not afford a fur coat could normally at least wear a big fur collar or trim.

Evening gowns were mostly sleeveless and low-cut, either at the front or back, but no longer differed greatly from day wear. They assumed the same basic

Evening wear by Jeanne Lanvin.

form: one piece, slender cut, often short or of uneven length, with tails or a skirt that was longer at the back than the front. Evening wear did, however, differ from day wear in the amount of bare skin it revealed. The materials used for the gowns were also different. Evening wear was often made of gold or silver lamé, often sequined, beaded, or embroidered with pearls, or made of extremely soft silk with sequins or fur trim, intended to produce an alluring, fairy-tale effect. The modern, practical woman was transformed at night into the bewitching seductress.

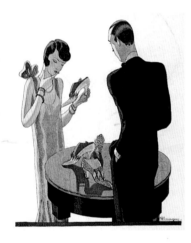

Woman selecting Perugia shoes, 1924/1925.

Accessories, makeup, and hairstyles

On their heads women wore decorated headbands or turbans, often studded with fine feather aigrettes or diamonds; evening hats had fallen out of fashion. Fans were also an important accessory, often made of ostrich feathers or silk painted by popular contemporary artists. Having been for centuries an eminent and undispensable fashion element, the fan now enjoyed a last burst of popularity before its star finally began to dwindle.

Women's hair was worn short again for the first time since the late 18th century. During the war, women still wore their hair long, wavy, and decoratively pinned up. The hats that adorned these hairstyles were decorated with feathers, ribbons, and flowers. The pageboy hairstyle now appeared, popularized by actress Louise Brooks: This was a straight, chin-length cut, with straight, even bangs.

Even shorter and more radical was an imitation of the male "Eton" cut, where the hair was combed back straight. Naturally, big hats were no longer appropriate for such hairstyles; small, tight hats shaped like pots or bells and often pulled jauntily over the face, were more becoming.

Hats taken from the avant-garde magazine *Art, Goût, Beauté*, 1928.

Around the turn of the century, thick, obtrusive makeup for women had been frowned upon; it supposedly suggested an immoral way of life and, if at all, was applied inconspicuously. Now, however, makeup came to be a part of everyday life, and the later the hour, the more dramatic it became. Eyes and mouth were highly emphasized, the eyes outlined in black, brows plucked, and lips painted bright red in heart-shape.

Sweater advertisement by André Gillier, 1927.

Democratization

The fashion of the twenties enlarged upon pre-war trends, and started to become more democratic. Clothing that had been reserved for the idle rich in Poiret's day was now available to the woman on the street. As off-the-rack clothing, it was affordable in all price ranges; even the less affluent women, including the majority of office workers, could dress fashionably and have a stylish hairdo. Of course, the art of tailoring was as exclusive and expensive as it is today. Few could afford clothing from Jeanne Lanvin, Jean Patou, or Madeleine Vionnet. Even Coco Chanel, who wanted to revolutionize women's clothing and had no qualms about being imitated,

Left, sportswear by Patou; right an afternoon dress of black crêpe by Jenny, 1928.

From *Art, Goût, Beauté*, 1929.

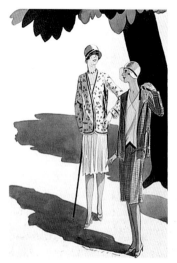

demanded high prices for her clothing, which only the rich could afford. Chanel was well aware that high prices increased the desirability of the product, conferring it the appearance of exclusivity.

In the twenties, production and distribution were not the only factors responsible for the new democratization of fashion: The fashionable outlines themselves contributed to this. A person's social class was no longer distinguishable from his or her silhouette. Any woman could wear a bell hat and a short, straight dress with a low waistline in any color she liked. Of course, there were still visible social differences, but these were focused on finer differences such as the quality of fabrics and workmanship, the finesse of detail, or on the ways in which fashion was worn.

Sexuality

Time and again, contemporary statements expressed reservations about the new fashions; these were tantamount to reservations about the "new" female image. The "nakedness" of women was equated with a lack of morality. Men were suspicious of women's evident sexual self-confidence. They sensed that fashion was more than merely a matter of outward appearance; it affected how women felt about themselves and their own bodies, thus also affecting the way they behaved. Many men regarded these new women as competitors, both in the working world and sexually. More women than ever before were insisting upon their right to choose not only their partners, but also the course of their

own sexual experiences—whether with men or women. Berlin, for example, was famous in the twenties for its lesbian and gay subculture. Women's clubs existed, where women could meet one another, talk, dance, and flirt. These establishments' patrons felt free to sport stern masculine haircuts or wear tuxedos, and sometimes even a monocle.

Fashion and art

Living conditions changed drastically in the early years of the 20th century. Life became much faster-paced, the social structures were more democratic, technology more advanced, and morals more relaxed. The gulf between prosperity and poverty was wider

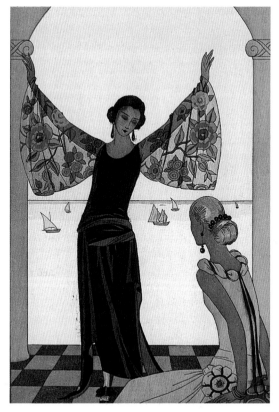

Watercolor painting by the famous fashion artist Georges Barbier, dated 1923.

135

than ever before, and the unemployment rate soared. All these factors contributed to changing fashions, but did not entirely explain why such far-reaching changes had taken place so rapidly. Aesthetically speaking, fashion finally became modern in the twenties. For the first time, it did not lag behind the other arts—architecture, literature, painting, or design; now it became contemporaneous and developed parallel to them. This meant that fashion also became emancipated from its former, primarily exhibitive function. It stepped into artistic independence and found its own niche in concurring with the practical requirements of changing lifestyles, on which it was not, however, strictly dependent. It is no coincidence that even today, the design of the *Bauhaus* is as classic as the clothing fashions of the twenties. The fashions of the pre-war years, on the other hand, are considered hopelessly out-of-date; they never experienced a revival, as did the fashion of the twenties.

Many avant-garde artists of the twenties took an active interest in fashion. The futurists wanted to detach fashion from the human body, and turn it into an independent art form that reflected the movement and speed of the modern urban lifestyle. The Russian avant-garde reverted to folklore tradition or worked constructionist elements into fashion. Vladimir Tatlin, Alexandra Exner, and Varvara Stepanova designed clothing that was supposed to make further change superfluous, by being functional, attractive, and practical.

With her husband, Sonia Delaunay (1885– 1979), who lived in France, developed a style of painting called Synchronism. These were compositions of pure bright colors and geometric forms, behind which a vibrant, alive subject emerged. Such paintings attempted to convey the concept of Synchronism by employing overlapping planes of color. Sonia Delaunay transplanted her artistic experiments onto fashion and developed

"simultaneous clothing." The French poet Guillaume Apollinaire described it thus: "She (Sonia) wore a violet suit with a wide violet and green belt, and a blouse with blithe, soft faded patches of color including pinks, oranges, blues and reds. A variety of materials—cloth, taffeta, tulle, flannel, moiré and silk were combined." One can picture the avant-garde effect of these colorful clothes, which had meanwhile gathered quite a following.

Sonia Delaunay did not develop new cuts. She adopted the contemporary geometric silhouettes of the twenties, which appealed to her sense of modernity, and modified them through her use of colors and shapes. These were either printed on fabric, embroidered, or appliquéd onto her clothing. Toward the end of the decade, when sculptured styles became more important than ornamentation, Delaunay gave up fashion production.

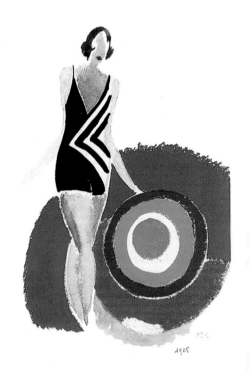

Design by the artist and fashion designer Sonia Delaunay.

Elegant Femininity: Evolution of Form

1931
Spain becomes a republic
1933
Hitler becomes chancellor of Germany; Roosevelt is president of the U.S.
1936–1939
Spanish Civil War
1938
Persecution of Jews begins in Germany; Austria annexed
1939–1945
Second World War
1945
United Nations (UNO) founded; nuclear bomb dropped on Hiroshima
1947
Horkheimer/Adorno: *Dialectic of the Enlightenment*
1948
International Declaration of Human Rights
1949
North Atlantic Treaty Organization (NATO); Founding of the People's Republic of China
1951
Simone de Beauvoir: *The Other Sex*
1953
Stalin's death; popular uprising in East Germany
1954
Fellini's *La Strada*
1955
James Dean killed in a car accident
1956
Popular uprising in Hungary suppressed by Soviet troops
1957
European Economic Community founded

Evolution of form

Around the end of the twenties, styles began to be modified, a trend which continued into the thirties. The somewhat angular fashions of the twenties marked by an athletic boyishness made way for a more mature, traditional femininity. Silhouettes were elongated and

Sportswear by Jeanne Lanvin and Edward Molyneux, 1931.

became softer and more elegant. Slimness was still the ideal, and the new styles made women appear even slimmer and taller; boxed forms went out of fashion and waistlines were no longer emphasized. The clothes now accented the body and flowed with it.

Often, they became softer and wider at the bottom; the cup skirt was a popular style of the thirties. Hemlines dropped to below the knee and then to the middle of the calf. The waistline was raised again to its "natural" location and was accentuated by a narrow belt. The long, narrow skirts and high waistlines produced the illusion of very long legs. Tops fit more closely and sleeves were tighter. Women no longer wore corsets, but they did wear elastic girdles which helped give them a thinner, smoother silhouette.

Long hair came back into fashion, framing the face in soft waves. The stern look disappeared and makeup changed, too: No more cherry-red mouths or darkly outlined eyes. These stark applications were replaced by more subdued colors that subtly accented the now thinner, expressive face, giving a more "natural"

look than previous makeup trends. Marlene Dietrich, with her thin face, sunken cheeks (she had her back molars pulled to enhance this effect), and thinly plucked eyebrows, was the embodiment of the female ideal of the thirties. Likewise, Greta Garbo, with her perfect proportions and her womanly, androgynous body, also represented the ultimate expression of the thirties' woman.

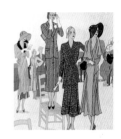

From *Art, Goût, Beauté*, 1931.

With these narrower outlines, bigger hats came back into fashion. Men's fashions did not change so dramatically during this decade, although they, too, became softer and more elegant.

Clothing forms

The most popular form of clothing of the thirties was the princess dress, a dress with vertical cuts accenting the longer, thinner "silhouette." During the day, the dress was worn with a high neck, adorned with small bows or collars. The evening-wear version, however, had a rather more seductive *décolleté*. Now floor-length, the dress often ended in a small train at the back, which could be draped dramatically around the wearer's feet if she were to pose for a photographer. To make the princess dress more flattering, the fabric was often cut on the bias (diagonally across the grain of the woven fabric). This technique had been introduced in

Dresses by Maggy Rouff, Edward Molyneux, Jean Paton and Jeanne Lanvin, 1931.

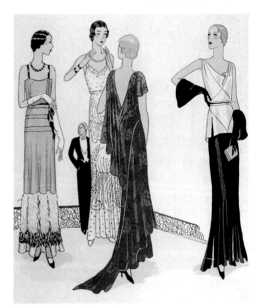

139

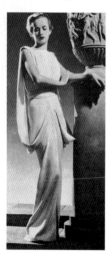

Evening gown by Robert Piguet, 1936.

the twenties by Madeleine Vionnet; it now became common practice. Evening gowns rarely came without the bias cut, which improved the soft draping quality of the garment, thus flattering the figure. Preferred fabrics included *crêpe de chine* or silk jerseys. Synthetic fabrics also began to appear on the fashion scene.

The practical combination of skirt and blouse gained in popularity. Boleros—short jackets with a rounded cut in the front—were more decorative than practical. Elsa Schiaparelli made boleros her fashion trademark and had them fancifully embroidered. Suits also became very popular and consisted of a narrow, calf-length skirt that broadened out at the hem, worn with a cinch-waisted, belted jacket with a relatively low neckline. The suit became an elegant article of day wear suitable for all occasions. Coat styles adapted to the narrow

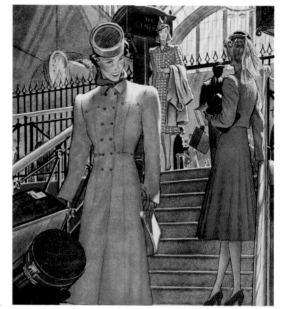

Advertisement from
Harper's Bazaar, 1939.

dress and suit: Narrow blazers or redingotes replaced the wide, fur-trimmed coats of the twenties. Fur collars remained popular, but they were adapted in shape and style to the new, tighter body silhouettes.

Hemlines rose again around the end of the thirties. Skirts still covered the knees, but became narrower (doing away with the bell shape). A single fold was added for ease of movement. Tops were cut in a manner that strongly accentuated the shoulders with shoulder pads adding to this effect. Until now only men's jackets had been padded, so this new silhouette was again felt to be masculine. Epaulettes, stiff collars, and lapels all added to a manly, almost military style—appropriate to the approaching war. During the war itself, these styles were emphasized even more strongly.

Dress with plissée trim by Joe Strassner, 1934.

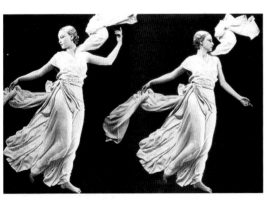

A Vionnet model, 1931; photographed by Hoyningen-Huene.

Fashion designers

The 1930s in Europe and the United States saw the rise of a notable number of women fashion designers, comparatively more than in the decades to follow. This trend began in the twenties and would come to a temporary end with the Second World War. Among the names

emerging in this period in Europe are Augustabernard, Louiseboulanger (both of whom are known by the elided form of their names), and Maggy Rouff and the Americans Valentina, Elizabeth Hawes and Muriel King. Nina Ricci founded her fashion empire, still flourishing today at the beginning of the thirties. Madeleine Vionnet and Madame Alix Grès are today considered the most artistically innovative and influential fashion artists of the time.

With her cutting technique—especially the bias cut—Madeleine Vionnet (1876–1975) helped shape the silhouette of the thirties. Both she and Madame Grès patterned their work after the silhouettes of Greek statues and the drawings on Greek vases. Many of their clothes used flowing fabrics such as jersey, silk crepe, or muslin and were cut on the bias and pleated. Some were borrowed from sources other than the ancient Greek.

Coco Chanel changed her style in the thirties. She distanced herself from the functional, angular style of the twenties which she herself had helped establish, and switched to a more romantic, flowing style for evening wear. Her creations in the thirties—tightly fitted tops, net skirts, ruffles, and wide sleeves—are more associated with Hollywood movies than with what we regard today as the Chanel style. In the thirties, however, a serious rival arose: the sensational Elsa Schiaparelli.

Elsa Schiaparelli.
Portrait from 1937.

Fashion as art

Elsa Schiaparelli created the most exciting, theatrical, and amusing fashions of the thirties. For Schiaparelli, fashion was a form of art. She experimented with avant-garde movements in contemporary art (particularly surrealism), and by incorporating such trends from the art world in her fashion designs, she succeeded in altering both fashion and art.

A famous Schiaparelli model: the jacket is of coarse linen, embroidered with a *trompe l'œil* style designed by Jean Cocteau.

Elsa Schiaparelli collaborated with renowned artists and even persuaded Salvador Dali to design fabrics for her. For her "tattered" dress, she used new, unheard of synthetic materials such as rayon or cellophane to create fantastic effects.

Elsa Schiaparelli made broad shoulders fashionable. She designed hats in the form of backwards shoes, ice-cream cones, and facial masks—ideas that varied and resurfaced decades later in the Patisserie collection by Lagerfeld or in the commercial for the shoe company, Bata. Schiaparelli's fashion was colorful and often magnificently embroidered. "Shocking pink," then a tremendously loud color, became her calling card. "Shocking" is also the name of her first and most famous perfume, put on the market in 1937 in a bottle manufactured by Leonor Fini in the shape of a bust corresponding to Mae West's measurements.

Fashion designers of the thirties

Some of the most important male fashion designers of the thirties include Marcel Rochas,

Day and evening wear of artificial silk, 1938.

who was one of the first to design pantsuits for women, and Cristobal Balenciaga, a Spaniard who opened his Parisian Couture house in 1937. Others include Sir Norman Hartnell, a British designer who worked for the British royal family and produced classic fashion, as well as Mainbocher, one of the few American fashion designers of that time to achieve fame in Paris. Like the designs of Captain Molyneux in the twenties, Mainbocher's clothing befitted every occasion. Averse to experimentation, he produced stylistically perfect and elegant clothing for affluent women. At her wedding in 1937 to Edward VIII of England, after his abdication of the throne, Wallis Simpson wore a Mainbocher dress.

War years

The scarcity of resources during the Second World War affected the fashion world as well as commerce in general. Clothing, like so many other commodities, was rationed, and styles became shorter and tighter. England even resurrected dress codes. One year after the rationing of clothes began in 1941, the British government enforced the "utility scheme." British fashion designers such as Norman Hartnell, who worked for the queen, designed chic clothes for all women, working within the limits of the cloth rations. The number of pleats in a woman's dress was restricted and the maximum width of the sleeves, collar, and belts prescribed. Embroidery, furs, and leather trims were all prohibited.

Throughout Europe, women began to improvise. Considerable imagination was bestowed upon hats, which could be made of a multitude of materials. Turbans became popular again, since women could hide their hair beneath them if it was untidy. As if to counteract the improvised and restricted dress styles, women wore their hair in extremely feminine curls; they sought to look "feminine" any way they could, even though the means were quite limited. Shoes often had to be made by hand. Platform soles became common during this period because wood and cork were more readily available than leather or other materials.

Dresses and skirts covered the knee and were cut relatively narrow. Suits were designed to be practical for all occasions. They often resembled military uniforms, an impression reinforced by shoulder pads and tight belts. Some women's garments were actually made from handed-down men's clothing. The great challenge was to create fashion from limited means. How could old garments or accessories be reworked or recycled into new pieces? How could one improvise? Sewing skills were a necessity for the average woman, and would remain so for years to come.

1940: Even in wartime, fashion remained important. "Utility clothes" combined economy and style.

A woman trying on a hat, 1942.

145

Haute Couture

Despite the war, *haute couture* lived on, paying little regard to practicality and continuing to develop fashion. And the fashions developed did not look as if they had been produced out of limited resources. However, this fashion was far removed from everyday attire; it had little influence on the wardrobes of ordinary women. Paris was still the capital of fashion—despite the rising prominence of New York, and despite Nazi propaganda efforts during the war years to supplant it with German fashion—or rather, to import the Parisian fashions into Berlin. Berlin fashion was no longer as significant as it had been in the twenties. It remained important economically, but wealthy or well-connected Germans still imported French fashion during the war. Many of the French fashion houses closed at the outbreak of the war, including Elsa Schiaparelli and Coco Chanel, though some remained open throughout and even staged fashion shows for the German occupying forces.

The New Look and the Fifties

Postwar

In the first years after the war, fashion silhouettes remained basically unchanged. Then, in 1947, Christian Dior unveiled his first collection to enthusiastic acclaim. Dior, once a relatively obscure, shy designer, brought new gleam and glamor to the world of fashion. After so many years of deprivation, people were hungry for pretty clothes; Dior recognized this, and the overwhelming popularity of his first collection indicated how successfully he stilled that hunger. In the late forties and fifties, many people wanted to forget the barren war years and focus their

energy on something other than politics and destruction. Many women wished to appear feminine once again in the traditional sense, to disguise the marks of the hard work.

Affluence became more important than anything; this was reflected in the fashions of the time. Postwar reconstruction and growing prosperity influenced the ways in which people expressed their convictions. Sociologist Thorstein Veblen had intro- duced the term "conspicuous consumption" in 1899, by which he meant that middle- class men used their wives as symbols of their affluence. What was true in the 19th century became applicable with a vengeance in the 1950s, as the United States and many European countries enjoyed a previously unheard-of level of booming affluence. At the same time, social and family values took a distinctly conservative turn, pushing women back into the representative, housewifely role. It was no coincidence, then, that fashion itself consisted of a variety of elements adapted from outmoded 19th-century styles: tightly cinched waistlines, long, wide skirts atop an abundance of slips, narrow shoulders, and so on—all of which had been around in the first half of the 19th century.

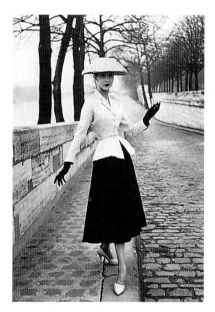

The "bar" dress which launched the New Look in 1957.

The fashion creators
Where the great fashion designers of the twenties and thirties had been women, *Haute Couture* was dominated by men in the fifties. Coco Chanel, Elsa Schiaparalli, Madeleine

Design by Heinz
Schröder, 1958.

Vionnet, and Madame Grès were still working, but the new trends were coming from the men: Christian Dior, Yves Saint Laurent, Christobal Balenciaga, Pierre Balmain, Jacques Fath, and Hubert de Givenchy. Naturally, not many people could afford original creations by these masters, but the clothing industry soon adopted their trends and put corresponding styles within the reach of the less well-to-do. Dior himself wrote the comforting words: "Many believe that *Haute Couture* is only for the affluent. In this assumption, however, they are wrong: Every woman who follows the ground rules of fashion and carefully selects those clothes which are becoming for her can be elegant without having to spend a great deal of money. Simplicity, good taste, and care are the three ground rules; and adhering to them costs no money."

The new silhouette

All the same, new fashion was expensive. And the feminine silhouette changed once more: Skirts were once again calf-length and either extremely wide or pencil-thin. Tops fit snugly and emphasized the waistline. Breasts, buttocks, and hips were also emphasized. The ideal female shape could not be naturally achieved but was modeled with girdles and padding. Shoulder pads disappeared as shoulders once again became narrow and sloping.

High-styled forehead curls disappeared and hair became shorter and softly waved. The ostentatious and improvised femininity of the war years shifted to a well-thought-out elegance. A ladylike appearance once again became the female ideal. In the fashion photography of the fifties, the detached beauty and elegance of the women is striking. Self-contained and serene, immaculately dressed, faultlessly made up, and with perfect posture, the models present themselves to the eyes of the world as complete, beautiful statues. Everything had to be perfect from head to toe: Gloves were as much a part of the outfit as hats, shoes, and purses. Hats could be small and discreet, or large and sweeping. Platform soles and wedge heels disappeared; shoes were narrower, with high, comparatively wide heels.

Elegant dress, design by Heinz Schröder, 1958.

New luxury

Suits were now an indispensable element of female attire. Both jacket and skirt emphasized the waistline; jackets had lavish lapels and sometimes asymmetrical buttons or other kinds of fasteners. The sportier alternative had a wide, bell-shaped back and a small, round collar. Suit skirts were usually tight. The combination of skirt and blouse or skirt and sweater-set, which had been around since the thirties, were unbeatable for everyday wear of home or in the office. If women wore pants at all, they were

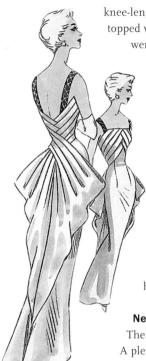

Evening gown by Heinz Schröder, 1958.

knee-length and tight, worn with girdles, and topped with blouses or sweaters. Bathing suits were still relatively chaste, with longer legs or skirts.

Evening dresses had full skirts and deep necklines. The bare-shouldered look often required a whalebone corsage to hold the top in place. Cocktail dresses appeared again and were immediately successful; these were short, festive dresses, less expensive and more practical than formal evening wear. Later on in the fifties, petticoats came into fashion; they allowed girls' skirts to stand out almost vertically. Shoes became tighter and more pointed, in contrast, and hairstyles were puffed up.

New materials

The fabric industry boomed in the fifties. A plethora of new synthetic materials were introduced into the market, all claiming to be easy to handle, beautiful, and easy to care for. Young girls yearned for nylon dresses; men sweat in the new nylon shirts, and synthetic silks made silk dresses affordable for the average woman. The new fabrics were easier to wash, dried quickly, and were easy to iron—indeed, some were wrinkle-free and never needed ironing. They looked festive and were less expensive than natural fibers such as silk and taffeta. The fact that they were machine-manufactured made them cheaper and more colorful and gave them shine and gleam.

Men's fashion

In the years immediately after the war, men's fashion barely changed in the light of fabric rationing. Men wore old uniforms and made do

with what they had. Formal dress codes were dispensed with for a time. Suits were functional, and men wore them in muted colors with white shirts and a narrow, modest tie. Jackets remained sack-like through the end of the forties, when the V-line fashion from the United States became popular, with broad shoulders and a narrow waist. Still, men's fashion remained rather conventional. The fashionable man sought little more than to dress in a correct and practical manner and valued quality and workmanship more than style.

The new synthetics, especially nylon shirts, which were wrinkle-free and easy to clean were also very popular with men. And the well-dressed man always wore a hat, not only with his coat but also with his suit.

The triumphal march of blue jeans

Jeans began to conquer the world in the 1950s; today, a wardrobe without them is virtually unthinkable. Created in the 19th century by Levi Strauss as durable working pants for manual laborers in the American heartland, blue jeans were transformed in the 1930s into casual, or leisure, wear. They were exported to Europe where they were adopted by young people as a symbol of defiance. It was only in the sixties that jeans finally became all-around pants that could be worn on any occasion and were themselves subject to modification. Their success is due to more than just their practicality and durability: Jeans embodied a certain life philosophy, reminiscent of prairies and cowboys, of loneliness (typified in the James Dean movie *Rebel Without a Cause*), and the protection of nature. Through this, jeans provided a welcome symbolic protest against established middle class.

Christian Dior's (1905–1957) maxim was that fashion was a product of fantasy and that fantasy was a good means of escapism from reality. His designs were dream-like, not only his evening wear but even his day wear as well. His designs were out-rageously opulent: The skirt of a luxurious evening gown required up to 90 yards of fabric. These skirts were built up with

Christian Dior on his estate in Millet.

many layers of material and derived stability from the nature of the fabric used. The elaborate cuts meant that a separate petticoat was superfluous; models were reinforced with starched muslin, taffeta, and cotton padding.

Fashion-conscious women were addicted to the New Look.

The fashion of the *Belle Epoque*, which Coco Chanel had resisted so energetically, resurfaced in a new form. The New Look was nostalgically reminiscent of a femininity defined through seductive beauty. It had nothing to do with the demands of the mechanized, fast-living modern world. Such fashion helped repress the memories of the horrors of the war and the Holocaust. Instead, fashion design took postwar consumers on a nostalgic flight back into a fantasy past; it painted pictures of great women and fairy-tale princesses, of wealth and coquettishness, of intoxicating balls and theater evenings, of promenades in the park and elegant tea parties. Yet the new look was modern enough not to be scorned as ana-chronistic.

Every season, Dior surprised the world with some new sensation. Every collection introduced a new silhouette: pencil-thin or slightly loose around the body, A-lines or Y-lines, with very narrow, deemphasized, almost invisible waistlines. Dior, of course, was not single-handedly respons-ible for launching these styles. Other designers were either inspired by his lines or developed their own, similar ideas. Thus it was a small step

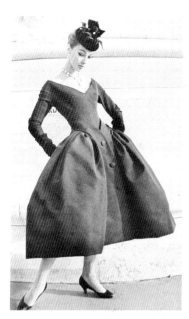

Y-Line, Autumn 1955.

great number of licenses. He was briefly succeeded by Yves Saint-Laurent who was in turn relieved by Marc Bohan. Bohan was responsible for the Dior fashion house up until 1989. Then he was succeeded by Gianfranco Ferre, who assumed the position of artistic director. In the year 1997 a new generation took over, the fallout of which remains to be seen: The British John Galliano, born in Gibraltar in 1960 and famous for his own poetic-eccentric creations, was appointed chief designer of the House of Dior (after a short interlude by Givenchy).

from the exclusive Dior original to the off-the-rack and mail-order mass distribution. Meanwhile, the name Dior became a fashion standard. Even today it is synonymous with the fashion of the fifties and even with *Haute Couture* in general.

Christian Dior was probably the last fashion "dictator" to launch entirely new silhouettes and thereby change the course of fashion. When he died in 1957, he left behind a huge fashion empire, dealing not only in *Haute Couture*, but also in furs, perfumes, hats, shoes, and jewelry, and awarded a

A-Line, Spring 1955.

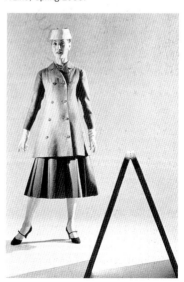

1961
Berlin wall erected
1962
Cuban missile crisis
1963
John F. Kennedy assassinated; summit meetings of the Independent African States, founding the OAS
1965
U.S. enters the war in Vietnam
1967
Third war between Egypt and Israel (Six Day War)
1968
Student protests in Paris; Prague Spring; Stanley Kubrick's *2001: A Space Odyssey*.
1969
Neil Armstrong sets foot on the moon; American-Soviet SALT talks concerning strategic nuclear weapon restrictions commence
1974
Richard Nixon resigns following the Watergate affair; energy crisis
1979
First direct votes for the EC Parliament; NATO commission

The sixties: Cult of youth

The fifties, so far as fashion is concerned, were a time of elegance and of femininity. Young people, however, described it differently: They saw fashion as conservative, middle-class, and much too old. English fashion designer Mary Quant (b. 1934) claimed that young women looked like their own grandmothers. She wanted people to retain their childlike charm rather than becoming stiff and ugly, as did most adults. Quant began to develop her own designs toward the end of the fifties. Her short, loose dresses gave women freedom of movement and made young women to look like schoolgirls; she also designed suspender skirts and tight sweaters, and, of course, the miniskirt. Mary Quant and the French couturier André Courrèges both claim to have been the first to develop the miniskirt. Mary Quant designed clothing for all young people, and not just for those who could afford expensive designer originals. Thus, fashion became more youthful in the sixties, and, in a sense simultaneously more democratic and international.

The new fashion was able to spread quickly because already youth had become the archetype of Western society, and thus also the role model for fashions. People now wanted more than to work constantly and stockpile material possessions, as their parents had done; they wanted to enjoy life. The predominantly young consumer class wanted fashion that complemented their lifestyle and that they could afford. Thus, fashion finally lost its elite character and became a youth and mass phenomenon. Characteristic of the time was the short loose dress: Continuous, straight, very plainly cut, colorful, often printed with a geometric design, mostly of synthetic fibers, it disguised feminine curves, showed a lot of leg, and allowed grown women to look like small girls. Originally the new dresses and coats were invented for very young, slim, and wide-eyed women. Soon, however, all women

were wearing the new style in some variation or other, because, to all intents and purposes, there were virtually no fashion alternatives.

New role models

The fashion stars of the sixties were petite, andro-gynous, and youthful—a type embodied in women like Audrey Hepburn, who was clothed by Hubert de Givenchy and became world-famous in movies like *Breakfast at Tiffany's* and *Funny Face* (a movie specifi-cally about the world of fashion photography). For the first time (and by no means the last), models were as famous as movie stars. The English gamine Twiggy shaped the face of the decade with her skinny figure and huge eyes set in a narrow, pale face, as did Jean Shrimpton and Veruschka with their thin, sullen faces. British television offered a strong female archetype in the character of Emma Peel, karate-kicking heroine in the adventure/spy series *The Avengers*, played by Diana Rigg. Mrs. Peel was a powerful woman whose popularity helped establish black leather clothing as a socially accepted fetish. This was also a time when sexuality was losing its taboo status: the advent of the birth control pill seemed to free women from old constraints and made it possible for the first time for women to determine their sexual life.

Jackie Kennedy became First Lady of fashion, setting fashion standards for many with her pillbox hats and narrow (often pink) clothes. The Beatles, with their icono-clastic music and epony-mous bowl/ Beatle haircuts,

The model of the decade: Twiggy.

clashed with the older generations and managed to achieve the age-old adolescent ambition: to provoke and distinguish themselves from the adult world.

Barbie

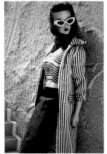

The Barbie doll heralded a new era, 1960.

In 1959 the first Barbie doll arrived on the U.S. market, and she was exported to Europe soon thereafter. Ironically, Barbie's predecessor was a German pinup doll, the *BILD*-Lilli, originally a popular cartoon figure that was designed as a fashion doll for adults. Mattel bought up the copyright and produced an almost identical doll in the United States: Barbie. Barbie was the first doll in the world that looked "grown up" and yet was still intended for and adored by children. Contrary to the expectations of pedagogues, girls did not just want to play mommy and child with baby dolls. They seemed to be much more fascinated by grown-up-looking dolls with which they could play a variety of different roles. Barbie taught the young girls of the sixties how to dress, since the *sine qua non* of Barbie's existence was her capacity to come up with the perfect outfit for any occasion. Her first designer, Charlotte Johnson, adapted *haute couture* for the doll and dressed her luxuriously, as fashion-conscious women would—but often could not afford—to look (while many parents bemoaned the fact that Barbie's outfits cost more than their own). Every detail fit, including the gloves and underwear, and so young girls who played with the dolls grasped the role femininity plays in fashion. The doll was designed as an exaggerated version of the 1950s' ideal female body, and her perfect wardrobe has since served as a loyal reflection of the changing tastes in fashion. The doll's body itself did not change during the sixties despite the transformed body image.

The fashion of the street

Traditionally, fashion originated in the privileged classes and trickled down in various permutations to

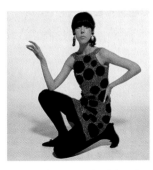

Peggy Moffit in a sequined dress by Pierre Cardin, 1966 .

the lower classes. But time and again the reverse has been true. Thus the torn *lansquenet* clothes with slits became fashionable for the nobility in the 16th century. In the 1960s, the reverse process became the norm and has remained so to this day. Youth cultures evolve their own fashions; these are then adopted by *haute couture* or *prêt-à-porter*.

Carnaby Street

The fashion center of the world in the sixties had shifted from the distinguished fashion houses of Paris to Carnaby Street in London. Here one could find everything that was "in;" here, trends were set in motion. Old and new clothes were mixed; second-hand became popular during this time. Here, one could find bright colorful dresses and shirts, extremely short and futuristic, or wide and long, romantic flowery skirts; colored pantyhose—with flower prints or geometric Op art—real and fake furs, sunglasses and pointy shoes, crocheted tops and see-through blouses, over-the knee patent leather boots with flower applications, jeans and huge bags, and pant suits in every color and fabric.

The audience and market for fashion expanded. Fashionable clothing was produced from inexpensive materials and shipped and sold cheaply. Fashion was expected to be single and functional, while at the same time being pretty, fashionable, and eye-catching. Details such as color and shape changed quickly. New, more efficient methods of manufacturing clothes sped up production and thus opened up new markets. The consumer world of the

Fashion for the sixties' woman as promoted by Sak's Fifth Avenue in New York.

sixties seemed boundless. Mail-order catalogues and warehouses boomed. Many now established separate sections for young (junior) fashion. Among the better known was Biba, the first department store for avant-garde, romantic, youthful fashion,

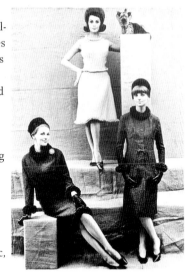

founded by Barbara Hulanicki. Simultaneously, there was a boutique boom: Small one-person shops sold the latest trends and helped to shape fashion considerably.

Haute couture and *prêt-à-porter*

Many of the great French fashion houses read the writing on the wall and prepared themselves for new forms of production. They still sustained their reputations for innovative and exclusive hand-made designs, but these were no longer their primary source of income. Profits and financial viability were earned through *prêt-à-porter* (industrially manu-factured fashion) produced in greater quantities and on a large scale. Pierre Cardin (b. 1922) had been working for department store companies since the late fifties and was the first couturier to sign a licensing contract. As such, he became a trend-setter on the fashion market, establishing the commercial mechanisms on which the industry today thrives.

In the sixties, Pierre Cardin created a sensation with his space look: dresses of synthetic fibers, with

holes in the waistline, topped by helmet-like head pieces, and stamped with wild, zigzag patterns.

André Courrèges (b. 1923) was one of the most innovative stars of the sixties. He made white wet-look leather chic, using it to make half-boots, which he combined with pants, dresses, jackets, and pinafore dresses. In his collection, women's pants became an essential item. His pants sat on the hips (hip-huggers) and were worn with short, box-shaped tops. He also designed one-piece jumpsuits, sometimes skintight, sometimes wide-legged, sometimes even with short legs. The short, geometric hairstyles created by Vidal Sassoon, star hairdresser of the sixties, were part this fashion look.

Paco Rabanne (b. 1934) introduced cloth_s made of metal and plastics in 1965. They were less wearable than avant-garde clothing and thus made their mark, more as museum pieces of futuristic design than as popular clothing.

Yves Saint Laurent's fashion, however, was always wearable, no matter how avant-garde. Laurent was a proponent of transparent clothing worn over no underwear. His styles, inspired by modern art (like the Mondrian dress of 1965, *see page 160*), shaped fashion history. Laurent was acutely aware of the changing times as his multifaceted collections show. He also had the required sense of humor to transcend the boundaries of elegance and vulgarity and create something new in keeping with the times.

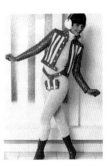

Patent leather jacket worn over a body stocking: Courrège's fashions were regarded as futuristic.

Hippies and counterculture

The hallmark of the mid-1960s was the hippie—the peace-loving flower child who loved nature and peace and expressed this through playful, romantic clothing, soft nonconformity, a growing sympathy for Eastern spirituality, and a seemingly carefree life. Their German counterparts were also antiwar and anti-imperialist and rejected middle-class meritocracy; they were marked, among other things,

Mondrian dress by Yves Saint Laurent.

by an insistent disregard for fashion. Young people dressed down. They wore unmatching, tattered, sloppy clothing, and long hair. Marijuana was in, and, with the pill, so was "free love." The movement culminated in the 1968 "Summer of love," a halcyon period before the Kent State killings, the escalation of the Vietnam War, and the deaths of popular rock music icons like Jimi Hendrix and Janis Joplin. Soon after, Martin Luther King and Robert Kennedy were assassinated.

The hippie movement was one of protest against the established social order. Changing technology and freedom to travel meant that the counterculture was not confined to any one country or region but took on global proportions. The same developments that allowed the attitudes and lifestyles to spread also helped benefit commercialism—ironically, since the heart of the counterculture was, ostensibly, a rejection of the material world.

Hippies traveled from Haight Ashbury in San Francisco and Greenwich Village in New York City across the Atlantic, where they took Europe by storm. And the opportunists followed close behind. Hippie clothing soon became stylish, thus losing its original significance as a form of protest. Suddenly multitudes of young women—even the most conservative—were wearing flowing "maxi" skirts, made of Indian cotton flower prints, with tee-shirts, lace or peasant blouses, and almost pre-Raphaelite dresses. They also wore their hair long, with headbands or bandanas across their foreheads rather than pushing the hair back off the face as had been the more conventional fashion of the fifties and earlier part of the sixties. The youthful hippie anti-fashion became the international fashion trend and shaped the seventies, which turned abruptly away from the futuristic sixties, now pursuing a kind of nostalgic romanticism.

The seventies

Transitional styles

The seventies did not produce a new, independent silhouette; rather, the decade enlarged upon certain tendencies of the sixties, such as the romantic look, and simultaneously sowed the seeds for the "Dress-for-Success" style to come in the eighties.

The fashion of the seventies was heavily influenced by leisure wear. Jeans became the unrivaled favorite among all social classes and for all occasions. Dress codes essentially vanished: The anti-authoritarian lifestyle also influenced fashion. The growing women's lib movement attacked fashion as an instrument used by men to oppress women. A liberated woman, according to feminists, did not wear miniskirts and high heels; she wore comfortable shoes she could walk in and

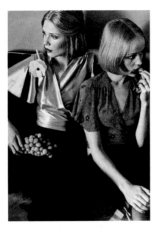

Blouses with bell-sleeves were considered particularly feminine.

comfortable asexual clothing such as dungarees. Fashion had tended to encourage men to see women as sex objects, an the intention was was to forestall sexism and eliminate unwanted or inadvertent erotic signals. Of course, fashion did not eliminate such elements entirely, but the feminists had made a legitimate point, and this was heard in the fashion world to a degree. For a time, styles did become somewhat less erotic. Basic, everyday wear consisted of gender-neutral jeans and a sweater, or jeans and a blouse (toward the end of the decade this evolved into a very feminine combination of jeans and a lace blouse, which was considered especially chic).

Men's fashion in the seventies.

Straight-cut and flared skirts, often of tweed or other sporty materials, sporty shirtwaist dresses belted at the waist, or looser fitting dresses that hid rather than revealed the body, were also worn. Evening wear consisted of the same basic styles. For the first time in fashion history, evening gowns were distinguishable from daytime clothing only by fabric and color. The cut (though not the length) was basically the same for both evening and daytime dresses. Evening wear drew upon the same sober simplicity or playful nostalgia of everyday style. A woman was no longer transformed in the evenings into some more glamorous beauty; she remained herself (or appeared to). Authenticity was a key word for the decade: People wanted to be real, authentic, "themselves." Hairstyles reflected these tendencies. The long hair of the sixties faded into certain subcultures, while men in the seventies grew their hair naturally over their collar. Sideburns grew steadily longer. Women aimed for "natural" hairstyles. Even perms were supposed to look natural. Instead of using rollers and curlers to secure a fixed style, hair was air- or blow-dried for a naturally wavy, almost Afro look.

It was no coincidence that coordinates appeared on the market around this time. A wardrobe of "coordinates" was a collection of matching individual pieces that could be combined with various other pieces. This enabled women at all income levels to look chic, fashionable, and dress appropriately at all times with only a limited basic wardrobe. Coordinates saved not only money, but also time; it was now no longer necessary to change one's outfit completely when going from the office to the theater.

Zandra Rhodes' fashions were elegant, romanticized versions of ethno styles. Born in 1940, she started out as a fabric designer, but since couldn't get anyone interested in turning her wildly colored fabrics into adequately styled clothes, she began to create her own designs, thus uniting fabric and style.

Nostalgia and exoticism

In mid-decade came the so-called Indian-look, reminiscent of the hippie style: wide flowing shirts and blouses in light fabrics, long scarves that fell to the knees, and loose, wide dresses. These clothes

were not necessarily authentically Indian, nor was the Indian silver jewelry. The "grandmother-look" was just as inauthentic, but this was intended: Ruffled blouses with stand-up collars and skirts with valance harked back to the styles of the 19th century, though now simplified and "modified" in keeping with the times. Patchwork originally suggested country life and now became so fashionable that it was printed directly onto fabrics instead of being produced from actual scraps. Complementing this quilted look were vests, sweaters, tank tops, caps, shawls, scarves, dresses, and bags, all crocheted in all the colors of the rainbow. Colorful crocheted granny-square afghans blankets lay on beds, crocheted curtains hung in windows. It was in the seventies that the Swedish furniture company, Ikea, began its triumphal march across the world, as did Habitat/Conran's from Great Britain: Both marketed light, functional pine furniture and simple, rural accessories such as rag rugs and dhurries, all of which harmonized with the crocheted look. People saw these rugs as "natural." Shawls, which had become fashionable in the 19th century, now reappeared as a crocheted alternative.

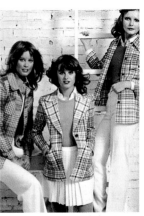

White pleated skirt, checked blazer— everyday wear in the seventies.

For glamor, one might turn to Yves Saint Laurent's somewhat conservative patchwork style. Laurent modified this style for *haute couture* and conjured up wonderful, colorful, luxury clothing. He also adopted the oriental influence and produced opulent fashions, otherwise uncommon in the seventies.

The nostalgic style and the practical style (shirt-dresses, tweed skirts, and pants suits) coexisted peacefully. They could even be combined with one another. Heterogeneous combinations, in fact, became a distinctive element of fashion during this time, sowing the seeds for the postmodern. And the postmodern is in essence a mixture of duplication and montage.

Hemlines and hotpants

In 1970 the miniskirt barely covered the buttocks.
Then came the midi-skirt, which fell to mid-calf. It
was worn with a waist-length sweater or a short
velour or knitted top. Hooded jackets were adapted
from sport and leisure fashion (that is, from the
basic sweatshirt) for everyday wear. The midi, how-
ever, did not really catch on at this time. Many of the
midi designs were cut in a manner that made them
seem fairly stiff and unappealing. Most women
preferred the shorter hem; the miniskirt and the
maxicoat—a study in contrasts—were a fashionable
combination for a while. The "hottest" piece of
clothing for young women in the early seventies
were the skintight, extremely short shorts, which
had nothing in common with casual shorts. For
winter, hotpants were manufactured from warm
woolens and were worn with wool pantyhose and
floor-length coats. The maxi-length dresses and
skirts was generally a transitional, pre-junior
fashion for the very young.

In the second half of the decade, skirt length
finally settled at the knee, and bell-shaped as well as
pleated skirts became fashionable. Platform shoes,
which had dominated the first part of the seventies,
went out of style.

Basic forms of clothing

In the seventies the simple belted shirt-dress was
common. Later came soft, easy-to-care-for jersey-
knit dresses with ruffled skirts and tops. A belt—
whether thick or thin—drew the dress together in
the middle. Most clothes, even the short-waisted
jackets, were not lined, and this enhanced their soft
appearance. Popular for summer were light floral-
print wrap-around dresses with wing sleeves or
halter-neck or off-the-shoulder dresses.

Polo shirts and shirt-blouses were common;
later came the omnipresent tee-shirts (initially
for teenagers) and romantic "grandmother

blouses." Paint smocks or wrap-around tops with wide hanging sleeves, often made of thin cotton, were worn with jeans and skirts. Pantsuits became acceptable for all occasions, often made of wools, tweeds, corduroy or velveteen, and later velvet, knitted fabrics and synthetic fibers. Pant legs at the beginning of the decade were wide and sometimes cuffed at the hem; they were very tight around the hips. As the seventies progressed, this silhouette inverted: The legs became narrower, and the top of the pants tended to be gathered with pleats and was, therefore, much looser around the lap area.

Also in fashion were blazers of corduroy velvet or checked fabric: trevira in the summer, wool in the winter. In the earlier part of the seventies, waist-length blouses and bright-colored, some-times checked jackets were fashionable. They were also often made of fake fur or plush, or of coarse woolen materials or jersey. Knitted jackets were an essential item. They could be elegant or sporty, were often belted, and offered an interest-ing range of collar styles. Conservative knitted jackets went right out of fashion. Knitted suits and knitted pants were available in many varia-tions; and for a time, long knitted coats were fashionable. The French fashion designer Sonia Rykiel established a reputation by designing very feminine, finely knitted clothes. By now, though, such knitted wear was no longer brandmarked as coarse leisure and work clothing as it had been in the past.

White knitted suit from *Brigitte* magazine, 1972.

Afghan jackets and suede coats with waxed hide and fur trims gained popularity through the anti-fashion movement of the counterculture. These were mostly waisted and often adorned with embroidery. Those who now wanted to go against the grain wore parkas with jeans; these were usually heavy army-surplus, khaki-green jacket with many pockets for storage.

Postmodern Fashion: The Cult of the Body

1981
Elias Canetti awarded Nobel Prize for literature
1982
Falklands War
1983
Pershing II missiles stationed in Europe for the first time
1987
Disarmament treaty for middle-range missiles
1989
Berlin Wall falls; reunification of Germany
1990
CSCE-summit meeting in Paris marks the end of the Cold War
1991
Gulf War; end of the Soviet Union and foundation of the Russian Federation
1993
Common market established in Europe
1994
Apartheid ended in South Africa
1997
Hong Kong returned to China

Success cults

A contradictory tendency developed in the 1980s. Fashion dispensed with its need to be an "authentic" expression of personality; instead, it was now used to express accomplishments. The cult of success overshadowed the naturalness ideology and manifested itslef even in fashion. For many people, success at work became an important aim in life. The sociopolitical fights of the seventies were over, and the focus shifted back to material goals and personal ambition. The oil and energy crises were apparently conquered and resources again seemed plentiful.

A strong force in the eighties was the peace and anti-nuclear arms movement. Middle-class consciousness was also evident in the many activist groups of the period. The women's movement, on the other hand, seemed to become increasingly superfluous; women seemed to have surmounted the barriers to equality. The fashion of the eighties reflected these apparent victories: the strength of women was taken for granted and this molded the decade. As powerful women, they were expected to be successful in all realms of life. Meanwhile, a counteractive male group surfaced, whose goal was to "find themselves" and engender more humanity. The enlightened man was a more controversial figure than the high-powered woman and therefore was unable to assert himself so well. He did not play a dominant role in the eighties.

The cult of the body

Success had to be written, as it were, on one's face. The eighties were the decade of the body cult, of bodybuilding and aerobic obsessiveness. The ability to shape the body according to prevailing ideals of beauty indicated an individual's level of self-discipline. A beautiful body therefore intimated success in other areas as well. Self-

realization, the buzz word of the seventies, manifested itself in the form of self-shaping in the eighties.

A beautiful body was now considered to be a strong, disciplined, athletic body—the direct result of healthy nutrition, restraint in appetite, bodybuilding and aerobic exercise. Bodybuilding had previously been considered a sport for tough men, which women avoided, lest they develop unsightly musculature. Now, however, bodybuilding and bodyshaping became socially acceptable even for women. This was, it seemed, a perfect way to shape the body as desired. Women no longer wanted to be soft and skinny (not to mention soft and not so skinny), but rather strong and healthy. The untouchable woman of the fifties was no longer the ideal, nor the emaciated Twiggy of the sixties or the cocaine addicts of the seventies. The ideal, high-powered woman now knew what she wanted, she was ambitious, but at the same time also distinctly feminine.

Aerobics were the fashionable sport of the eighties, developed into a sort of fashion. To complete the aerobic look, women wore brightly colored tee-shirts or cotton-knit tops, leggings, bright sweatbands, leg warmers, and aerobics shoes. This athletic fashion soon spilled over into everyday fashion and all women, whether athletic or not, suddenly wore leggings and tennis shoes, legwarmers and headbands. Jeans and sneakers were socially accepted everywhere. Even those who did not actively participate in sports, or work out, should look as if they did.

Madonna

Pop star Madonna became an icon for the eighties. She greatly contributed to the sporty element in fashion, and also strongly promoted fetish-fashion. She brought glamour back to Hollywood and wittily presented herself as the model high-flying woman

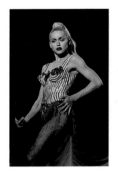

Madonna wearing a dress by Jean Paul Gaultier, 1991. Gaultier designed the costumes for Madonna's Blond Ambition Tour in 1990.

167

who, through hard work, had brought her body into form. In so doing, Madonna played upon many of the clichés of femininity in American and European cultural history, sometimes incorporating Marilyn Monroe, sometimes the "bad girl." At all times she was the perfect product of an ingenious marketing strategy. In her shows and videos, Madonna presented her body as both domesticated and highly sexual. The effects of such femininity and eroticism were precisely calculated to suggest that "natural" femininity had become unserviceable. Among the tools of her self-exhibition, of course, were her costumes: These were always sexy, body-emphasizing, and full of fetishistic elements. The bodices created by Jean Paul Gaultier for her Blond Ambition Tour in 1990 gained especial renown.

Madonna with Jean Paul Gaultier.

The media as fashion role models

In the forties and fifties, movie theaters were the rage; the eighties, however, were ruled by television and video, and these became the channels for spreading fashion trends. Soaps such as *Dallas* and *Dynasty* influenced style more than the big movie hits of the past had ever done. The image of the high-powered American woman with chic hairstyles and clothing contributed greatly to the popularity of the Dress-for-Success style. Men who were interested in fashion took their cues from the impeccably casual Don Johnson types from shows like *Miami Vice*, who

Two high-powered women from *Dynasty* ...

dressed in pastel jackets with white pants and tee-shirts, or in dark, smooth, and perfectly cut suits. These television stars injected new life into men's fashion, which had lain dormant for a long time.

… and their male counterparts from *Miami Vice*.

From the public announcement of her engagement to Prince Charles up until her tragic death in 1997, Diana, Princess of Wales, became a media star, and from her highly touted wedding gown to the cast-off designer dresses she donated to charity auctions, she was a fashion trend setter. Diana developed beyond the expensive but conservative tastes of the royal family, boldly experimenting with fashion and becoming a glamorous beauty. Young women around the world eagerly followed and imitated her changing styles.

Modern silhouettes

In the 1980s, the fashion pendulum swung back again. After the 1970s' lack of contours, clear outlines now reappeared: wide, padded shoulders, narrow hips, long legs. Sports and business fashion both influenced the new styles. Many women believed that access into the male-dominated working world would be easier if they donned men's fashion and masked any hint of femininity. Bright, sensuous evening gowns were still, however, worn at night. Suits—conspicuously adapted from men's suits—were mixed with various feminine elements; long, wide jackets with broad, padded shoulders, short, straight skirts, or middle-length pleated skirts with simple, elegant pumps. In place of skirts, women could wear wide pleated pants of high-quality fabric such as Cool Wool or cashmere. The somewhat more feminine alternative to the white blazer was a short, waisted jacket with emphasized

shoulders. Fabrics were soft and fine, and colors were bright.

The preferred style for dresses used soft fabrics with wide, padded shoulders and pleats at the waist. They were worn with swing coats, trenchcoats, or wide, box-shaped jackets.

Form-fitting styles that accentuated the figure coexisted peaceably in the fashion market of the eighties with angular, oversized styles. Oversized sweaters came into fashion and have remained so to the present day. The oversized styles served to cover the athletic body casually while simultaneously providing a sanctuary for the bulges of the not-so-athletic. They allowed unrestrained movement and suggested a carefree lifestyle, especially when made of natural fibers, which became very popular again as the decade wore on.

Lamé dress by Lagerfeld for Chloe, 1982.

Furs, on the other hand, fell into disrepute. With environmental and animal rights movements growing more vocal, a general awareness developed for the dangers of exploiting nature. In the face of near-extinctions of animals hunted for their luxurious fur, animal rights activists fought against the hunting, trapping, and farming of fur-bearing animals for the fur-garment industry. They also protested against animal testing in the cosmetics industry; as a result, cruelty-free products became a new marketing standard. The anti-fur, anti-cruelty campaigns were successful. For the first time in

fashion history, furs were not seen as a desirable luxury or mark of status, but as an expression of thoughtless egotism. Many women left their furs to the moths, and fur merchants had to be much more discreet in their marketing and advertising. Meanwhile, designers quickly responded to the shift in attitude with fake furs and quilted coats.

The internationalization of fashion

In the eighties, the fashion scene became completely international. French *haute couture* had lost its significance for the development of new silhouettes, forms, and shapes. Designing for a handful of very rich women no longer paid; turnover could only be made through *prêt-à-porter* and licenses (e. g., for cosmetics). These, however, demanded more advertising, and *haute couture* became invaluable as a publicity mechanism for the large fashion houses. This led to the big "défilés:" large-scale shows in which the big names in fashion—Thierry Mugler, Christian Lacroix, Jean Paul Gaultier, Karl Lagerfeld (for Chanel and Karl Lagerfeld for Lagerfeld)—gave free rein to their imagination and skill. Few of the spectacular designs were ever transformed into actual fashion. They did, however, benefit the *renommé*, the label— and the label, in the world of fashion shopping, became more important than ever.

"Rag look" by Rei Kawakubo from *Comme des Garçons*.

The role once played by *haute couture* in shaping fashions was completely assumed by *prêt-à-porter* in the eighties. Almost all large firms had their own *prêt-à-porter* collections, and many restricted themselves to this niche on the market. This shift opened the door for American, Italian, Japanese, and German designers. The international success of Calvin Klein, Donna Karan, Ralph Lauren, Giorgio Armani, Gianni Versace, Jil Sander, or Joop! began in these years and has been growing ever since. Purist styles, modified for the modern working world, marked the work of both Jil Sander and

Dior elegance, 1995.

Donna Karan, and were sold throughout the world. These styles were always appropriate and comfortably chic. Specifically, designs tended toward clearly defined lines, splendid fabrics and perfect (though sometimes seemingly formless) cuts. Giorgio Armani's classic designs, influenced by elegant men's fashion, were always cut in body-flattering patterns. Armani successfully bridged business and leisure clothing. The German fashion designer, Renate Güntert, created long, highly elegant fashions for refined women reminiscent of the classic French style. Karl Lagerfeld over the years worked for various companies, including his own. In the eighties, with humor and irony, he began to rejuvenate the style of Chanel without falsifying it. He did this by implementing shorter skirts, bodices instead of blouses, by using leather, and creating accessories, which, in their playful gracefulness were almost suggestive of Chanel's rival, Schiaparelli. Such accessories included hats in cake or fruit shape. Lagerfeld was versatile, had a perfect sensibility for the changing times, had wit (in the sense of the French *esprit*), and contributed prolifically to fashion. He may well be regarded as one of the greatest designers of recent years.

Avant-garde fashion in the postmodern period

The counterbalance to the classical lines of the big *prêt-à-porter* houses such as Jil Sander, Donna Karan, or Rena Lange came from experimental avant-gardists such as Vivienne Westwood, Jean

Paul Gaultier, Alexander McQueen, and Gianni Versace. In the eighties, the Japanese also began to forge their way into European fashion, and their success has continued and grown in the nineties; they, too, provide alternatives to European *prêt-à-porter*. This "alternative" fashion has been labeled "postmodern."

Fashion has become increasingly diverse. One can no longer speak of a single trend: The fashion world is characterized today by many different, often contrasting trends. Consumers now decide for themselves what they like, what is in or out. The fine line between the fashionable and unfashionable has become more and more difficult to distinguish. There are no more overarching guidelines, no obligatory dictates. Elegance, harmony, and a traditional definition of beauty seem to have lost their original definitions. The bizarre and the surprising have taken over, symbolizing the essence of fashion: continuous change and the search for something new.

Fashion is increasingly borrowing elements from the recent past. During the seventies, fashion also borrowed from past styles, but with a different manner: single elements were adopted from 19th-century fashion such as wide skirts, high-necked blouses, and frills; these were then reworked into nostalgic blouses and skirts and modified for mass production and distribution. The way in which these clothes had once been shown off to best advantage (through corsets and crinoline, and various fabrics and cuts) was no longer considered important.

Colorful, comfortable, feminine—model by Sonia Rykiel, 1997.

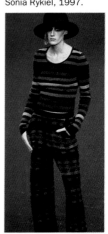

In the eighties and nineties, the reuse of old ideas was no longer exclusive to so-called mass fashion; it could be found every day in *haute couture* and *prêt-à-porter*. Behind such repetition lay both a thorough knowledge of fashion history, as well as the understanding that everything had existed before, and that originality is merely a conscious manipulation of past styles. In the postmodern,

Punk..

"authenticity" has become an obsolete concept, even though people want to be more "authentic" than ever. Authenticity, however, is hard to define; identity and personality are molded by the existing culture and social setup. Even gender differences have started to become hazy; an obsession with transvestitism has become strong in the nineties. The postmodern has caught up to fashion.

Gender game

Jean Paul Gaultier (b. 1952) plays the gender game brilliantly. He brings traditional feminine elements—skirts, frills, and transparent fabrics—into men's fashion and offers women wide men's suits and extra large suspenders, preferably worn over bodices. His work, writes his biographer, combines elements from *haute couture*, street culture, and flea market styles. His first perfume, brought onto the market in 1993 in a flacon, paid ironic homage to Elsa Schiaparelli: it was formed as a female torso, as Schiaparelli's *Shocking* had

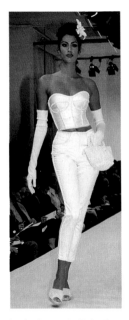

Ironic glamour by Dolce & Gabbana.

been. Thierry Mugler (b. 1948) produced designs which were strongly influenced by fetishism: His women have sharp, angularly posed bodies with wasp waists, wide shoulders, and narrow hips, and are dressed in shining leather. One of his last collections (1997) presented women as strange insects.

The Queen of English fashion: Vivienne Westwood

Vivienne Westwood, born in England in 1941, created Punk in the seventies: torn tee-shirts with aggressive-sexual slogans, black leather, safety pins in the ears, and neon-colored spiked hair. Punk was instantly swallowed up by mainstream fashion and made socially acceptable, as if it were a joke. Under the circumstances, it lost its appeal for Westwood, a former school-teacher. She had

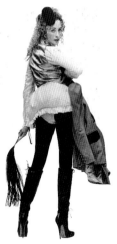

"Provocation," by Vivienne Westwood, 1995.

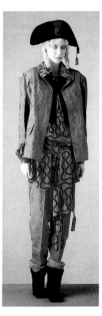

From Vivienne Westwood's pirate collection, 1980.

intended her fashion as a protest against a saturated, affluent, but disinterested society. She now began to adopt elegance and beauty as antidotes against the increasing banality of culture. Westwood's elegance, however, already bordered on the tasteless. She reworked old styles with irony, combining a flair for the unexpected and perfect tailoring technique.

Vivienne Westwood was the first to put the bra on the outside of the clothing; she reinvented the crinoline by cutting it back to mini-length. Her extreme designs always caused a stir. She developed clothes with *cul de Paris*. One of her trademarks was the platform shoe, which reached dizzying hights. All these ideas later appeared in other designers' collections. Vivienne Westwood, however, had an unrivaled knowledge of fashion history, and no one else matched her ingenuity for creating styles which were so completely new and contemporary.

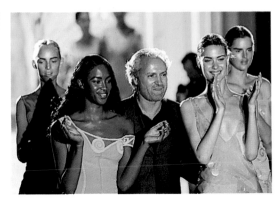

Gianni Versace with top model Naomi Campbell after his last fashion show, January 1997.

Gianni Versace

Gianni Versace was born in Calabria, Italy, in 1946, and was murdered on the steps to his villa in Miami, Florida, in 1997. In the eighties, he became one of the leading figures of international modern avant-garde. His fashion for both women and men was colorful, sexy, and spectacular, sometimes even on the verge of vulgar and obscene; his designs were almost always skin-tight, often with low necklines or high slits held together only by a huge safety pin. This made them wearable only for the very young, slender people whose lives revolved around sports, body shaping, and dieting. Versace revived the magnificent, exaggerated men's fashions that had been popular before the French Revolution.

His fabrics, whether for men or women, were neo-Baroque, magnificently decorous, and colorful. They were adorned with shells and leopard imitations, pop stars and covers from

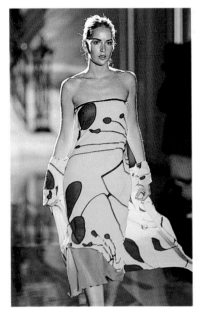

Versace model, 1997.

Vogue—and, of course, the head of Medusa, the logo of the house of Versace. Thus, his fashion became an ongoing self-reflection of fashion. In the early eighties, Versace unleashed a furor with a metallic fabric that looked like live snakeskin.

Versace's fashion was magnificent and simultaneously mocked its own magnificence; the clothing often appears tacky. The irony lay in the fact that traditional elegance had ceased to be a fashion criterion for the second half of 20th century, and also in the absence of clear boundaries between taste and tastelessness—between elegance and kitsch, between the prestigious and the base, between the elite and the popular.

Fashion from Japan

Since the end of the seventies, fashion designers of Japan have been among the most innovative and influential avant-gardists working in Europe. Rei Kawakubo of Comme des Garçons, Yohji Yamamoto, and Issey Miyake create clothing that lacks traditional European forms. Their designs seem to stand in complete opposition to Western ideas about the human body. They boast unexpected silhouettes and create spatial effects which are unusual for Western eyes. Fabric—or other materials such

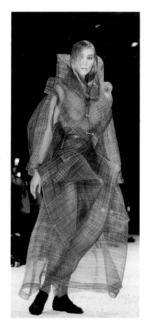

Fashion scolpture by Issey Miyake.

177

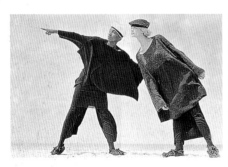

Creations by Rei Kawakubo, 1983.

as plastic or paper—is draped in wide swaths around the body. Instead of creating a second skin, these fashions often build a sculptural space around the wearer's body, exhibiting almost complete disregard for gender. Classic cuts are modified into something unshapely and come to life only through the movement of the person wearing them. In 1997, Rei Kawakubo presented her irregularly shaped designs, and these eclipsed all other designs on show.

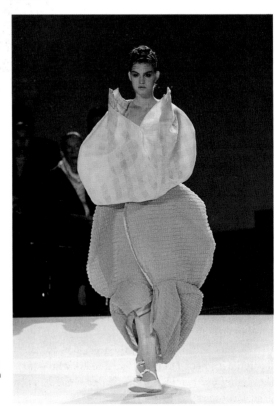

Spring/Summer, 1997: Rei Kawakubo invents a completely new body form.

New fabrics, new combinations

The major fashion development in the nineties has been in the materials used. Forms and shapes had all been tried in every way possible, but now fabrics like plastic wrap, vinyl, Teflon, or other synthetic fibers, layered cotton looking like leather, and other novelties have been introduced, presenting old forms in a new somewhat ironic form. What Elsa Schiaparelli could only dream of in the thirties has now become reality. A seventies style dress made of a nineties fabric is easily distinguishable from the authentic "vintage" dress of the seventies. The "business style" of the late nineties, which is no longer confined to the office, is far removed from the men's suits on which they were loosely based. This is because of the new elastic materials that have made clothing incredibly comfortable. In addition, the possibilities for combining clothes have changed: One may wear a blazer with a lace skirt and Doc Martens, and still be fashionable.

Michael Jackson, fashion idol of the younger generations in the eighties and nineties.

Youth fashions experiment with all styles and materials. The seventies revival, retro, techno, and grunge are style conglomerations that appear to be new, provocative, and tasteless. They have already been adopted by the mainstream. In reality, fashion is no longer only designed in the studios of the big fashion designers, but by the consumers who wear the clothes and combine the different elements in innovative ways.

Glossary

Aigrette A headdress consisting of one or more upright feathers fastened onto a turban, alice band or pearl band, either in a row or as a bouquet. It was a particularly popular head adornment at the beginning of the 19th and 20th centuries. In the 1930s and 1940s, people began to affix the feathers to hats.

Arts and Crafts English art and social reform movement in the 19th century, headed by the English artist, poet and social critic William Morris (1834–1896). Opposing industrialization, which was regarded as inhuman, the movement propounded a return to hand-made articles and a nature-oriented environment. The arts and crafts movement influenced *art nouveau*.

Braguette Originating out of the front flap of men's trousers or tights, the braguette became an independent element sewn onto male clothing during the 15th and 16th centuries. Round or elongated, later lavishly decorated with ribbons and bows, it concealed the male genitals while simultaneously and conspicuously emphasizing them.

Canon Trouser legs, originally close-fitting, and worked onto Heerpauke. During the 17th century they developed into wide flounces with points, and were worn with petticoat breeches.

Chambre Syndicale de la Couture Parisienne Association of Parisian Tailors, founded in 1868 on the suggestion of Charles Frederick Worth. The association attempts to protect fashion designers from counterfeits; it also organizes fashion shows and deals with publicity. In 1975, a department dealing with *prêt-a-porter* was added; the joint name is now "*Fédération de la Couture, du Prêt-a-porter des Couturiers et des Créateurs de Mode.*"

Chanel Suit Launched in the 1950s, this suit strengthened the world-wide reputation of Coco Chanel, whose fame had been growing since the 1920s. The suit comprises a straight cut, slightly flared knee-length skirt combined with a box-shaped jacket without a collar. The jacket is edged with braid trimming and closed with a row of gold buttons or chains. The most popular material is tweed. Karl Lagerfeld rejuvenated the Chanel suit in the 1980s; retaining its original basic design, the suit has since been updated regularly according to the latest fashion trends.

Chemise Shirt dress, *robe en chemise*: basic wear in the years following the French Revolution. The shirt dress was made of thin, flowing, lightweight materials, generally in white and sometimes transparent, and was cut in one continuous piece with a high waist. The shirt dress was a development of English fashions which in turn had taken their inspiration from antique images. It was worn without a corset, but sometimes with an undershirt or flesh-colored body; thus it was also referred to as "naked fashion."

Chiton Shirt robe, with side seams. Rather than sewn, the shoulder pieces were affixed together with pins. Knee or ankle-length, the Chiton was the most essential piece of clothing in Greek times for both men and women. It originated from Assyria.

Coordinates Skirt or trouser suit, the separate elements of which harmonize together, but are not made of identical fabric.

Corset Upper part of women's clothing (only occasionally found in male clothing). Fish bones or thin steel rods and adjustable laces help to model the female torso according to the prevailing ideals, with a very slim waist, and either no bust, or at other times, as much bust as possible. The

Glossary

corset was generally worn underneath the main dress, but became an integral, external part of it during the 19th century. Men and women began to bind themselves during the Middle Ages, and the corset became an essential accessory of Spanish fashion in the 16th and 17th centuries, when the bust was pressed flat with lead plates. Corsets were worn by women up until the French Revolution; then, during the renaissance of the antique period (also known as naked fashion) they were temporarily dropped, but soon revived. Up until the 17th century, corsets could also be found in men's fashions, and then again at the start of the 19th century. They have since been completely dropped by men, except as an element of "fetish fashion." Early on in the 20th century, the corset evolved into the bodice, losing some of its severity now that it was made from softer materials such as rubber. It did not completely disappear until the 1960s; now it exists only as part of fetish fashions and the postmodern styles influenced by these.

Crinoline (from the French word *crin*, meaning horsehair) An underskirt, stiffened with horsehair. Common in the 19th century, it was used to give women's skirts

more volume. In the second half of the 19th century, hoop skirts appeared on the scene, consisting of flexible steel hoops; these were also referred to as crinolines.

Cul de Paris See *Tournure*

Culottes See *Knee breeches*

Deshabillé See *Negligée*

Ensemble A suit, the elements of which—jacket, trousers and vest—are made of different coordinating fabrics, as opposed to the traditional suit, where all the pieces are made of identical fabric.

Fichu Scarf or neckerchief made of fine fabric, worn tucked into the cleavage by women in the 18th century. The loose ends were tied to a visible knot at the front, or crossed over the back. At the end of the 18th century, the fichu was artificially "inflated" by padding on the inside; it was then known as a *trompeuse* (deceiver).

Godet fold A wedge of fabric sewn into a skirt such that it flares out at the bottom while remaining close fitting at the top.

Goose-belly A waistcoat with elongated points at the front. These points were starched and padded (sometimes with tow), and were therefore very stiff. The goose-belly was very fashionable toward the end of the 16th century; it was supposedly designed by the French king Henri III and made the

front flap superfluous, while still heavily emphasizing the male genitals. Women's fashion also adopted the shape of the goose-belly in modified form, as an elongated bodice.

Haute Couture High class tailoring, evolving in the 19th century. Today the term designates a particular form of production: clothes are made by hand, individually and to measure . Since 1911 these clothes have been presented annually at the fashion shows in Paris. The patterns can be purchased and copied at home. During the 19th century, tailors designed clothes with particular customers in mind; after the First World War, however, their collections were increasingly produced without referring to individual's wishes. Nowadays, *haute couture* serves more as an advertisement for fashion establishments, but is no longer a lucrative source of income— profits are made much more through *prêt-a-porter*, or through licenses for a whole range of products including cosmetics, accessories etc. Each year, a jury from the "*Chambre Syndicale de la Couture Parisienne*" decides which of those fashion designers who have applied for membership are eligible to join the realms of *haute couture*. Cer-

Glossary

tain stipulations for membership are made; at least 20 seamstresses must be employed (excluding those working from home), two collections must be presented in Paris each year, each with at least 75 different models, and proof must be made that the fashion designer or director of the fashion house has designed the styles independently. Today, *haute couture* boasts a clientele of only 2000 women, and only 6% of the total turnover of French fashion houses is made with *haute couture*. One *haute couture* dress can easily cost $ 15,000 or more.

Heerpauke Stuffed, balloon shaped, thigh-length trousers for men, dating from the second half of the 16th century.

Hennin Women's head-dress from the Middle Ages, consisting of a high, pointed cone, covered with costly materials such as brocade. A veil of varying lengths could be draped over this. High, shaved fore-heads were also in fashion.

Hoop skirt A woman's skirt, formed into ball, bell, or barrel shape by means of wire or metal hoops. Invented in the 15th century in Spain, it did not become popular until the 16th century. In the second half of the 16th century it became broad at the sides, but flattened off at the front and rear. This style of hoop skirt remained dominant in courtly fashions until the 18th century, but was replaced in everyday wear around 1600 by padding around the hips. The hoop skirt came back into fashion in the 18th century, and was replaced temporarily in the 19th century by horsehair and other stiffened underskirts. It then later reap-peared as the crino-line, a flexible struc-ture made of steel hoops.

Horned bonnet Women's headdress from the Middle Ages, consist-ing of two horn-shaped cones over the temples, often draped with veils.

Jabot Ruffle or frill made of lace, linen or batiste, concealing the top button on men's shirts. Particularly popular in the 18th century, it was adopted by women in the 19th century.

Knee breeches Also known as *culottes*, these were everyday wear for the aristocracy and wealthy upper class during the 18th cen-tury. During the French Revolution, knee breeches became synonymous with the hated feudal system and were replaced with pantaloons, which later developed into the long trousers predominant in men's fashion today.

Mutton-leg sleeves Popular during the Bieder-meier period, these sleeves were greatly puffed out at the shoulders and close fitting toward the wrist.

Negligée Originally (during the 18th century), *negligée* was the general term for everyday wear, as opposed to courtly dress. During the 19th century, the meaning changed to denote solely clothing worn at home, not in public, and finally, in the 20th century, refers only to night-wear.

Off-the-rack clothing Indus-trially mass-produced ready-to-wear clothing, presorted into various standard sizes, and sold by department stores and other retailers. Quality and price vary greatly; the better class of clothes are made in smaller quantities and are known as *prêt-a-porter*.

Pantaloons Calf-length or ankle-length trousers which replaced knee breeches during the French Revolution. They have—in varying form—remained the male fashion for trousers ever since. Originally worn only by the working class and sailors, they were later also favored by the *Sansculottes*. The fashionable version was originally made of a sort of silk, some-times with wedges underneath the soles of the feet to prevent them from riding up. In the first part of the 19th century they then finally gained the wide, loose, ankle-length form

Glossary

which they have retained to the present day. The long trousers worn by women with shirt dresses around 1800 as part of the "naked fashion" were also referred to as pantaloons. During the Biedermeier period, pantaloons were long, broad trousers, edged with lace and worn by little girls under calf-length dresses.

Parure (French, "costume") was the term given to a reduced form of finery as opposed to the full-blown gala finery; it also denoted the *negligée*, street, and everyday wear.

Patchwork Piecemeal work; American settlers women sewed small pieces of leftover fabric together to make a larger whole, from which curtains or blankets could then be made. Patchwork gained popularity in the 1960s and was even printed as a design onto fabrics.

Petticoat breeches Extremely fashionable skirt-trousers for cavaliers in the second half of the 17th century, covering the knees, extremely widely cut and lavishly decorated with ribbons.

Pillbox A style of hat in the 1960s, popularized by Jacqueline Kennedy. The pillbox was a tiny, round hat in the form of a pillbox, worn on the back of the head.

Planchette Originally made of wood, and later of metal, ivory, fishbone or mother-of-pearl,

this was a rod used by women from the 14th century onward for reinforcement of the bodice. During the 16th century, the planchette became an integral part of the bodice or corset. It was often embroidered or embellished, and visible at the waist.

Plastron
1. A wide silken necktie, often wrapped several times around the throat, and covering the chest.
2. In women's fashion in the 20th century: an inset, sewn into or onto the bodice of dresses or front part of blouses, often with pleats or adorned with other embellishments.

Plissé Narrow, pressed folds in fabric, enabling the material to fit more snugly over the body. The Spanish-born Venetian designer Mariano Fortuny (1871–1949) and the Japanese designer Issey Miyake (b. 1938) are both renowned for their *plissé* techniques.

Poke bonnet Also known as a *capote* (adjustable hood), this had a perpendicular brim and was particularly popular during the Biedermeier period.

Posamentaries Textile accessories (gold/silver braids, tassels, trimming, laces) attached to clothing as adornment.

Prêt-à-porter (Ready-to-wear, *Alta Moda Pronta*) Ready made clothing designed for industrial production and not tailored to

individual measurements (as is *haute couture*), yet not mass-produced like off-the-rack clothing. *Prêt-a-porter* is still linked with the label of the fashion designer, and is an area of fashion which reaps large profits. It gained significance during the 1960s, when *haute couture* was regarded as out-of-date, and a young clientele with considerable buying power began to demand quality clothing in the more youthful spirit of the age. Many fashion designers began to develop their own *prêt-a-porter* collections, and nowadays, some of the most influential designers work solely in this field. Independent fashion shows in Paris, London, and Milan, and separate trade unions have been set up to accommodate *prêt-a-porter* fashions.

Redingote Originally an English riding coat for gentlemen, this was two-pieced, with an emphasized waist, with long laps that reached down to the calves. In the 18th century it was cut back somewhat. Women's fashions adapted the redingote at the close of the 18th century, creating a jacket or overcoat with a heavily emphasized waist, broadly cut laps and low neckline, into which a *fichu* was often tucked. Dresses

Glossary

were also designed in redingote style.

Ridicules/Reticules Small handbags formed in any number of shapes, including heart and basket shape, highly fashionable among women toward the end of the 18th century.

Robe d'Intérieur Also known as the tea-gown. Popular in the last decades of the 19th century, this was a comfortable, loosely waisted one-piece dress with wide sleeves and lacy flounces, made of flowing fabrics. It was not worn for going out of doors or traveling, nor for paying visits, but was worn solely within one's own four walls; however, it was also considered acceptable dress for receiving visitors.

Schaube Wide, dark overcoat with sleeves, open at the front (16th century).

Separates Various pieces of clothing which harmonize in color and fabric and can be worn together at will.

Tappert Coat-like cape (ca. 1300–1500).

Tournure Horsehair padding, or structure made of steel or fishbone in the form of a half-moon, fitted over the bottom and tied with ribbons to the waist. The skirt was then flounced up over this, forming a *cul de Paris*. This whole dress style was also referred to as a *tournure*. It was the characteristic silhouette of the late 19th century, originally in a more flowing line, tied to a high waist, and culminating in the 80s in a low waist, with the tournure sticking horizontally out at the back.

Traditional costume Clothes worn by a particular social group, indicating the class, gender, line of work or geographical home of the wearer. In contrast to changing and individual fashions, traditional costume aims for permanency and group feeling. Traditional costume often belatedly adopts weakened versions of fashion trends.

Trompe-l'œil (French, illusion) The depiction of objects with deceptive perspective, such that an optical illusion and a surprise effect results, either because the illusion appears deceptively real, or because two pictures have been superimposed and the eye cannot disentangle them (e. g., a human profile or an animal).

Twin-set Sweater and cardigan made of the same material in the same style, and worn together.

Vienna Workshops Founded in 1903, the "*Productiv-Gemeinschaft von Kunsthandwerkern in Wien*" (Productive Union of Craft Artisans in Vienna) wanted to reform everyday designs, and thus fashion itself. Clothing was to become comfortable, natural and aesthetic, adapted to the materials used and excellently crafted. Gustav Klimt was a significant exponent of the Union, as were the Flugge sisters and Eduard Wimmer Wisgrill, manager of the Vienna Workshops until 1922. The styles were initially geometric and abstract, but later became more ornamental. The Vienna Workshops were dissolved in 1932.

Bibliography

Bibliography

Ash, Juliet and **Elizabeth Wilson**, eds. *Chic Thrills: A Fashion Reader*. London: Pandora, 1992.

Crawford, M.D.C. *The Ways of Fashion*. New York: G.P. Putnam's Sons, 1941.

Davies, Stephanie. *Costume Language: A Dictionary of Dress Terms*. Malvern, UK: Cressrelles Publishing, 1994.

Davis, Fred. *Fashion, Culture and Identity*. Chicago: University of Chicago Press, 1992.

DuCann, Charlotte. *Vogue Modern Style*. London: Century, 1988.

Fogarty, Anne. *Wife Dressing: The Fine Art of Being a Well-Dressed Wife*. New York: Julian Messer, 1959.

Houck, Catherine. *The Fashion Encyclopedia*. New York: St. Martin's Press, 1982.

Howell, Georgina. *In Vogue: Seventy-Five Decades of Style*. London: Condé Nast Books, 1991.

Köhler, Carl. *A History of Costume*, trans. by Alexander K. Dallas. New York: Dover, 1963.

Ley, Sandra. *Fashion for Everyone: The Story of Ready-to-Wear, 1870's–1970's*. New York: Charles Scribner's Sons, 1975.

Lynam, Ruth, ed. *Couture: An Illustrated History of the Great Paris Designers and their Creations*. Garden City, NY: Doubleday, 1972.

Merriam, Eve. *Figleaf: The Business of Being in Fashion*. Philadelphia: Lippincott, 1960.

Milbank, Caroline Rennolds. *New York Fashion: The Evolution of American Style*. New York: Harry N. Abrams, 1989.

O'Hara, Georgina. *The Encyclopedia of Fashion*. New York: Harry N. Abrams, 1986.

Steele, Valerie. *Fifty Years of Fashion: New Look to Now*. New Haven, CT: Yale University Press, 1997.

Steele, Valerie. *Women of Fashion: Twentieth-Century Designers*. New York: Rizzoli, 1991.

Turner Wilcox, R. *The Mode in Costume*. New York: Charles Scribner's Sons, 1983.

Important Fashion Museums and Fashion Schools

Important fashion museums and fashion schools

Lipperheidesche Kostüm-bibliothek
Kunstbibliothek
Staatliche Museen zu Berlin
Matthäikirchplatz 6
10785 Berlin

Metropolitan Museum
1000 5th Avenue
New York, NY 10028

Münchner Stadtmuseum
St. Jakobsplatz 1
80331 München

Musée de la Mode et du Costume de la Ville de Paris
Palais Galliera
10, avenue Pierre Iᵉʳ de Serbie
F–75116 Paris

Musée des Arts de la Mode
Louvre – Pavillon de Marsan
107, rue de Rivoli
F–75001 Paris

Victoria and Albert Museum
Cromwell Road
South Kensington
GB–London SW7 2RL

Metropolitan Museum of Art
New York, NY

Museum of the Fashion Institute of Technology
New York, NY

Brooklyn Museum
Brooklyn, NY

Museum of Fine Arts
Boston, MA

Victoria and Albert Museum
London, England

Museum of Costume and Fashion Research Centre
Bath, England

Bata Shoe Museum
Toronto, Ontario, Canada

Important Fashion Schools

Germany

Burg Giebichenstein-Hochschule für Kunst und Design
Fak. Design
Neuwerk 7
06108 Halle

Deutsche Meisterschule für Mode München
Roßmarkt 15
80331 München

ESMOD Deutschland –
Private Modeschule für Stylisten und Modelisten
Fraunhoferstr. 23 h
80469 München

Fachhochschule Bielefeld,
FB I – Design –
Lampingstr. 3
33615 Bielefeld

Fachhochschule Hamburg
FB Gestaltung
Armgartstr. 24
22087 Hamburg

Fachhochschule Hannover
FB Kunst und Design
Herrenhäuser Str. 8
30419 Hannover

Fachhochschule Pforzheim
FB 2: Visuelle Kommunikation
Holzgartenstr. 36
75175 Pforzheim

Fachhochschule Trier
FB 9: Design
Schneidershof
54293 Trier

Fachliche Ausbildungsschule für Damenschneiderei und Modedesign
Berliner Allee 9–11
30175 Hannover

Hochschule der Künste
Straße des 17. Juni 118
10623 Berlin
(FB 3: Industrial Design)

Kunsthochschule Berlin-Weißensee
Abt. 1: Modedesign
Bühringstr. 20
13086 Berlin

Lette Verein Berlin
Viktoria-Luise-Platz 6
10777 Berlin

Modefachschule Sigmaringen
Römerstr. 22
72488 Sigmaringen

Private Modeschule Düsseldorf
Gustav-Adolf-Str. 43
40210 Düsseldorf

Staatlich anerkanntes Stuttgarter Berufskolleg Modegestaltung-Bekleidung
Postfach 300301
Rotebühlstr. 133
70197 Stuttgart

Westsächsische Fachhochschule Zwickau
FB Angewandte Kunst
Goethestr. 1
08289 Schneeberg

France

Atelier Fleuri-Delaporte
1 bis, impasse de l'Astrolabe
F–75015 Paris

Ecole de la Chambre syndicale de la Couture Parisienne
45, rue Saint-Roch
F–75001 Paris

ESMOD
16, boulevard Montmartre
F–75009 Paris

Studio Berçot
29, rue des Petites Ecuries
F–75010 Paris

Important Fashion Museums and Fashion Schools

USA

The Fashion Institute of
Technology
7th Avenue at 27th Street
New York, NY 10001

Association

Fédération de la Couture, du
Prêt-à-porter des Couturiers
et des Créateurs de Mode
100–102 Rue du Faubourg
St. Honoré
F–75008 Paris

Index of Names

Index of names

Adorno, Paolina (Marquise Brignole Sale) 60, 61
Armand 128
Armani, Giorgi 171, 172
Augustabernard 142

Bakst, Leon 120
Balenciaga, Cristobal 144, 148
Balmain, Pierre 148
Barbie 156
Barbier, Georges 135
Baudelaire, Charles 93
Beatles 155
Benois, Alexander 120
Bertin, Rose 82
Bloomer, Amelia 108
Boehn, Max von 43, 45, 53, 55
Bohan, Marc 153
Boissard, Jean Jacques 49
Brooks, Louise 132
Brummell, Beau 93

Cardin, Pierre 157, 158
Chanel, Coco (née Gabrielle) 126, 127, 131, 133, 134, 142, 146, 147, 152, 172
Charles II, King of England 69
Charles, Prince of Wales 169
Cocteau, Jean 143
Courrèges, André 154, 159
Crécy, Odette de 112

Dalí, Salvador 143
Delaunay, Sonia 136, 137
Diaghilev, Sergei 119
Diana, Princess of Wales 169
Dietrich, Marlene 139
Dior, Christian 146, 148, 152, 153
Doeuillet 10, 122
Dolce & Gabbana 174
Doucet, Jacques 122
Duchess of Croy 66

Duchesse de la Fontanges 71

Exner, Alexandra 136

Fath, Jacques 148
Ferre, Gianfranco 153
Fini, Leonor 143
Fokine, Mikhail 119
Fortuny, Mariano 120, 121, 122

Galliano, John 115
Garbo, Greta 139
Gaultier, Jean Paul 167, 168, 171, 173, 174
Gillier, André 133
Givenchy, Hubert de 148, 153, 155
Grès, Madame Alix 142, 148
Güntert, Renate 172

Hartnell, Sir Norman 144
Hawes, Elizabeth 142
Heideloof, Niklaus Wilhelm von 79
Helm, Clementine 108
Hogarth, William 72, 73, 76, 77
Hulanicki, Barbara 158

Iribe, Paul 120

Jackson, Michael 179
Johnson, Charlotte 156
Joop! 171

Karan, Donna 171, 172
Kawakubo, Rei 9, 171, 177, 178
Kennedy, Jacqueline 155
King, Muriel 142
Klein, Calvin 171
Klimt, Gustav 118

Lacroix, Christian 171
Lagerfeld, Karl 143, 170, 171, 172
Lange, Rena 172
Lanvin, Jeanne 129, 132, 133, 139
Lauren, Ralph 171
Laurent, Yves Saint 148, 153, 159, 163
Laver, James 20, 29, 107
Lepape, Georges 120
Louis XIV, King of France 68, 69, 72, 76
Louiseboulanger 142

Madonna 167, 168
Mainbocher 144
Margarete of Valois 55
Marie Antoinette, Queen of France 82
Martial 128
Mary of Anton 65
McQueen, Alexander 115, 173
Miyake, Issey 177
Moffit, Peggy 157
Molyneux, Captain Edward 139, 144
Mondrian, Piet 159, 160
Monroe, Marilyn 168
Morris, William 117
Mugler, Thierry 171, 174

Nijinski, Vassily 119

Paquiny 122
Patou, Jean 133, 134, 139
Pavlova, Anna 119
Perugia 132
Piguet, Robert 140
Pizan, Christine de 36, 37, 40, 41, 45
Poiret, Paul 8, 118, 119, 120, 121, 122, 124, 128, 129
Pompadour, Madame de (Marquise of) 74, 82
Proust, Marcel 112

Quant, Mary 154

Rabanne, Paco 159
Redfern 116
Rhodes, Zandra 162
Ricci, Nina 142
Rigg, Diana 155
Rochas, Marcel 143
Rouff, Maggy 139, 142
Rubinstein, Ida 119
Rykiel, Sonia 18, 165, 173

Sander, Jil 12, 171, 172
Sassoon, Vidal 159
Schiaparelli, Elsa 140, 142, 143, 146, 147, 172, 174, 179
Schröder, Heinz 148, 149, 150
Schwarz, Matthäus and Veit 49
Shrimpton, Jean 155
Stepanova, Varvara 136

Index of Names

Strassner, Joe 141
Strauss, Levi 151

Tatlin, Vladimir 136
Tissot, James 113
Twiggy 155

Valentina 142
Van Dyck, Anton 66
Velde, Henry van de 118

Vernet, Marie 115
Versace, Gianni 171,
 173, 176, 177
Veruschka 155
Vionnet, Madeleine 130,
 133, 140, 141, 142,
 148

Watteau, Antoine 74, 75
Weigel, Hans 49

Westwood, Vivienne 74,
 115, 173, 174, 175
William of Orange 65, 66
Worth, Charles Frederick
 114, 115, 130

Yamamoto, Yohji 177

Picture Credits

Agentur Reuters 127
Archaeological Museum, Heraklion, Greece 23t, 23m
Archiv für Kunst und Geschichte, Berlin 10b, 11t, 14t, 14b, 25, 43, 56, 63b, 68t, 94bl, 94br, 95, 100, 102t, 102b, 101, 103t, 104t, 105b, 106, 110, 111b, 135, 140t, 140b, 141t, 144, 145b, 150
Bildarchiv Preußischer Kulturbesitz, Staatliche Museen, Antikenmuseum 23b, 74 (photo Jörg P. Anders)
Bourdin, Guy 155b
British Museum, London 30
Brooklyn Museum, New York 115t, 132t
Claxton, William 157
Courtsey of Courrèges 159
dpa 9b, 167,168t, 168b, 169, 174t, 176, 179
Egyptian Museum, Cairo 22m
Frick Collection, New York 51t, 60
Fricke, Helmut 172, 175b
Graphische Sammlung Albertina, Vienna 45, 49r, 49l
Courtsey of Rei Kawakubo 9t, 178b

(photographs J. François José)
Khornak, Lucille 170
Harvard Theatre Collection, Frederick R. Koc Collection 141b
Lattès, Jean-Claude 126l
Lindbergh, Peter 178t
M. H. de Young Memorial Museum, San Francisco 66b
Mattel 156
Maywald, Willy 147
Metropolitan Museum of Art, New York 12b
Münchner Stadtmuseum 113t
Musée Carnavalet, Paris 88b
Musée Condé, Chantilly 32, 38
Musée de la mode et du Costume, Palais Galliera, Paris 114b
Musée d'Orsay 10t
Musée du Louvre, Paris 22t, 24t, 24b, 51b
Museo del Prado, Madrid 47
National Gallery, London 42
National Portait Gallery, London 13, 54l, 55
Öffentliche Kunstsammlung, Basel, Kunstmuseum 50b (photo Martin Bühler)
Pfizenmaier, Ed 158
Rheinisches Bildarchiv, Köln 48

Courtsey of Zandra Rhodes 162b
Rijksmuseum, Amsterdam 66t
Courtsey of Sonia Rykiel 18, 173
Courtsey of Yves Saint Laurent 160
Courtsey of Jil Sander 12t
Sotheby's, London 143
Staatliche Kunstsammlung, Gemäldegalerie Alter Meister, Dresden 62t
Wallace Collection, London 74b

© Sonia Delaunay: L & M Services B. V. Amsterdam 980210 137
© VG Bild-Kunst, Bonn 1998: Willy Maywald 147

The following illustrations were taken from the book by Brigitte R. Winkler, *Weltmeister der Mode*, Edition S, Verlag Österreich, Österreichische Staatsdruckerei AG, Vienna 1992 174b, 177

All rights for illustrations not mentioned here belong to the author, publisher, or could not be located.